IMAGES
of America

NATIVE AMERICANS
OF RIVERSIDE COUNTY

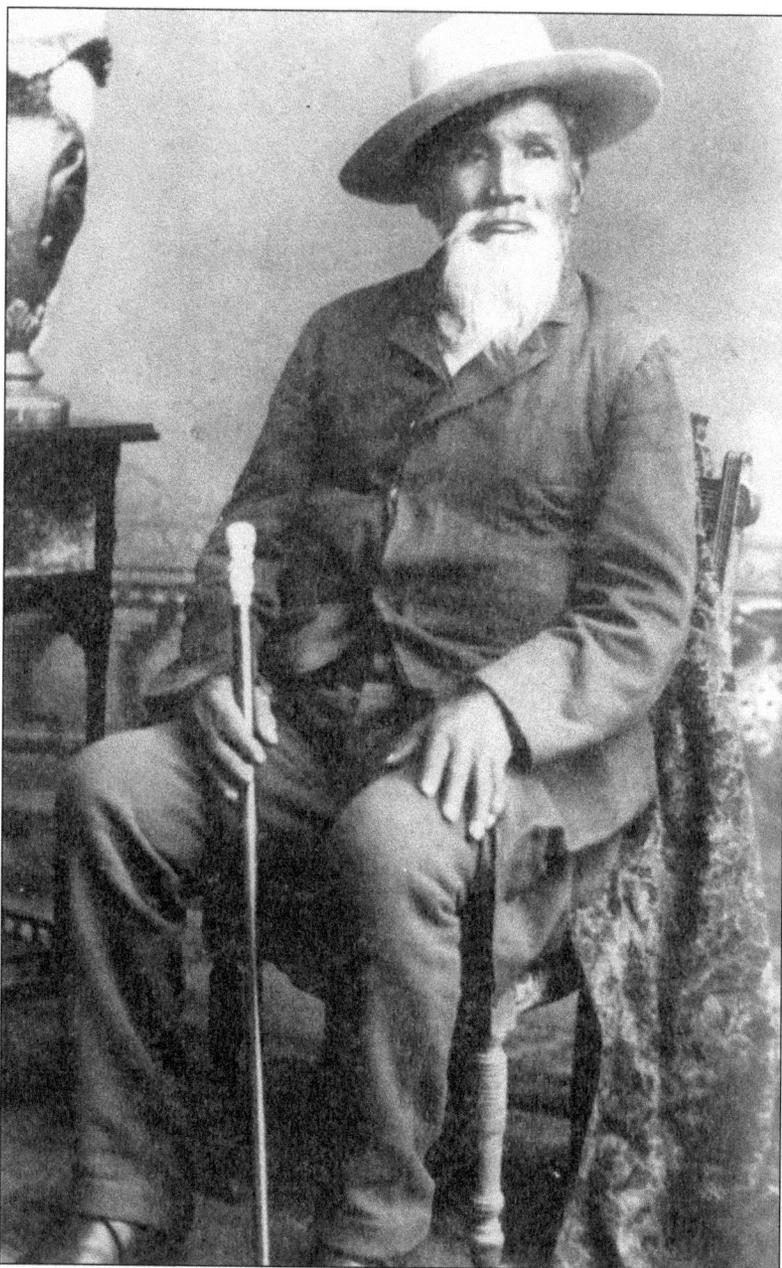

Chief Cabazon or Coos-pa-om-nu-it (Big Voice) was a highly respected leader of the Cahuilla people, and the Cabazon Band of Mission Indians honors his name. Cabazon taught his descendants to fight for Native American rights, respect the land, and care for families. (Courtesy of Cabazon Band of Mission Indians.)

ON THE COVER: All of the Indians of Southern California love their children and value their families. Each generation keeps the traditions, culture, history, and language alive. (Courtesy of A. K. Smiley Public Library.)

IMAGES
of America

NATIVE AMERICANS
OF RIVERSIDE COUNTY

Clifford E. Trafzer and Jeffrey A. Smith

ARCADIA
PUBLISHING

Published by Arcadia Publishing
Charleston, South Carolina

Library of Congress Catalog Card Number: 2006929373

For all general information contact Arcadia Publishing at:
Telephone 843-853-2070
Fax 843-853-0044
E-mail sales@arcadiapublishing.com
For customer service and orders:
Toll-Free 1-888-313-2665

Visit us on the Internet at www.arcadiapublishing.com

Dedicated to Lee Ann and Dani

CONTENTS

PREFACE

Riverside County, California, is rich in Native American history and culture. American Indians of the region point out that they have lived here since time immortal, since dynamic spiritual forces made mountains, valleys, deserts, and passes as well as many wondrous plants and animals. The aboriginal people of Riverside County have shared their homelands with many newcomers, and they have imparted their stories so that their cultures would live and survive. This book honors the first people of the county and their many contributions to contemporary life.

Generous American Indian people and their families within the county have shared much of what is presented here, and the authors owe a debt of gratitude to those people who shared their history and culture. For the authors, this work has been a labor of love, a task that allowed us to learn and grow as scholars as well as provide a voice for the first people of the county and a few contemporary Indians who now reside here. We live and work on Native American land that has witnessed many changes over the years. We all share a common link with the first inhabitants of the county, one we must nurture and never forget. This book is an introduction to the Native Americans of Riverside County, but we hope it will encourage readers to learn more about the fascinating first peoples of this powerful place we now call Riverside County.

—Clifford E. Trafzer and Jeffrey A. Smith
August 2006

INTRODUCTION

Since the beginning of time, many Native Americans have made their homes in the valleys, mountains, passes, and deserts of present-day Riverside County. The aboriginal Indians of Riverside County, including Cahuilla, Luiseño, Tongva-Gabrilleno, Serrano, Mojave, and Chemehuevi, revere the earth and resources encompassed within the region. For them, Riverside County is the center of the earth, the place of many origins and creations, the site where their ancestors interacted with the spirit of the land and other human beings long before the arrival of the Spanish in the 18th century. Over the years, the original Native Americans of the county have faced many changes, but they have never wavered in their love of their families and homelands. Today the original inhabitants of the territory encompassed in the county of Riverside share their attachment to the region with many newcomers, including indigenous people of others parts of the United States, Canada, and Latin America. These "urban Indians" have formed a new relationship with the land, but they honor the aboriginal inhabitants of Riverside County and their native sovereignty over this special place.

Native Americans of Riverside County have experienced many changes over a relatively short period of time. In 1769, Spanish soldiers under Gaspar de Portolá and president of the Sacred Expedition, Junipero Serra, led newcomers to San Diego de Acala to begin colonizing Alta California. From San Diego, friars, settlers, and soldiers spread out in many directions, crossing the present-day county claiming Indian lands in the name of the Cross and Crown. The newcomers resettled Indian lands, claiming native property and resources. Spanish and Mexican ranchers hired Indians to work as vaqueros and servants, and Indian labor contributed to the well being of the region. Unfortunately diseases spread among the Native American population, claiming the lives of thousands. Difficulties and change continued once the United States claimed California after its war with Mexico, which lasted from 1846 to 1848. American settlers and government agents dictated Indian policies, but the first people of Riverside County survived and made the best of their situation. In 1851, the new State of California passed a series of laws, and the two new senators to the United States Senate opposed the 18 treaties negotiated with the Indians of California. As a result, the tribes of the region had no legal relationship with the government until the 1870s, when the presidents created executive-order reservations for some tribes but not all. In the 1890s, Albert Smiley helped secure reservations for several tribes now living in Riverside County. Cahuillas, Luiseños, Chemehuevis, and Mojaves secured for themselves a small portion of their former homelands, but they "legally" had possession to some lands.

During the 20th century, American Indian people native to Riverside County and Indians from other areas worked hard to make a living. Native Americans worked as cowboys, farm laborers, and artists. They worked for merchants, teamsters, rail companies, and a host of others. They survived both on and off the reservations, making a living and maintaining their tribal sovereignty that they held so dear. The original inhabitants of Riverside County

often work and interact with Indians and non-Indians who are newcomers to the region, forging new alliances that contribute greatly to the well being of all people. Since the 1980s, Indian gaming has contributed to the growth of the region, but these businesses are a way to enhance all people, including the first peoples of the Riverside County and more recent arrivals.

The first peoples of the region continue to enjoy a special relationship with the mountains, valleys, and deserts of the area—a place they now share with many others. The Native Americans of Riverside County continue to be a hardy and resilient people who have faced much change and continue many of the traditions of their ancestors.

One

NATIVE PEOPLE
AND PLACES

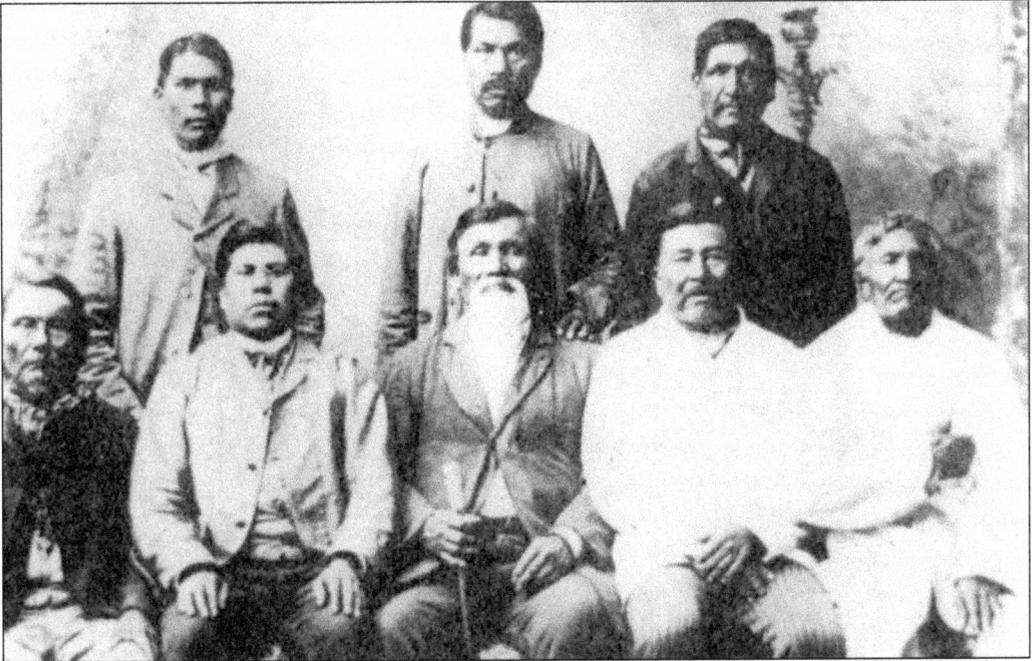

This group photograph of several Cahuilla leaders includes Chief Cabazon sitting in the middle of the front row. To his right is Santos Manuel. Cabazon led his people during a violent transitional period when non-Indians claimed nearly all of the former Native American domain, including nearly all of the Coachella Valley. Cahuillas retained a minute portion of their traditional estate. (Courtesy of Twenty-Nine Palms Band of Mission Indians.)

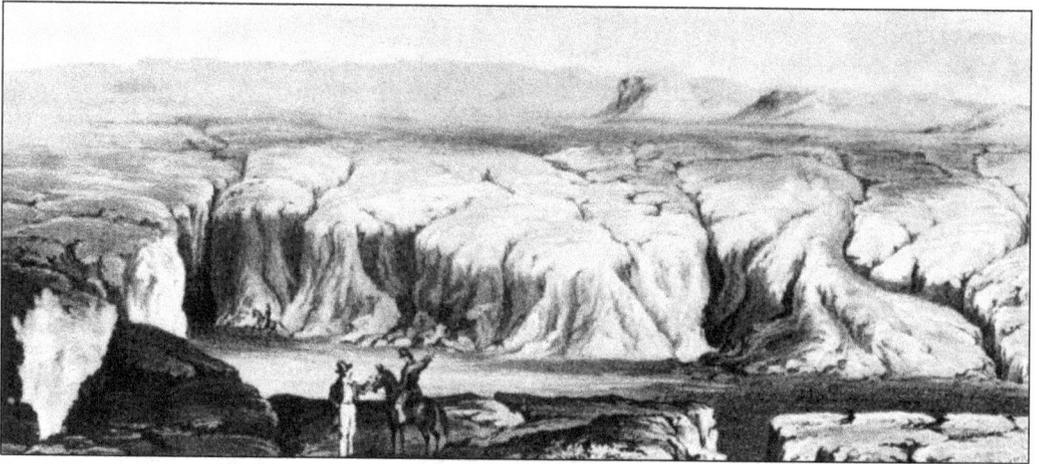

In 1856, a desire to plan a railroad route to the Pacific Ocean prompted the United States Army to explore the eastern portions of Riverside County. This is a sketch of the ravines and the bed of ancient Lake Cahuilla, which scholars believe dried up around 1500 A.D. to partially form the present-day Salton Sea. (Courtesy of Twenty-Nine Palms Band of Mission Indians.)

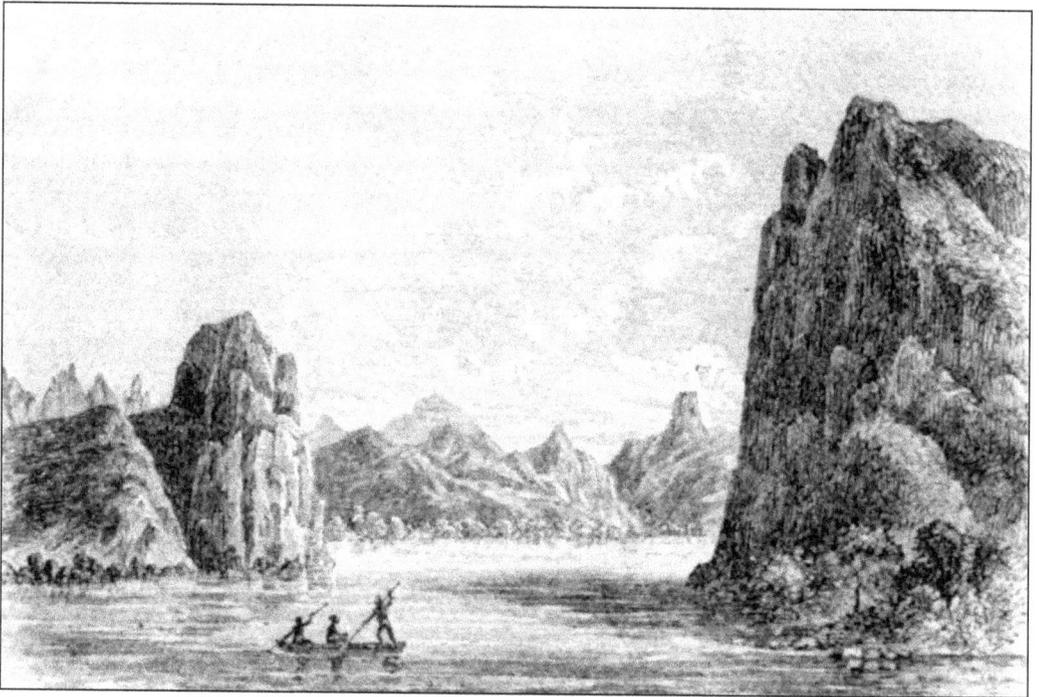

As Lt. Joseph Christmas Ives skirted the eastern edge of Riverside County, he had his artist, H. B. Mollhausen, sketch the landscape and people. Here he sketched Chemehuevis crossing the Colorado River from the Arizona side to California. (Courtesy of Senate Executive Document, 36th Congress, 1st Session, 1861.)

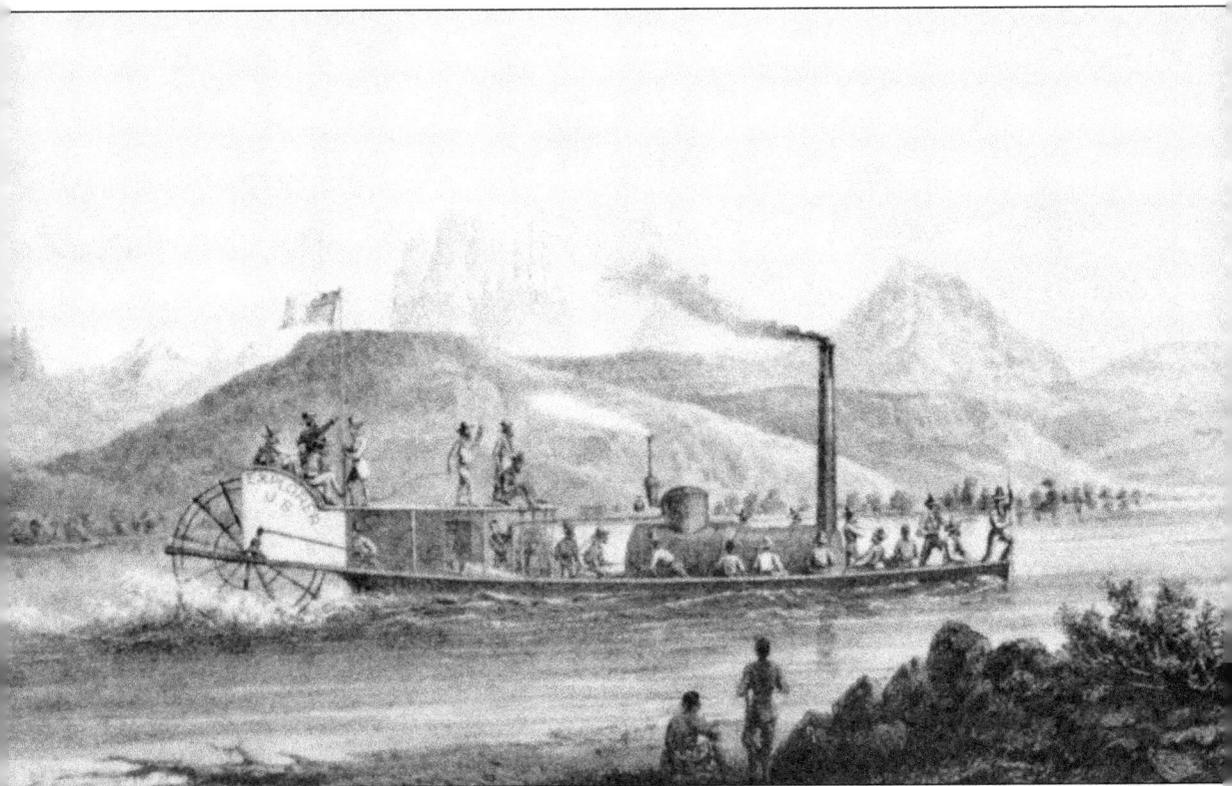

In 1858, the United States commissioned Lt. Joseph Christmas Ives to explore the Colorado River. Ives recorded details about the eastern borders of what would become Riverside County, commenting on the flora, fauna, landscape, and people. This is the steamboat *Explorer*. (Courtesy of Senate Executive Document, 36th Congress, 1st Session, 1861.)

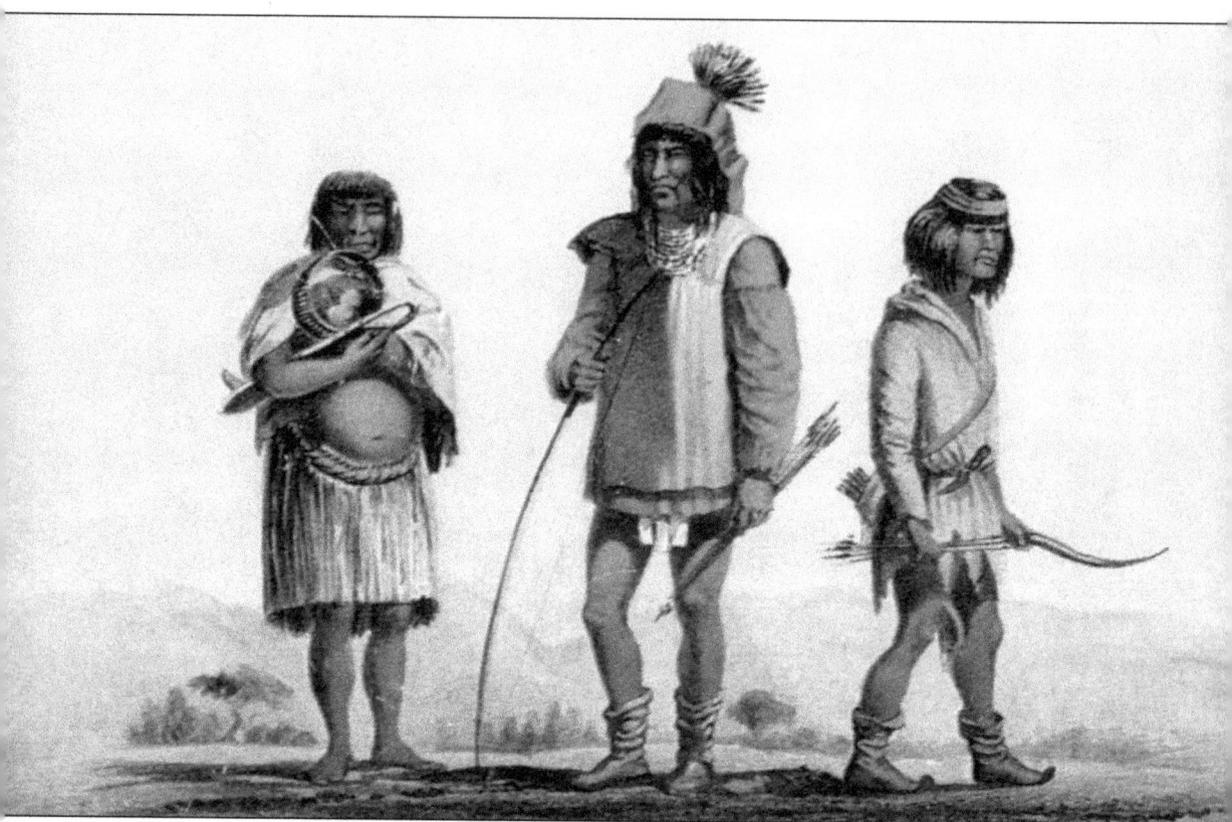

In the mid-20th century, exploring groups from the United States hired artists to record the people and places of Western lands. H. B. Mollhausen sketched three Chemehuevi on the expedition of Joseph Christmas Ives. Note the woman on the left holding a baby in a cradle board. The man in the middle holds a long bow while the man on the right carries a small, powerful war bow, the two types made by the Chemehuevis. (Courtesy of Senate Executive Document, 36th Congress, 1st Session, 1861.)

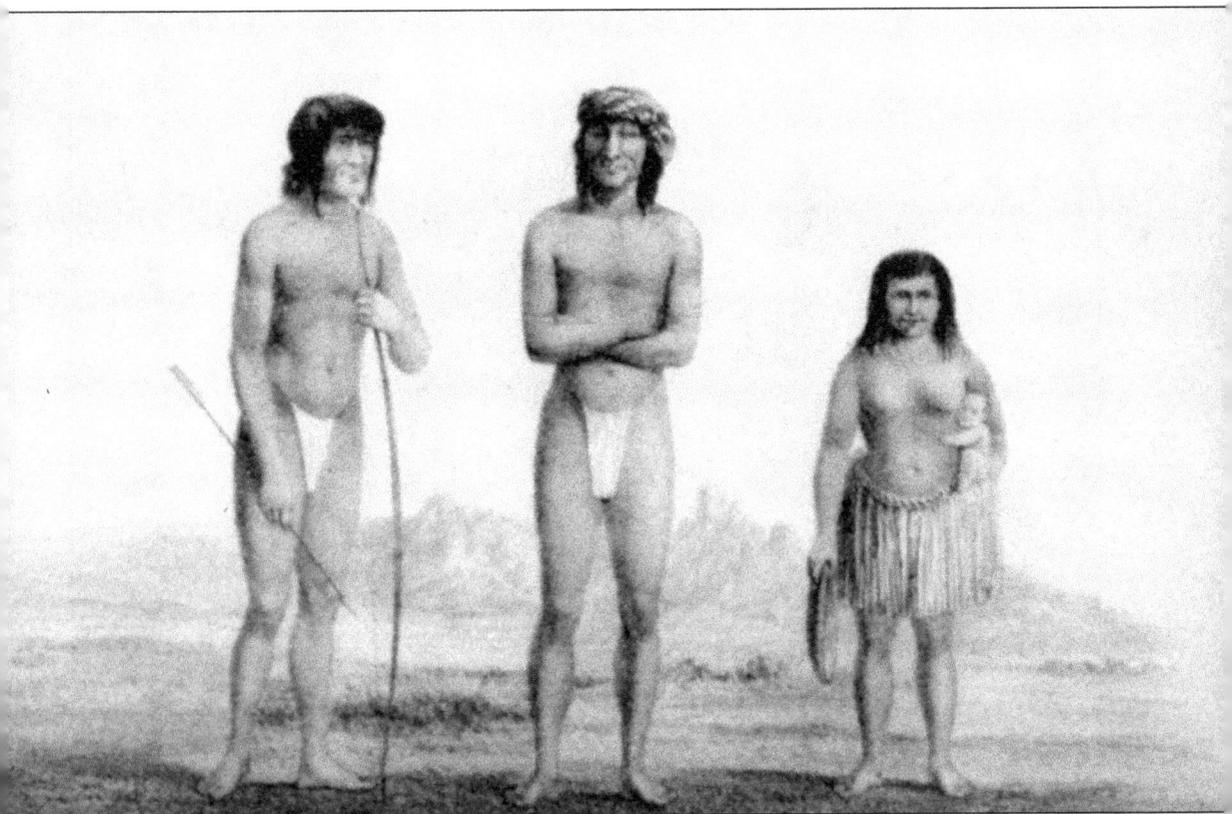

Today Mojave Indians live on the eastern boundaries of Riverside County. In the 19th century, several government and private observers noted the presence of Mojaves in California. This is a sketch made in 1858 by H. B. Mollhausen of two Mojave men and a woman. (Courtesy of Senate Executive Document, 36th Congress, 1st Session, 1861.)

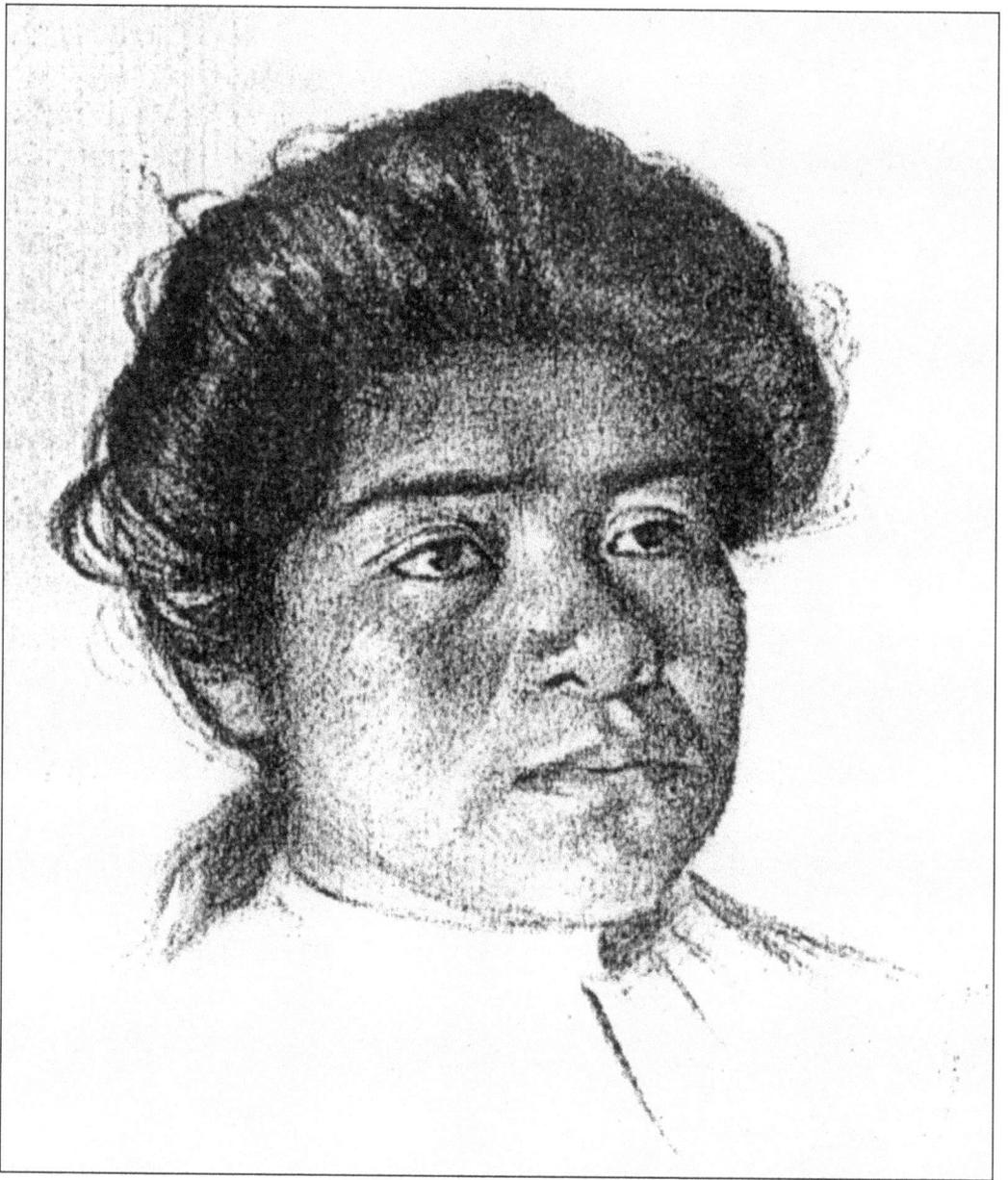

In 1905, an unknown artist created some portraits of Chemehuevi Indians living in Coachella, California. This is the image of Nah-ty. (Courtesy of Leleua Loupe.)

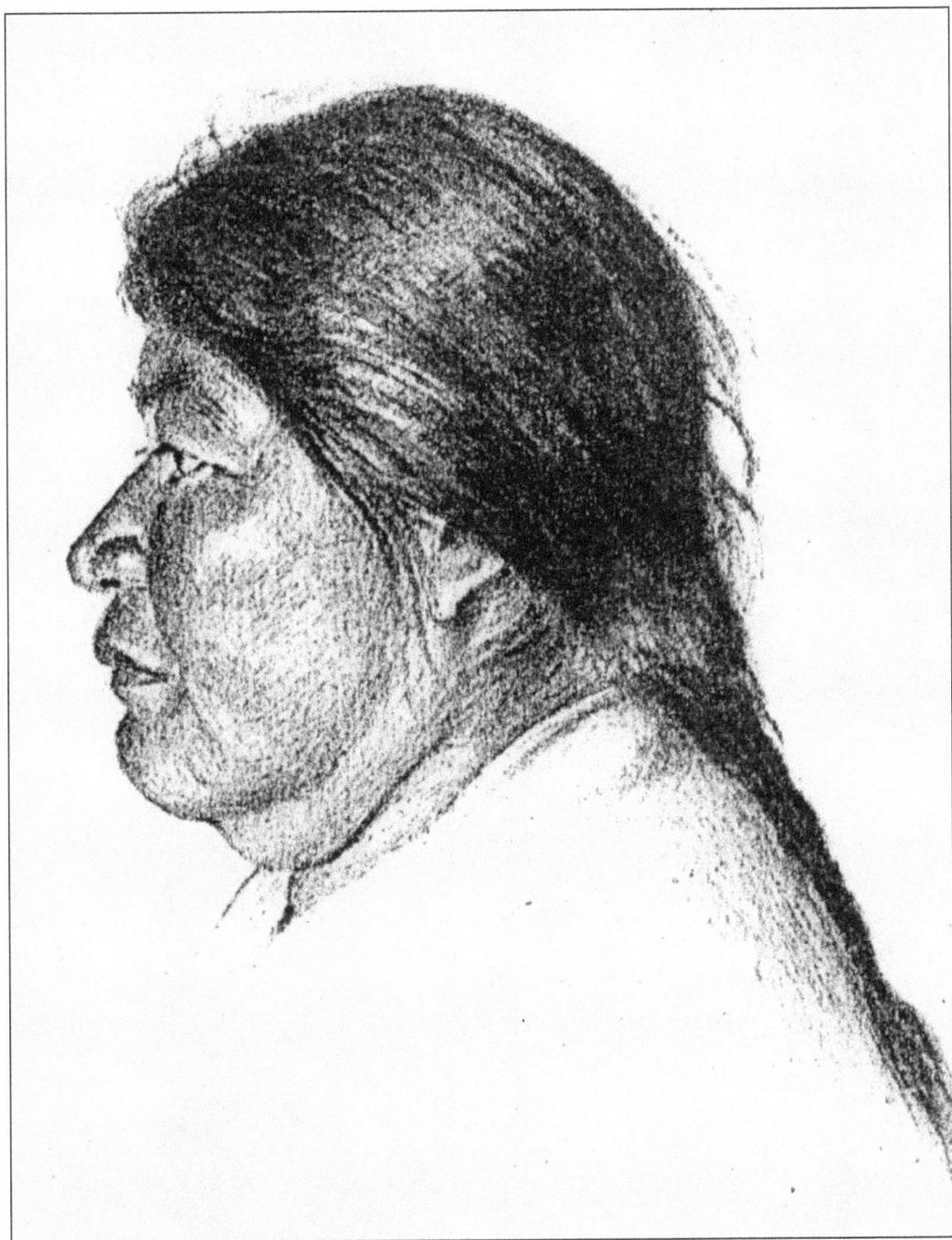

In 1905, Chat-ah Chimevava sat for a sketch in her home in Coachella, California. She is part of the Chemehuevi who lived in the county. (Courtesy of Leleua Loupe.)

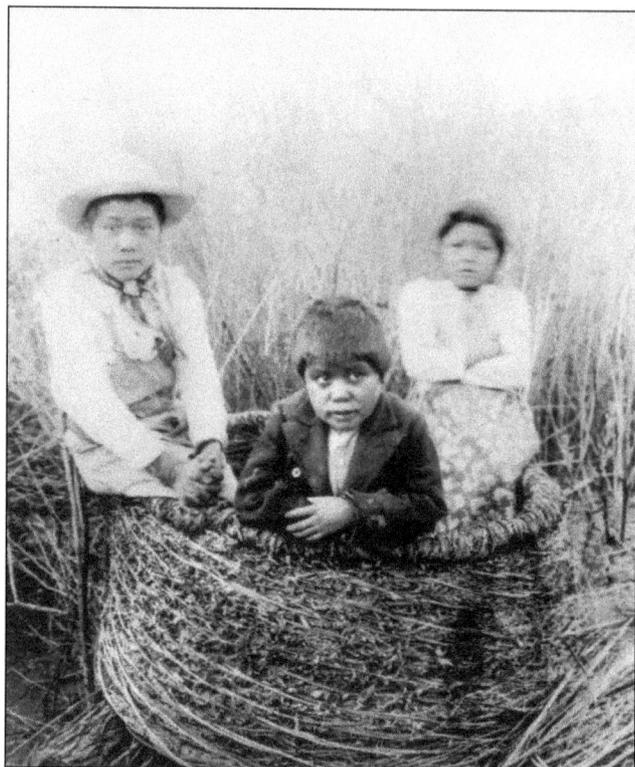

These three Chemehuevi children play in a *suqin*, or granary basket, their mother made. The people stored large quantities of mesquite beans, acorns, cactus, and other foods in these baskets, often placing them on top of their homes. The Cahuilla and Serrano people display a basket like this at the Malki Museum located on Fields Road on the Morongo Indian Reservation near Banning, California. (Courtesy of Twenty-Nine Palms Band of Mission Indians.)

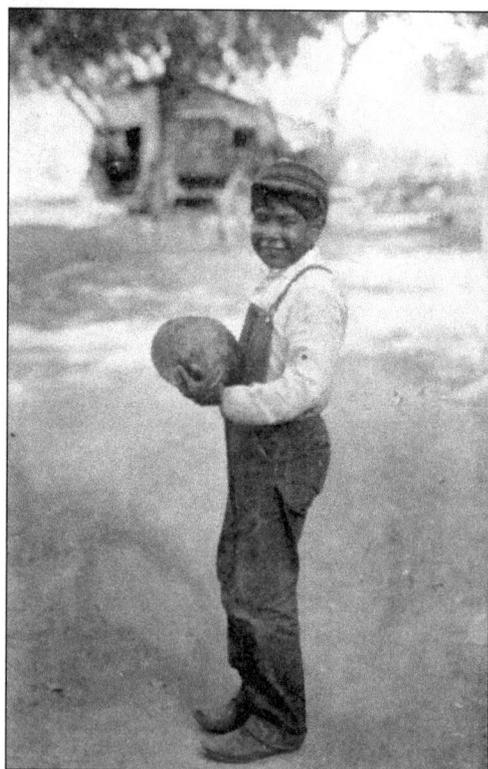

This Luiseño male is a fourth-grade student at Soboba Indian School. Indian children played ball for years, but games changed with the arrival of newcomers. (Courtesy of A. K. Smiley Public Library.)

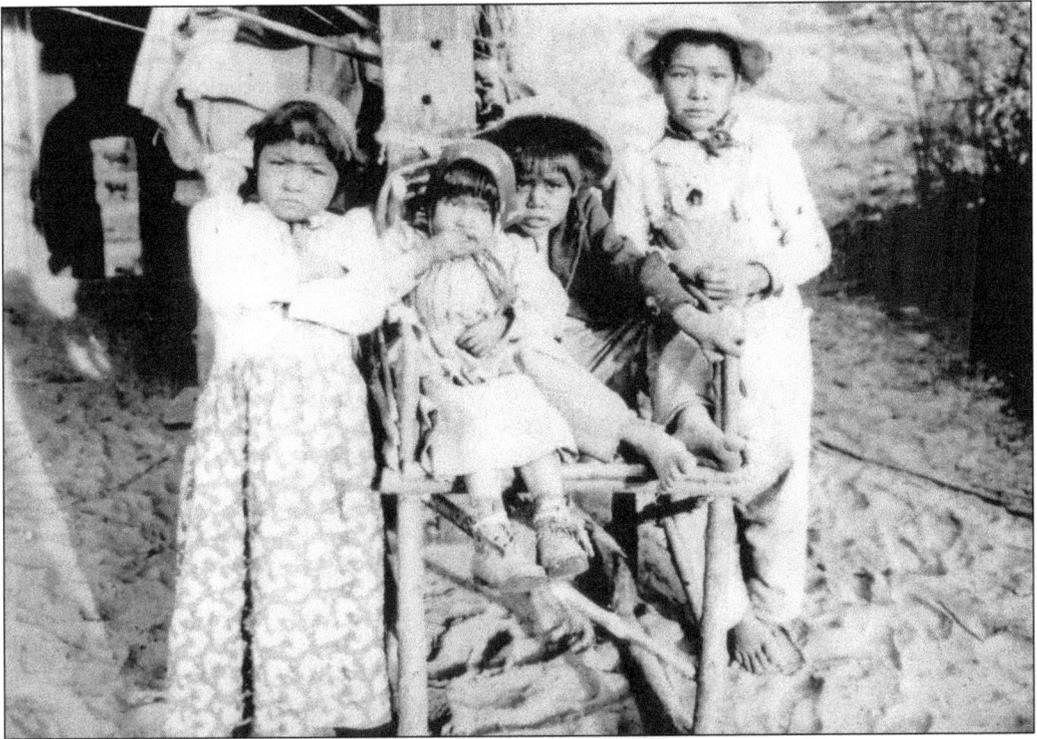

Four children play in a homemade chair in front of their home. The children are barefoot except the youngest girl who wears used boots. All of the children wear Western clothing, including the girls who have on skirts and dresses made from used flour sacks that their mothers used to construct the clothing. Because of the intense sun in the deserts of Riverside County, all the children wear coverings on their heads, including the two boys who wear hats. (Courtesy of Twenty-Nine Palms Band of Mission Indians.)

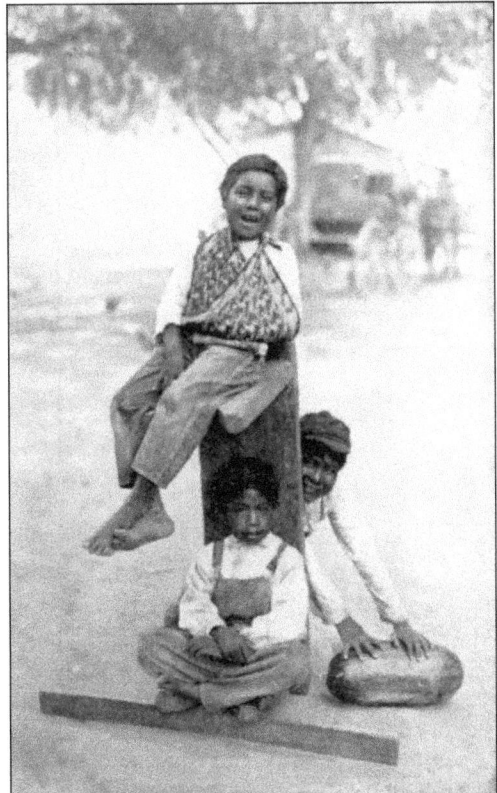

Three Native American children on the Soboba Indian Reservation play by the outskirts of a field. Native children in Riverside County often had to work to help support their families. However, they also found time to just be kids, playing many kinds of games and sports. Note the watermelon on the ground to the right. (Courtesy of A. K. Smiley Public Library.)

17

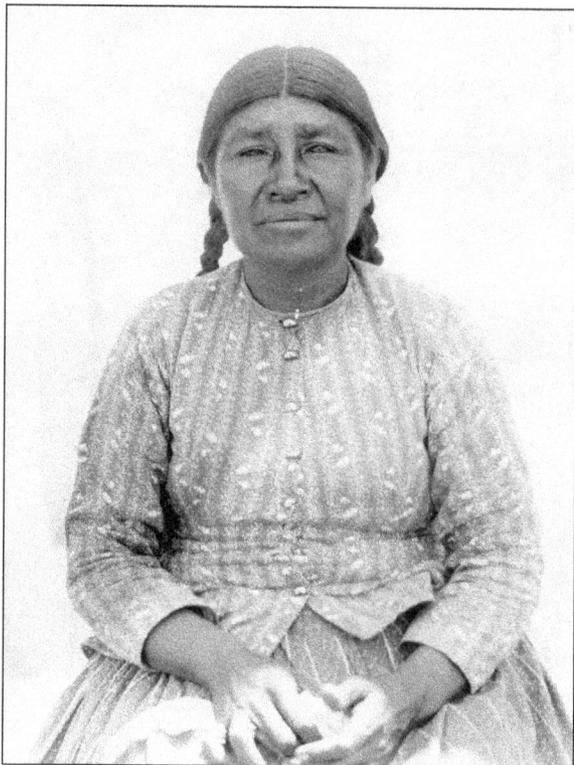

In 1884, Helen Hunt Jackson wrote her famous book *Ramona*. Although the book was fiction, Jackson based her character on Ramona, a Cahuilla Indian woman from the Cahuilla Indian Reservation in Riverside County. (Courtesy of A. K. Smiley Public Library.)

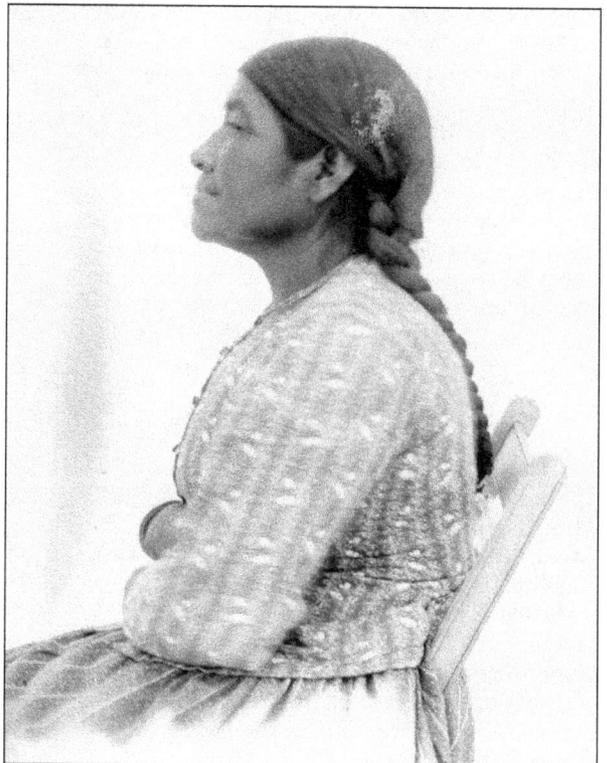

This is a side profile of the famous character Ramona, who lived out her life on the Cahuilla Indian Reservation. People throughout the region recognized Ramona as a fine basket maker. (Courtesy of Riverside Metropolitan Museum.)

A Mohave woman from Needles is pictured here in 1890. Over the course of thousands of years, Yuman-speaking Indians, including many of the tribes found in Riverside County, migrated and expanded to the south and west into areas of Southern California from the Four Corners region. This demographic shift did not occur suddenly, and the people did not move as a cohesive, homogeneous unit but in small familial bands. Mojave Indians lived on both sides of the Colorado River, including Riverside County. (Courtesy of A. K. Smiley Public Library.)

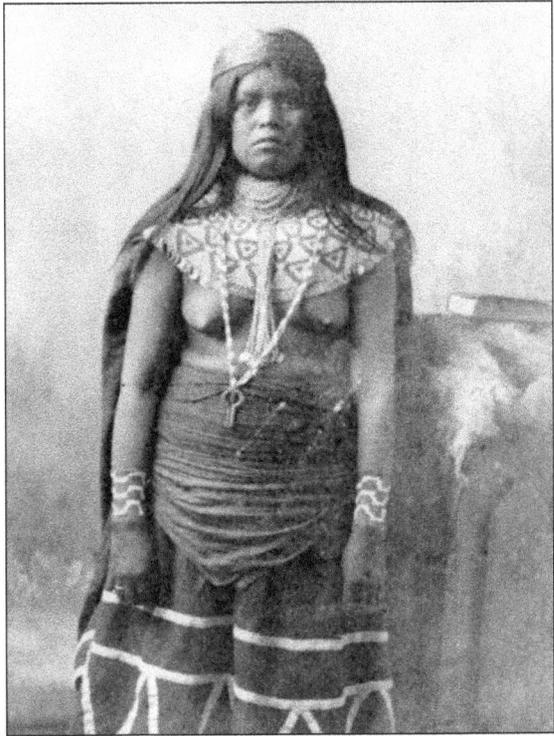

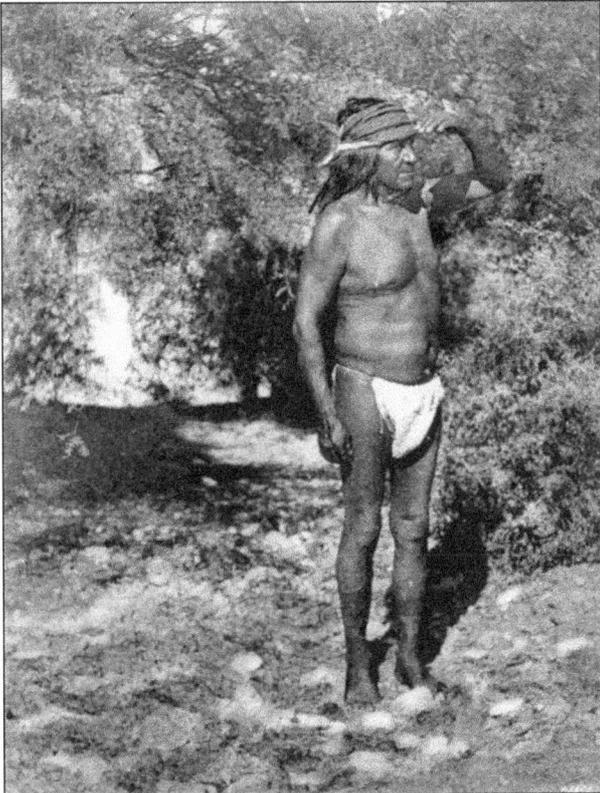

A Mojave man stands in animal-skin loincloth. Ancestral Mojave lands ran along the Colorado River, the eastern most boundary of Riverside County. Mojave Indians were known as great warriors, conducting victorious military campaigns against the Halchidhoma, Kohuana, Quechan, and Chemehuevi Indians of the Colorado River basin. (Courtesy of A. K. Smiley Public Library.)

19

Riverside County contains many sacred sites, including Mount San Jacinto, the home of *Taqwus*, a spirit among the Cahuilla and respected by all tribes in the county. The Native Americans of Agua Caliente, Soboba, and Morongo have helped protect their sacred mountain. (Courtesy of authors.)

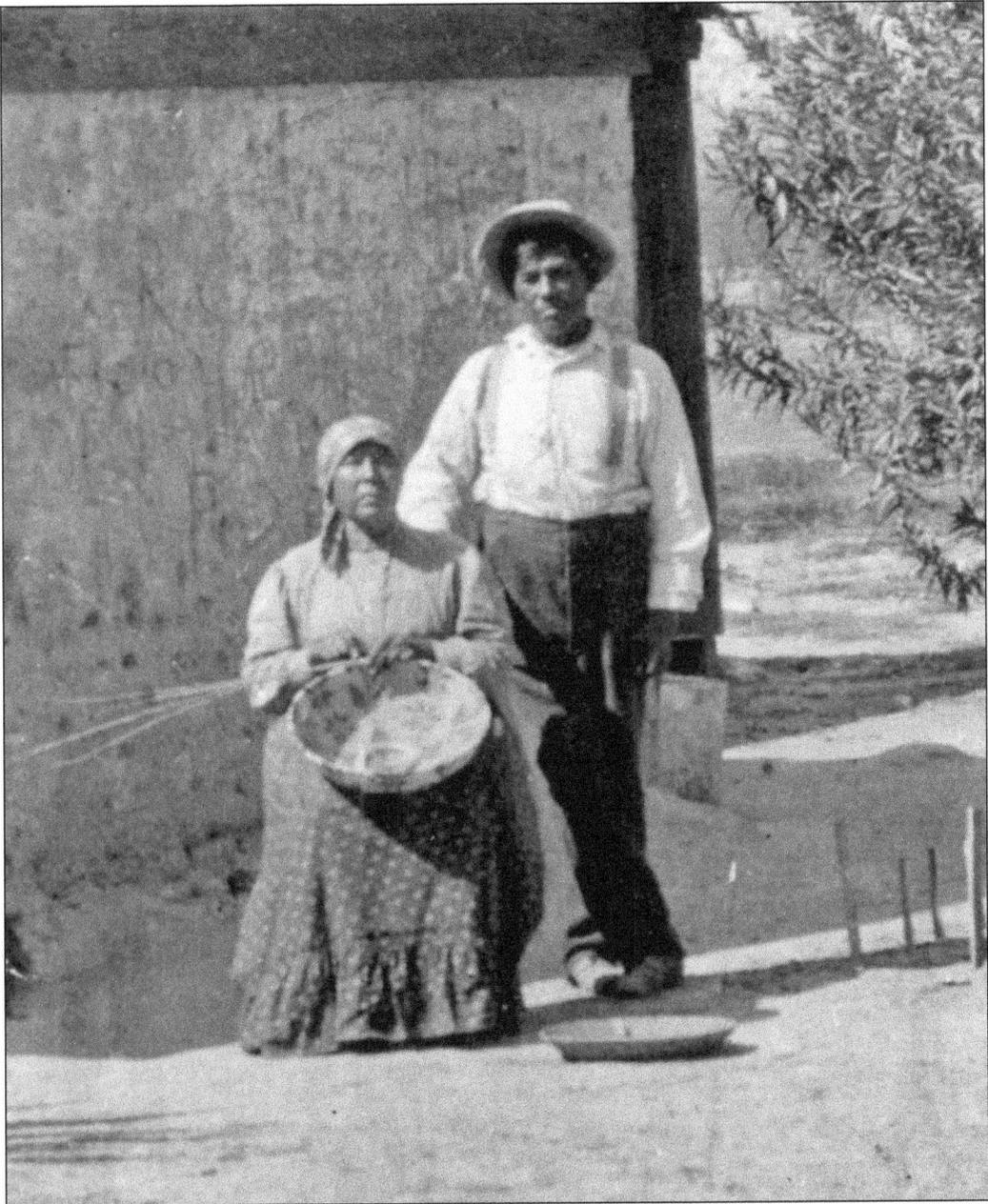

Here Francisco and Dolores Patencio of Palm Springs, California, pose for a photographer. Note their Western clothing and the artistic basket she proudly displays in her hand. Francisco was a famous medicine man, and Dolores was known widely for her baskets. (Courtesy of A. K. Smiley Public Library.)

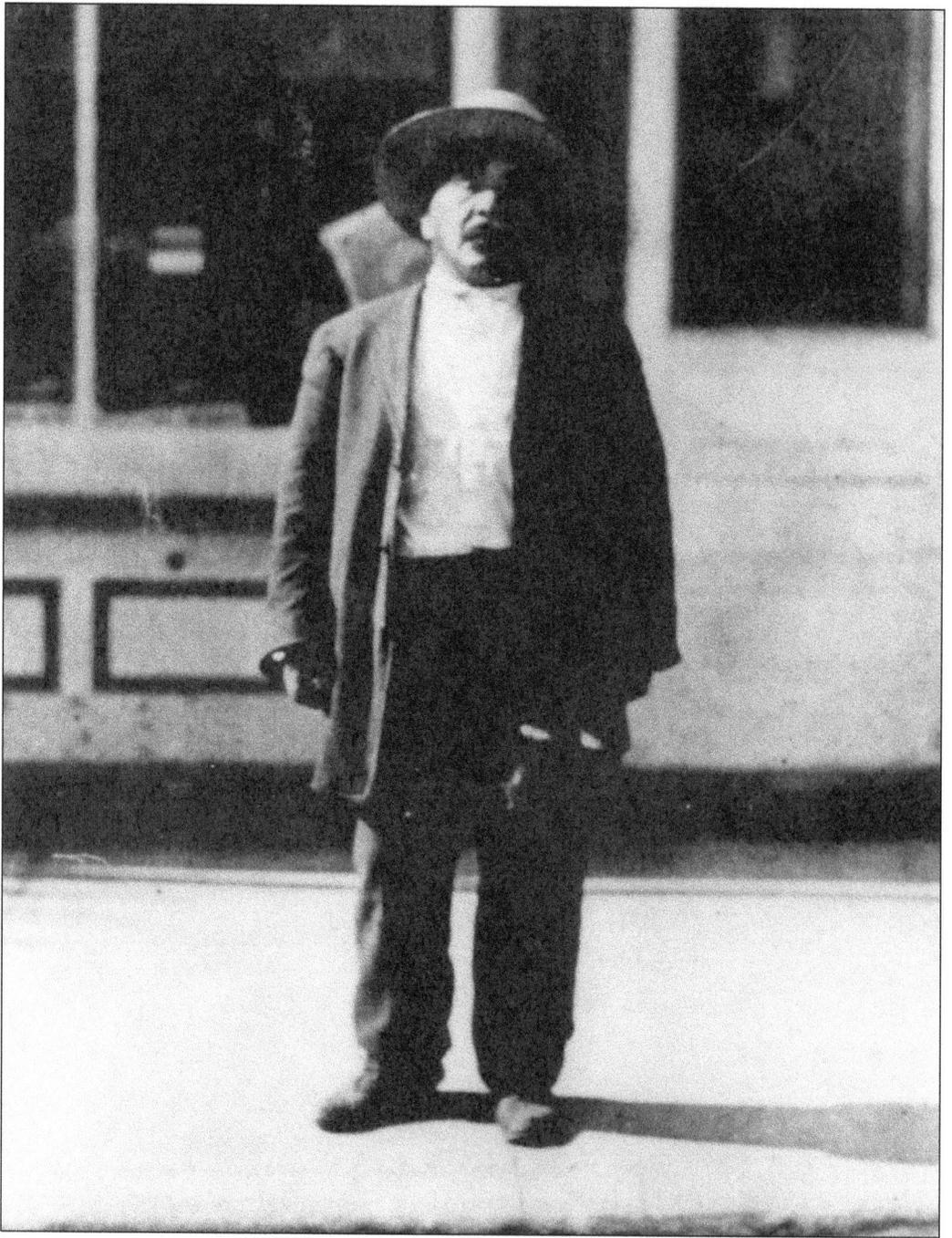

Ignacio Ormego, or "Chappo," was from the Torres Martinez Reservation. He was a medicine man who helped many people but accidentally left medicine at San Manuel that temporarily hurt Martha Manuel. (Courtesy of A. K. Smiley Public Library.)

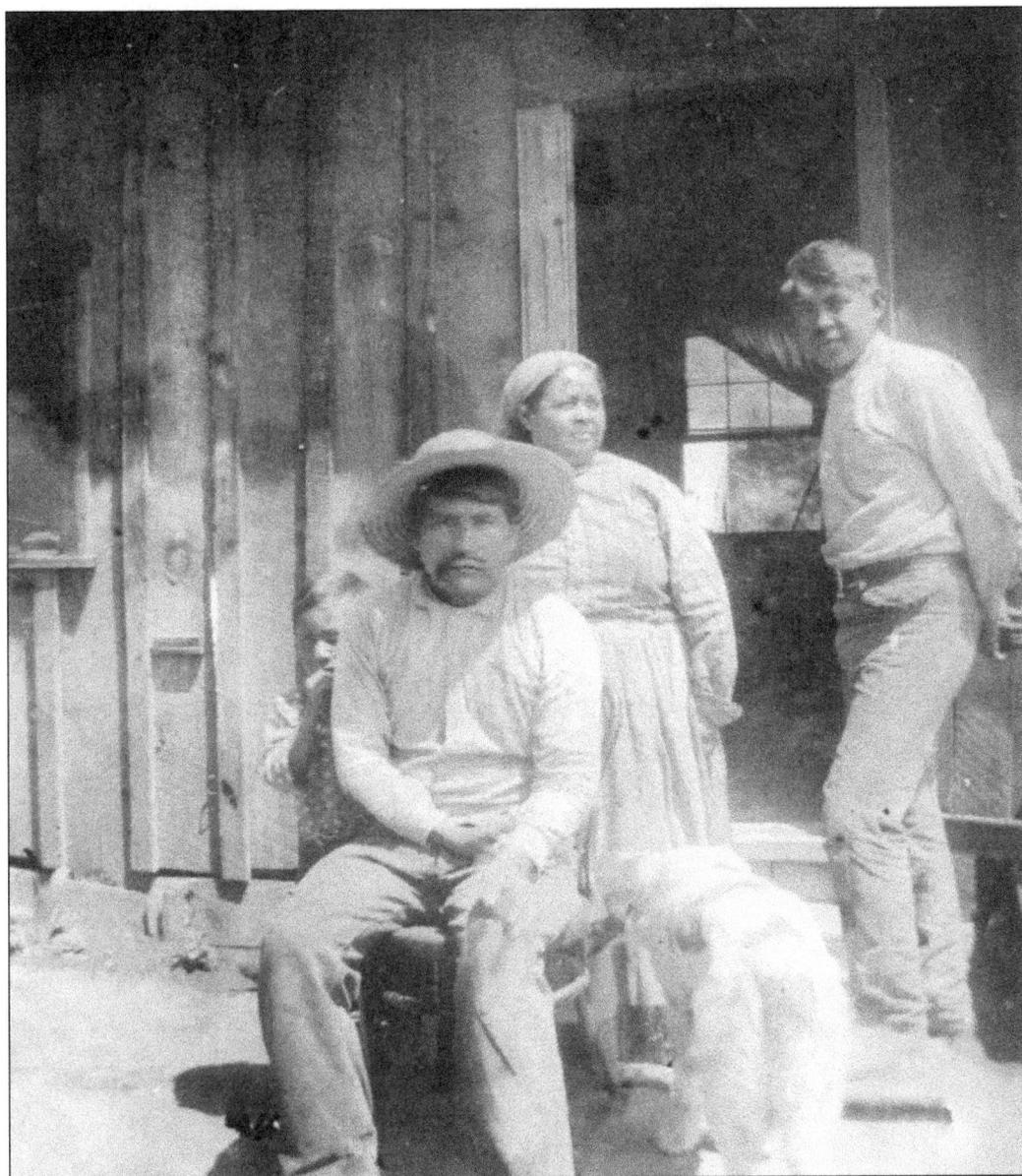

Lorenzo Ormego was a Cahuilla man from the Torres Martinez Reservation. He was the brother of Pablo Ormego and a son of Ignacio Ormego. He moved to the San Manuel Reservation, where he lived out a good portion of his life. (Courtesy of Pauline Ormego Murillo.)

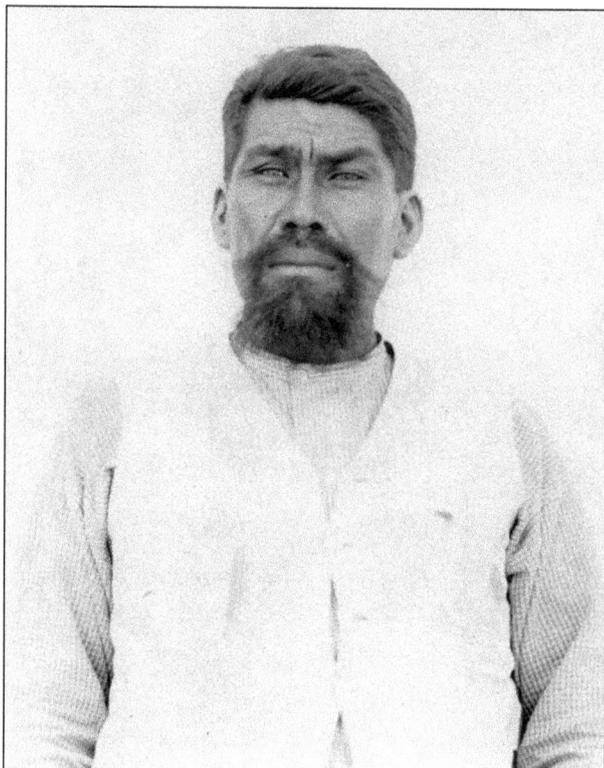

The Native Americans of Riverside County selected their own leaders, calling them by specific names within their languages to designate their leadership status. Agents of the United States often called such leaders "captains." Capt. Juan de Dios was a Cahuilla Indian from the Cahuilla Reservation. (Courtesy of A. K. Smiley Public Library.)

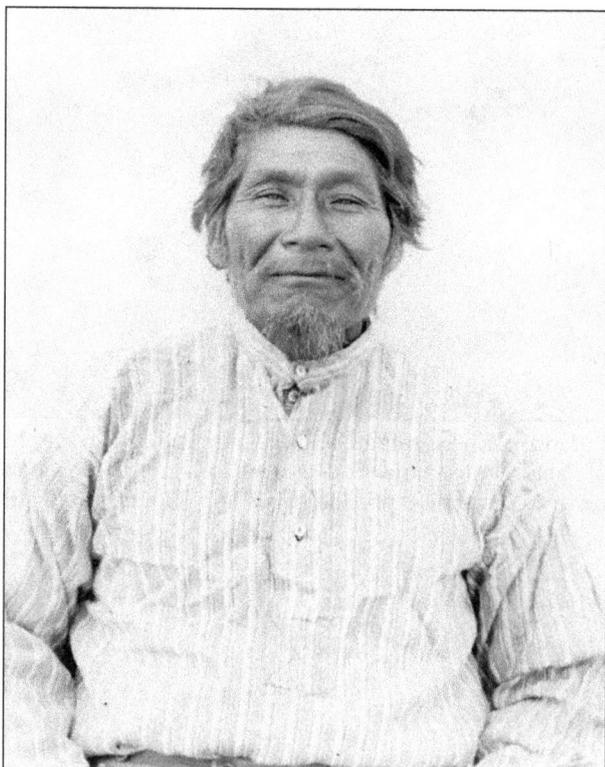

Pedro Casero, father of Juan Casero, was one of many in Riverside County who supplemented their livelihood by farming, ranching, and working at small jobs on a seasonal basis. (Courtesy of A. K. Smiley Public Library.)

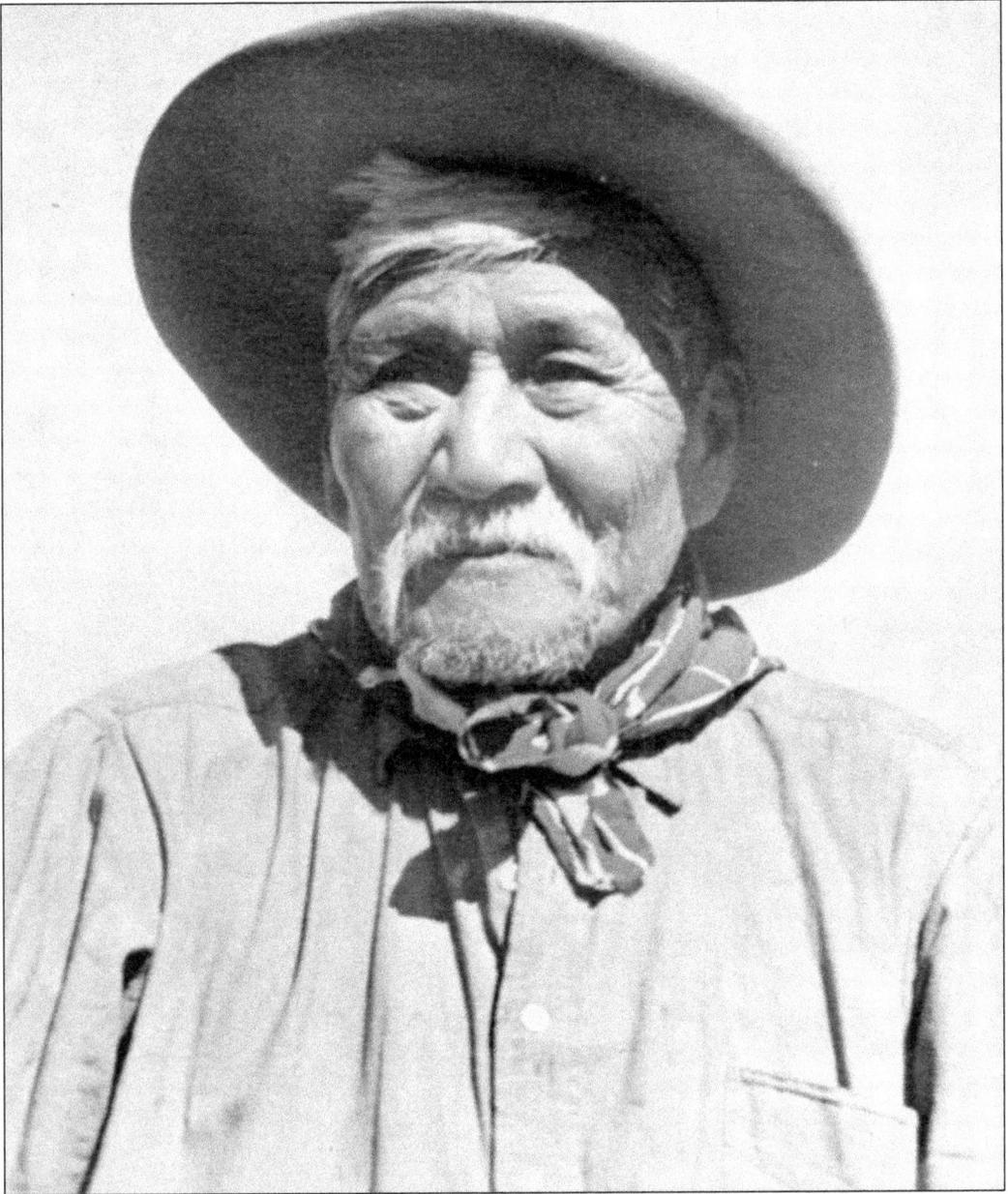

Pedro Chino lived in Palm Springs, California, at the hot springs. He was a high-level Cahuilla *pul*, or medicine man, who had many powers to heal. In the early 20th century, he saved the life of Serrano Martha Manuel. (Courtesy of A. K. Smiley Public Library.)

Two beautiful girls, Iris and Valerie, stand in front of an adobe home located along the Colorado River. Native Americans throughout the county liked to take pictures of their children and, as in this shot, dress them nicely for the occasion. (Courtesy of Leleua Loupe.)

Ambrosio Gabriel, a Cahuilla medicine man or *pul*, was known throughout the county as one of the most powerful and influential holy men among the tribes. He was a great fire eater. He primarily lived on the Morongo and Soboba Reservations, but his doctoring took him to all the reservations, where he earned a reputation as a respected healer. (Courtesy of A. K. Smiley Public Library.)

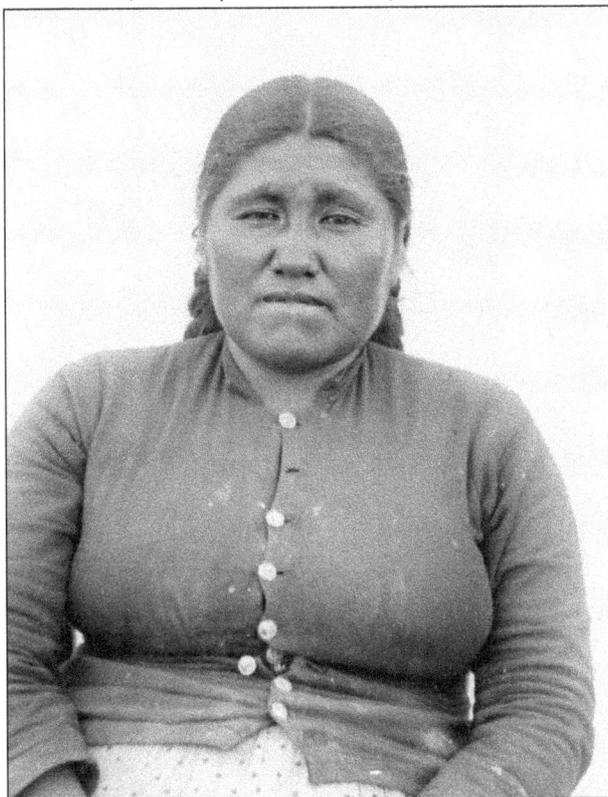

Native American women in Southern California provided for their families by gathering plant foods, preparing meals, building homes, and working on farms and ranches for cash. Rita Casero cared for her family in this way. (Courtesy of A. K. Smiley Public Library.)

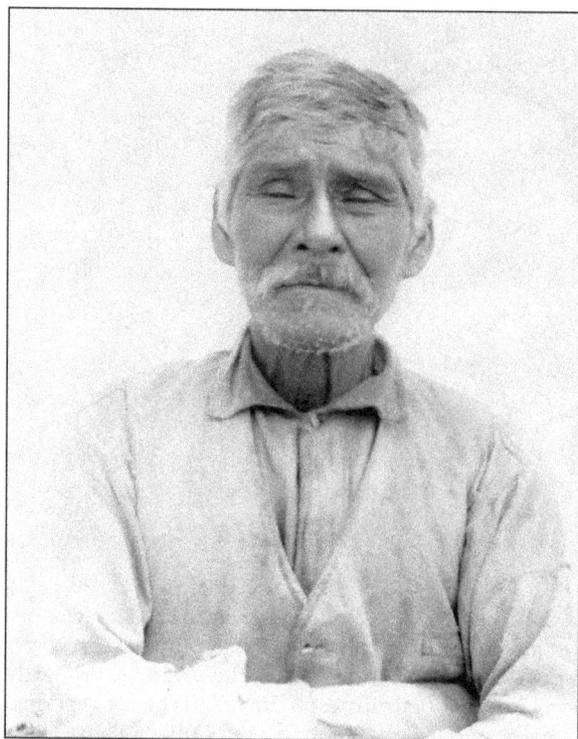

The Native Americans of Riverside County honored their tribal elders, including Isadore Casero of the Cahuilla Reservation. He was photographed when he was in his 80s. (Courtesy of Twenty-Nine Palms Band of Mission Indians.)

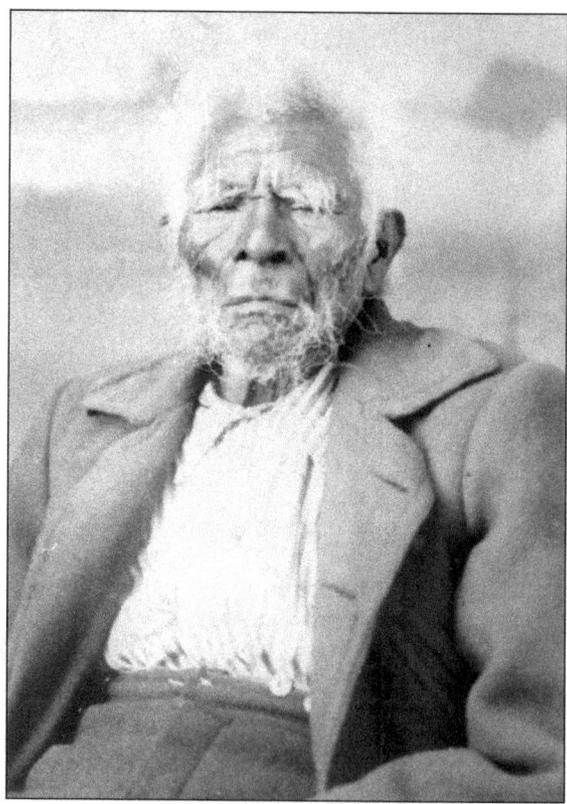

The Soboba Band of Luiseño Indians, located in San Jacinto, California, elected Victoriano Kwe-vish Quishish as their captain. He was a powerful leader and signer of the Temecula Treaty of 1852. Victoriano took his people to the Soboba Indian Reservation to protect them from newcomers. He was from a powerful leadership family that gave birth to Adam Castillo, who led the Mission Indian Federation in the 20th century. Victoriano was close to Helen Hunt Jackson and advised her on native culture and history. (Courtesy of A. K. Smiley Public Library.)

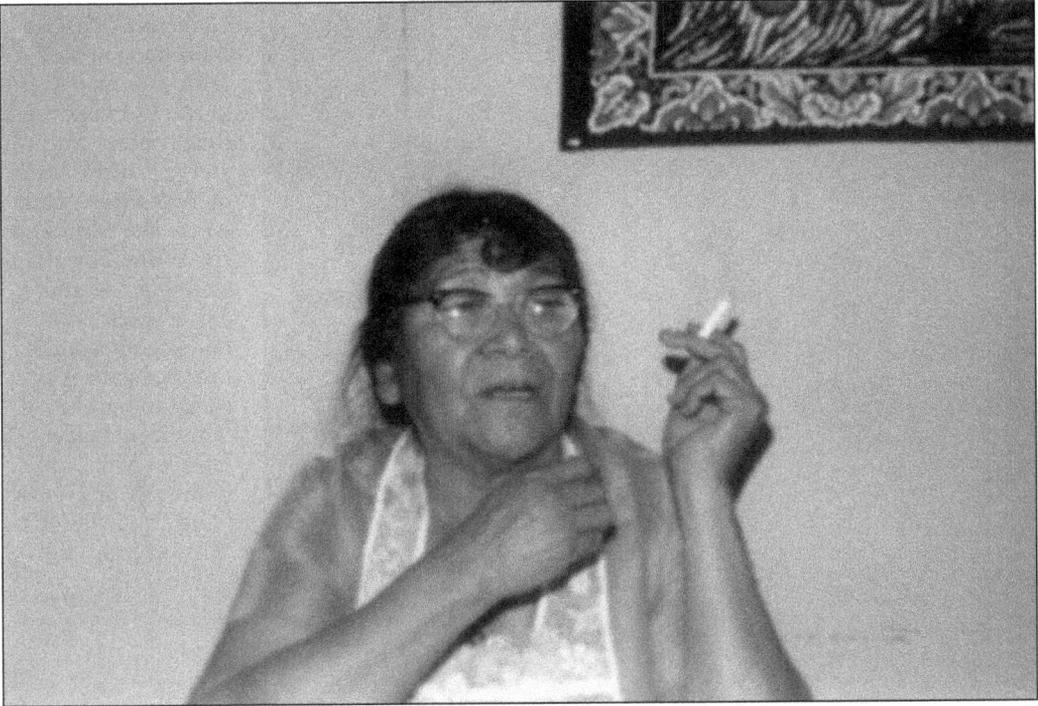

Gertrude Leivas attended Sherman Institute and spent a portion of her life in Riverside County. She is a highly respected tribal elder of Chemehuevi heritage and speaks the language. She has been a cultural teacher to the authors. (Courtesy of Leleua Loupe.)

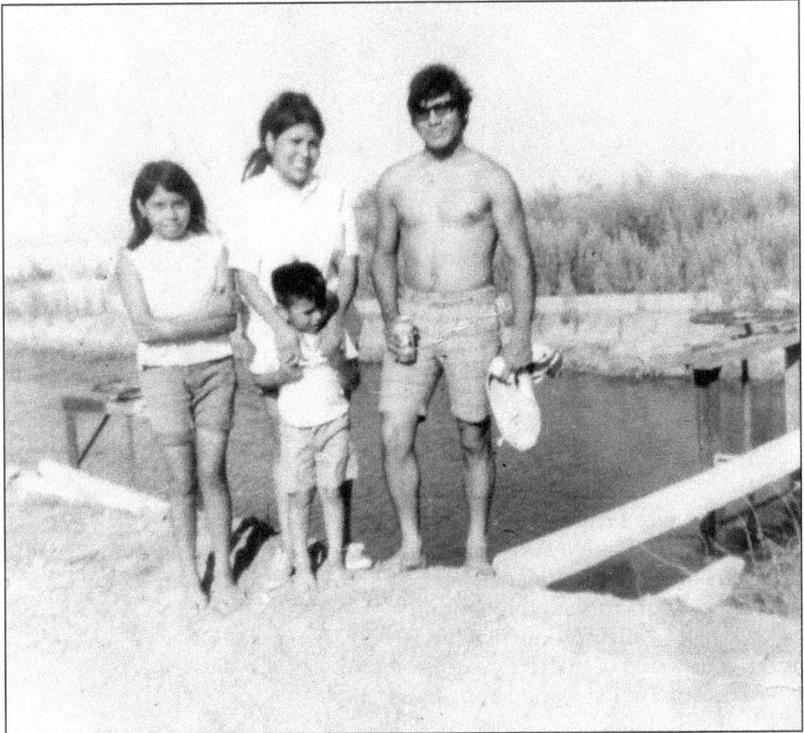

Pictured here in 1972, Mathew and Hope Leivas, Rachel Hanks, and Jeff Kellywood Sr. play at the Colorado River on the eastern edge of Riverside County. Today Mathew is a cultural leader among Southern Paiute people. (Courtesy of Leleua Loupe.)

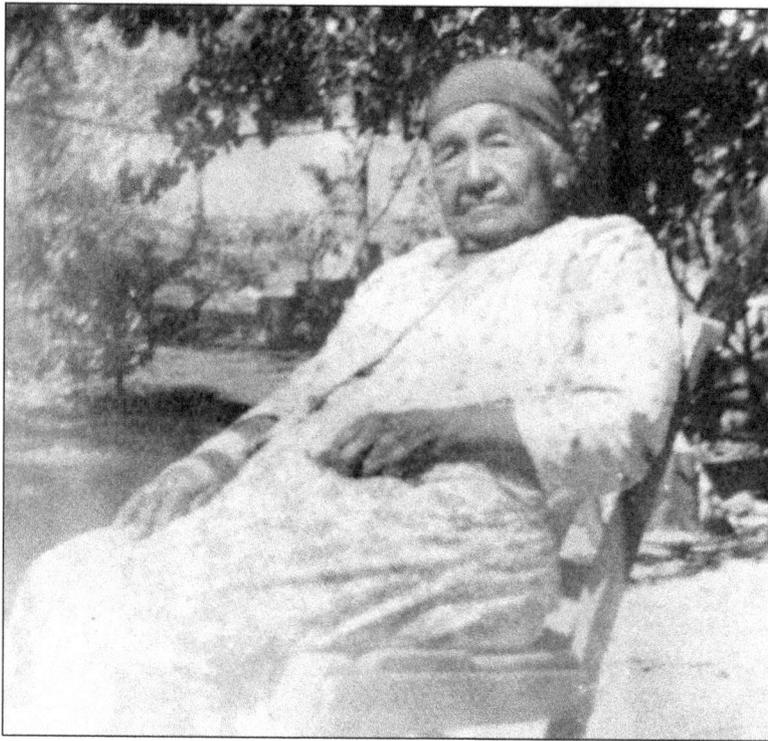

Nellie Holms Mike Morongo married John Morongo of the Morongo Reservation. She grew up at the Oasis of Twentynine Palms where she witnessed the Willie Boy affair (see pages 34 and 35). She left an oral account of the events. Nellie was the grandmother of respected elder Jennifer Mike. (Courtesy of Twenty-Nine Palms Band of Mission Indians.)

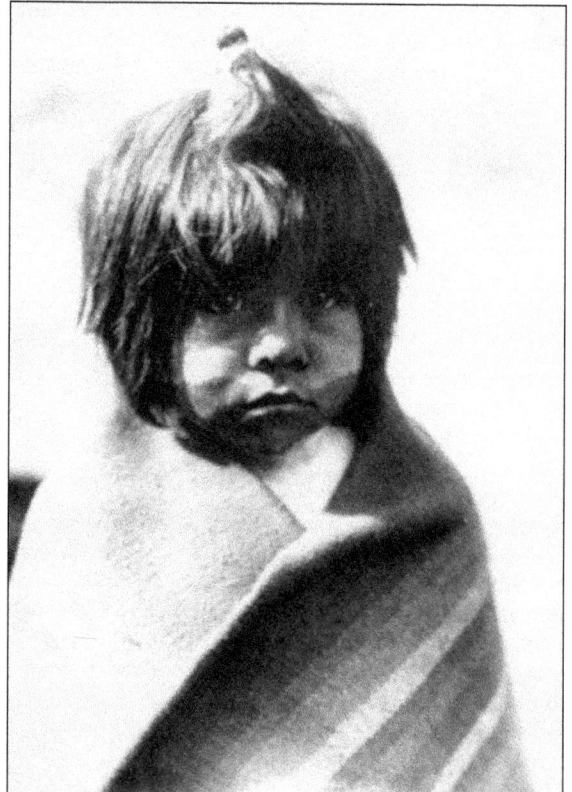

During the late 19th and early 20th centuries, Native Americans in Riverside County suffered from malnutrition and disease brought on by the theft of their productive lands and the invasion of microorganisms. (Courtesy of Twenty-Nine Palms Band of Mission Indians.)

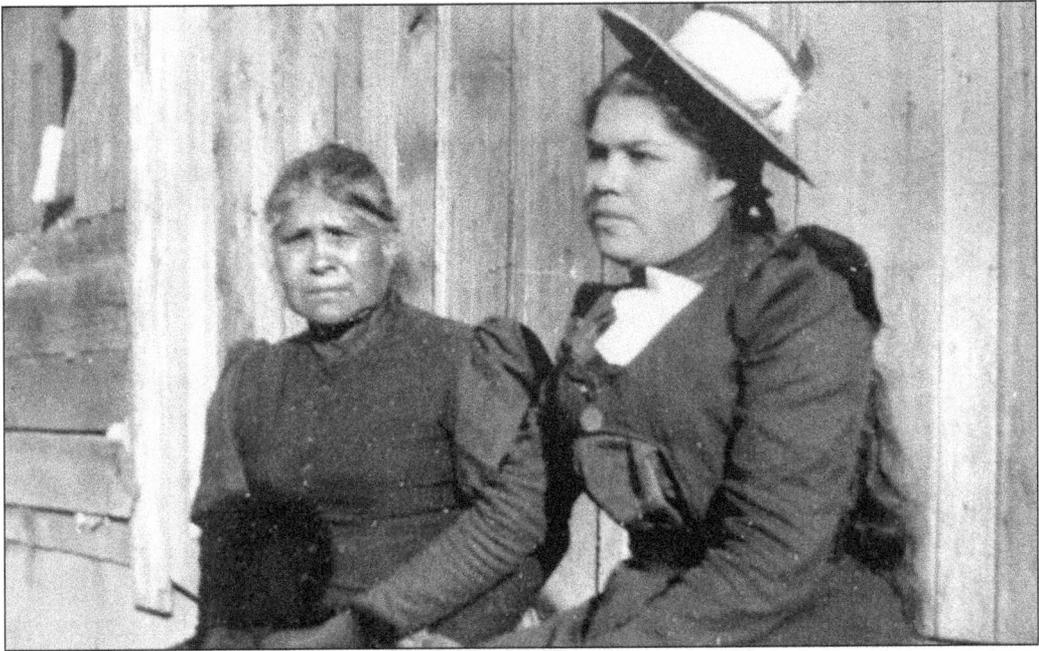

A younger native woman poses with her mother or grandmother. Family ties have also been a significant component of the Native American culture in Riverside County. Note that both women wear their best clothing for this photograph, including a smart-looking hat. (Courtesy of Riverside Metropolitan Museum.)

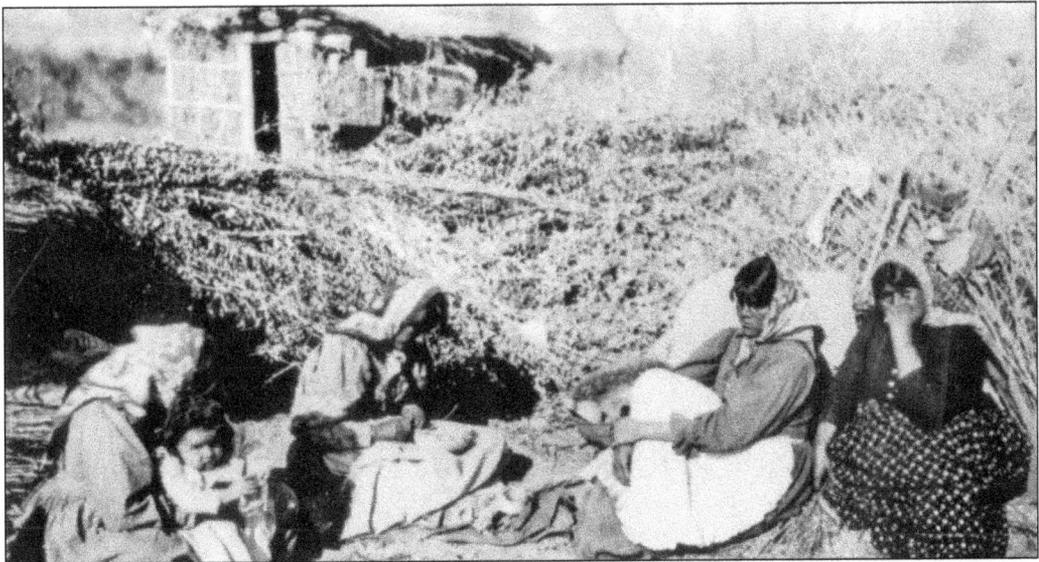

These women have gathered a large number of willow branches so they may construct a home similar to the one seen in the background. This house is made so that the wind can blow through the willow branches, bringing a cooling breeze to the inhabitants. They made their homes of logs, sticks, and thatch. Sometimes they plastered the outside and inside of their homes with mud. Chemehuevi elder Gertrude Leivas once explained that she loved the lodge where she slept as a child because she could see the outline of her mother's fingers where she had smoothed the wet mud to create the interior wall of their home. (Courtesy of Twenty-Nine Palms Band of Mission Indians.)

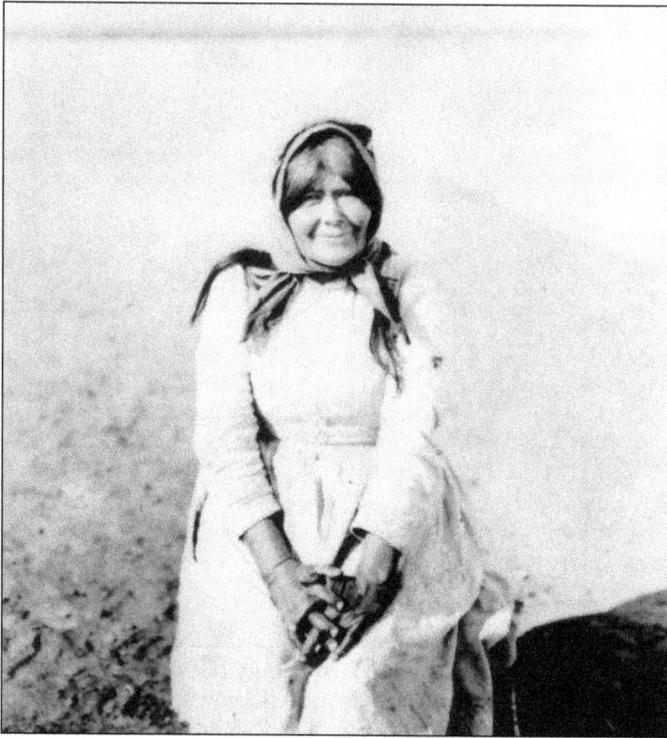

The photographer took this image on the shores of the Colorado River, the home of many Chemehuevi Indians. The photograph reveals the good nature of this woman who smiles in spite of her problems. Her hands tell us that she was a hard worker who took care of her family and worked diligently throughout her life. (Courtesy of Twenty-Nine Palms Band of Mission Indians.)

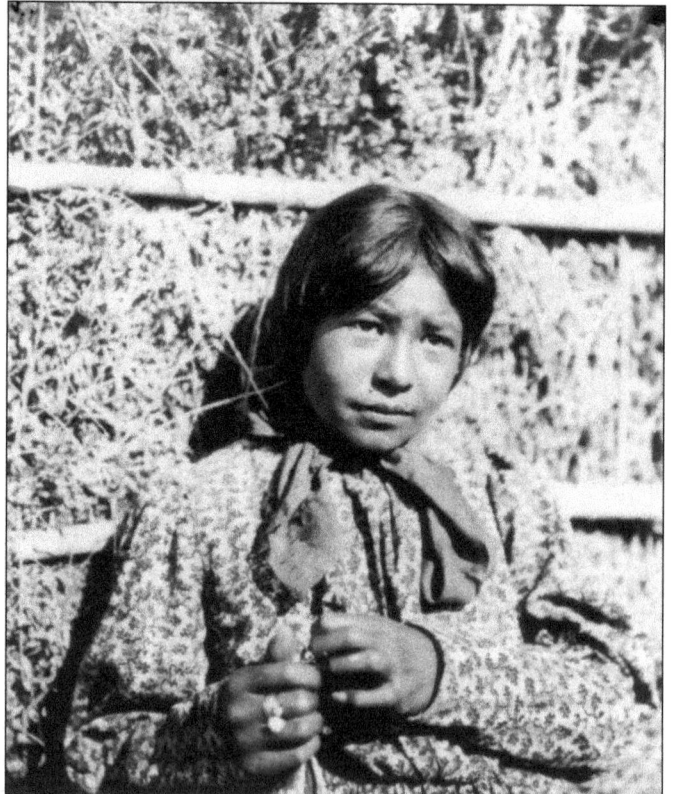

Once non-Indian newcomers invaded the lands that became Riverside County, Native Americans changed and adapted to survive. Women made dresses from the material taken from flour sacks, and they bought scarves sold to Indian traders. Here a Chemehuevi woman stands in front of a home on the California side of the Colorado River across from the Colorado River Indian Reservation of eastern Riverside Country. (Courtesy of Twenty-Nine Palms Band of Mission Indians.)

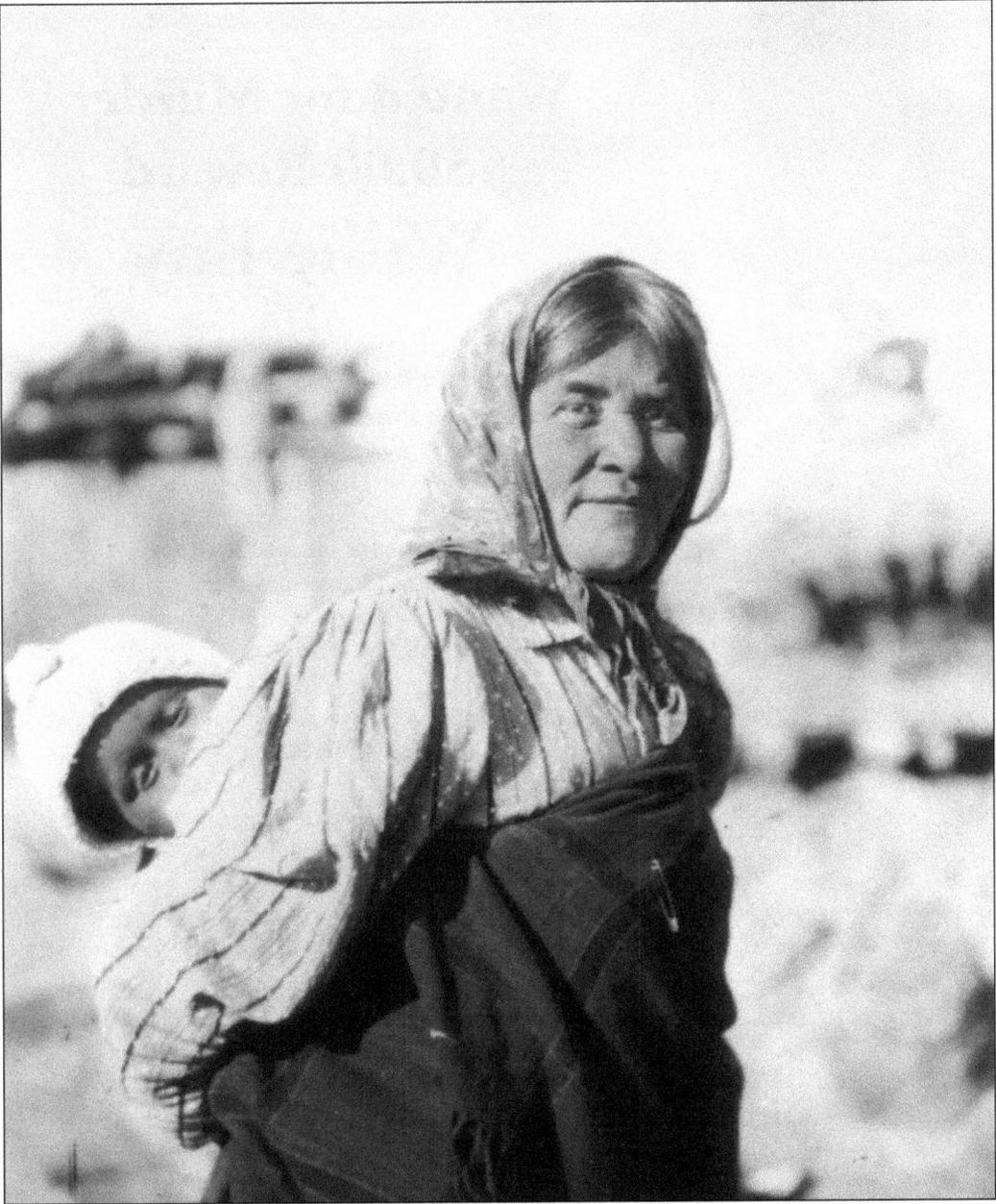

James Wharton James took this photograph of a Chemehuevi woman and child. The woman is wearing a cloth dress and manufactured scarf, while the baby is sporting a knitted hat. Native American women throughout Riverside County carried their children on their backs using tightly drawn blankets or cradle boards. This woman has used a metal safety pin to help support the blanket and keep it snug against her body. (Courtesy of Twenty-Nine Palms Band of Mission Indians.)

Riverside, Cal., Oct. 1st, 1909

Wanted for Murder
$50.00 Reward
Willie Boy

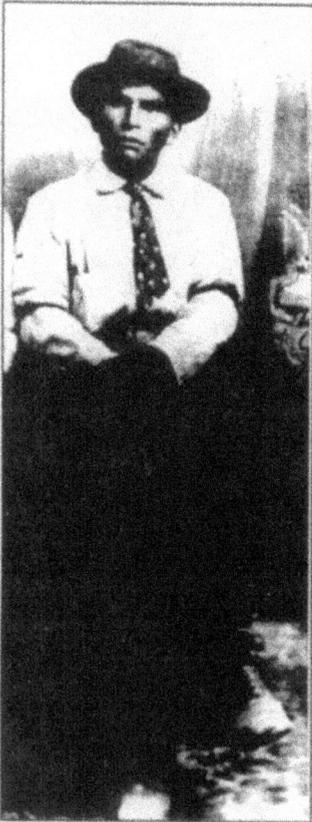

a Chimawawa Indian. 28 years old. Height 5 feet 8 or 9 inches. Weight 150 pounds. Smooth face. Medium build. Has a scar under his chin where he was shot about three years ago, the bullet coming out of the mouth, taking out two or three teeth. Wore new black hat, dark gray coat and pants. For years lived about Victorville, with a halfbreed American woman with two children, a girl of 10 and a boy of 2 years. She left him because he had beaten her, and returned to Victorville. His people lived along the Kingston mountains along the Nevada state line.

An Indian filling the description of Willie Boy was seen cooking a rabbit between Goffs Station and Manvel on Sunday evening, October 3rd. When he saw the approaching parties he ran away. This might have been Willie Boy as his mother was at Vanderbilt a short time ago.

Willie Boy is wanted for the murder of Old Mike Boniface, an Indian, on the night of Sunday Sept. 26 1909, at Banning, Cal. He also shot and killed Old Mike's daughter Ioleta Boniface at The Pipes in San Bernardino County on Sept. 30th, after forcing her to follow him 70 miles in the mountains. He was trailed to a point about 25 miles northeast of The Pipes in the San Bernardino mountains on Sept. 30, 1909, and was headed toward Daggett or Newberry. He has a 30-30 rifle with him and is a desperate man. Take no chances with him. I hold warrant for murder. Arrest and send any information to

F. P. WILSON, Sheriff

"Wanted for Murder!" In 1909, a Chemehuevi man named Willie Boy killed the powerful leader, William Mike. A Riverside County posse chased Willie into the Mojave Desert but the runner eluded them for days. (Courtesy of Twenty-Nine Palms Band of Mission Indians.)

34

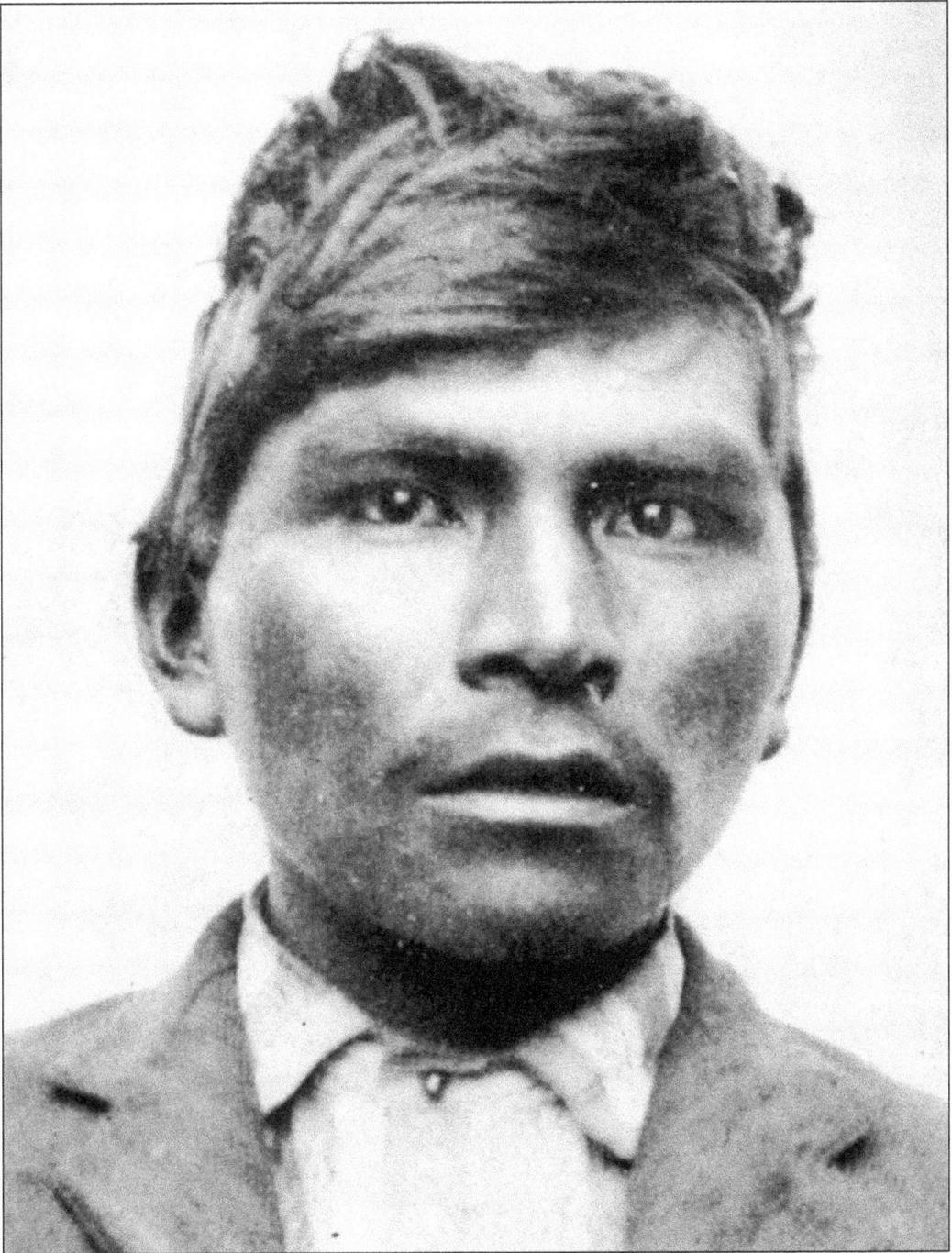

According to Indian accounts, the posse never captured Willie and did not find him dead from suicide. Willie left Ruby Mountain and resettled among Southern Paiutes at Pahrump, Nevada, near Las Vegas. (Courtesy of Twenty-Nine Palms Band of Mission Indians.)

This is a photograph of Perfecto and uncle Mio in front of an old car. They were two Chemehuevi men living along the Colorado River on the east side of Riverside County. (Courtesy of Leleua Loupe.)

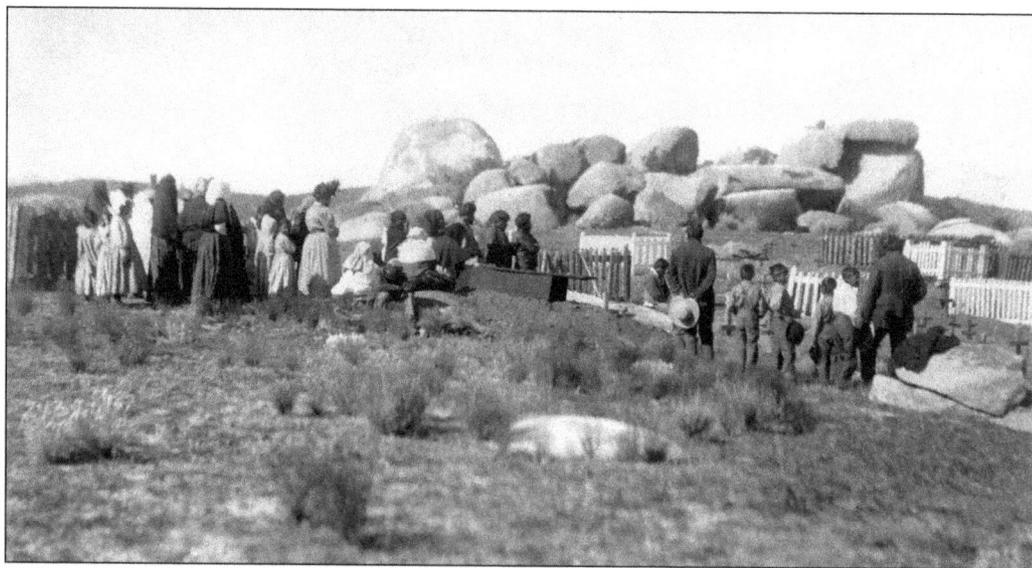

Helen Hunt Jackson made Allessandro famous in her book *Ramona*. Here Cahuilla Indians visit the cemetery where Allessandro is buried on the Cahuilla Reservation. Cahuilla, as do all Native Americans that call Riverside County home, hold a deep respect for the dead. Prior to non-native contact, many tribes cremated the deceased with his or her possessions in a large fire. At the time of Allessandro's death, the people burned his possessions as part of the mourning ceremony. (Courtesy of A. K. Smiley Public Library.)

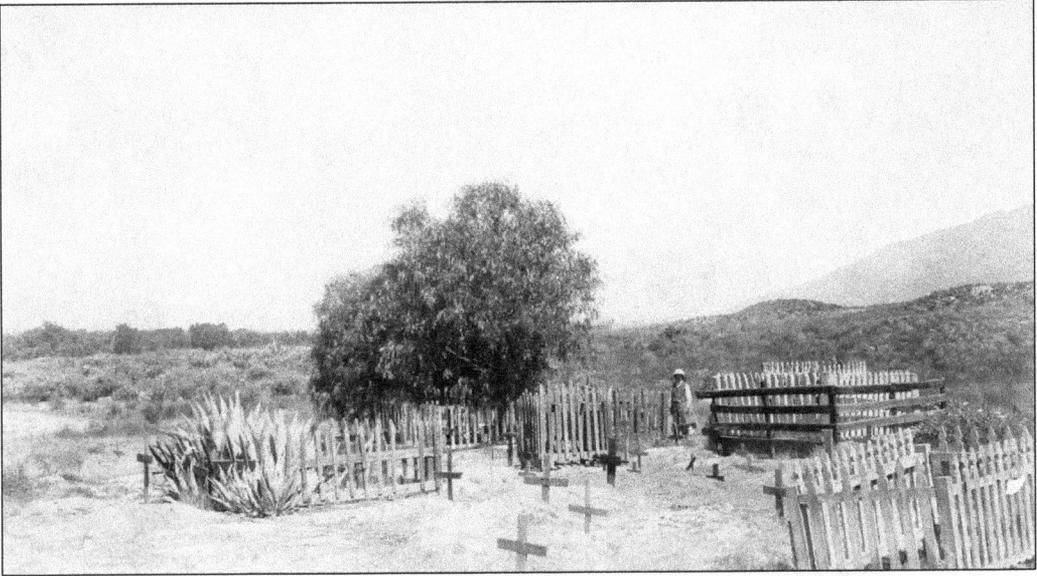

A Soboba Indian village cemetery is pictured here in 1892. First Nations People in Riverside County took a sense of pride and responsibility in maintaining the graves of their relatives. They had a spiritual obligation to care for the sacred sites. These feelings culminated in specific festivals, such as Decoration Day, similar to the Spanish *Día de los Muertos*, and in the spring, relatives joined in cleaning and decorating graves with flowers, an event known as Flower Day. (Courtesy of A. K. Smiley Public Library.)

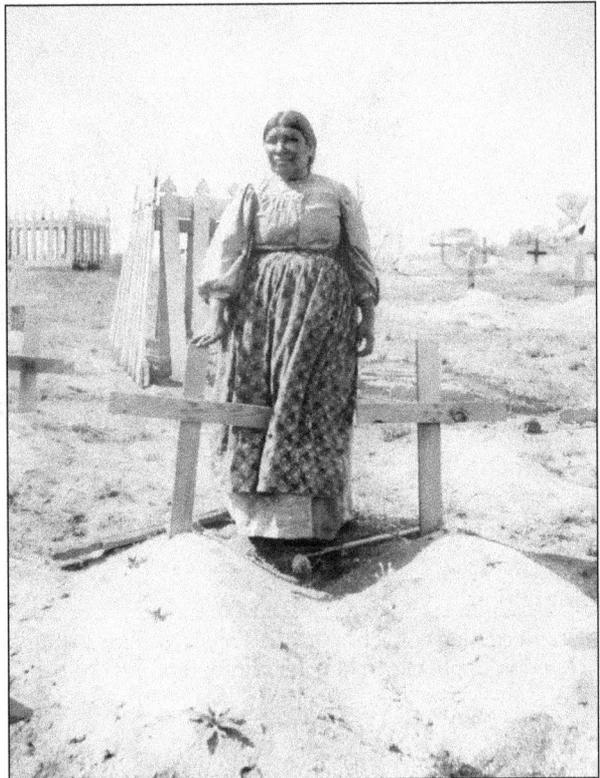

Taken in 1899, this is a photograph of the real Ramona, the Cahuilla woman who inspired Helen Hunt Jackson to write her famous, yet fictitious, novel entitled *Ramona*. Jackson's account depicted a Southern California Indian wrongly murdered by a non-native settler. The book brought great national attention to the plight of the Native Americans of Riverside County. (Courtesy of A. K. Smiley Public Library.)

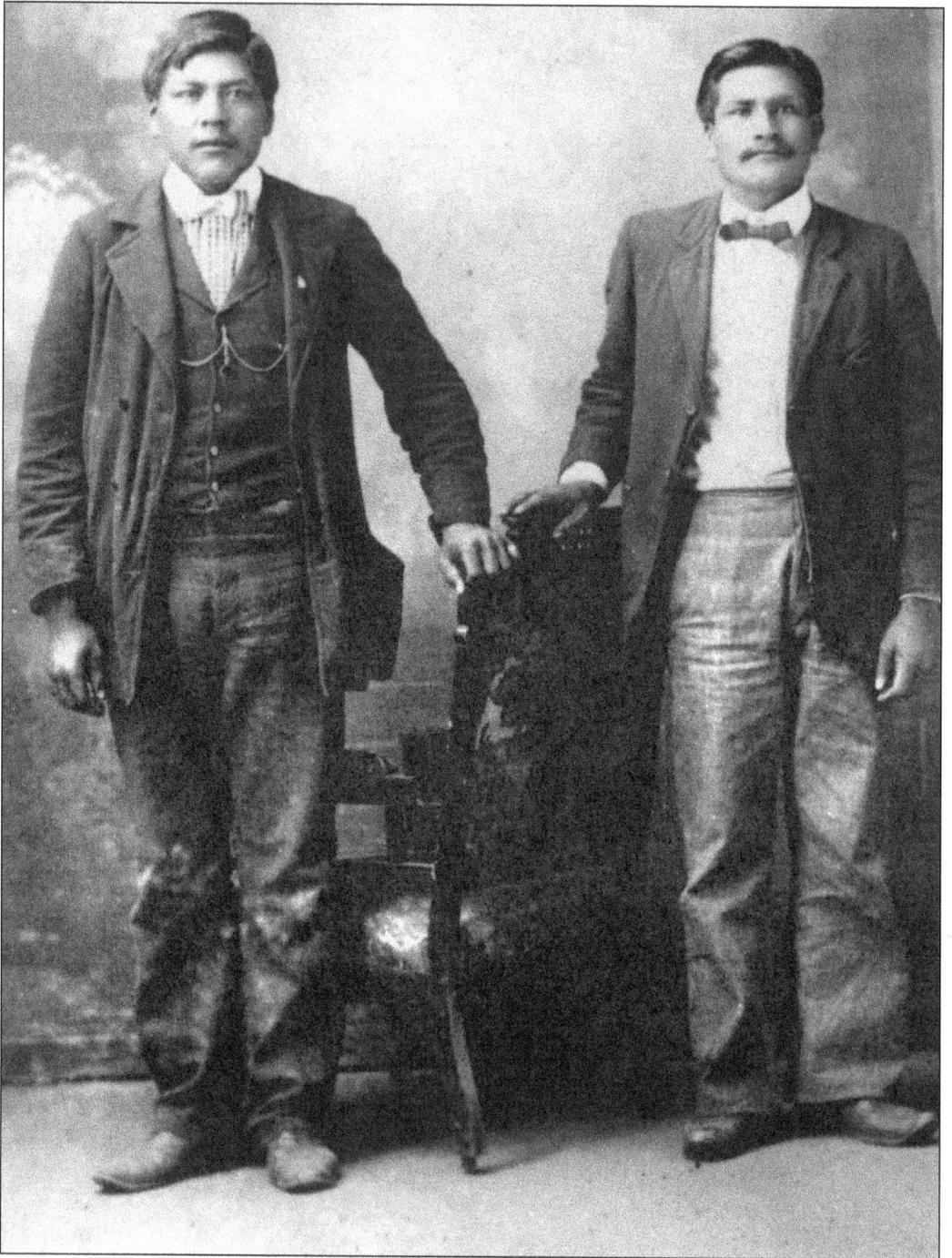

Juan Norte (left) is pictured with a relative. This Cahuilla man from the Los Coyotes Reservation is dressed in dapper attire for the photograph taken in 1900. (Courtesy of Pauline Ormego Murillo.)

Two

NATIVE AMERICAN HOMES

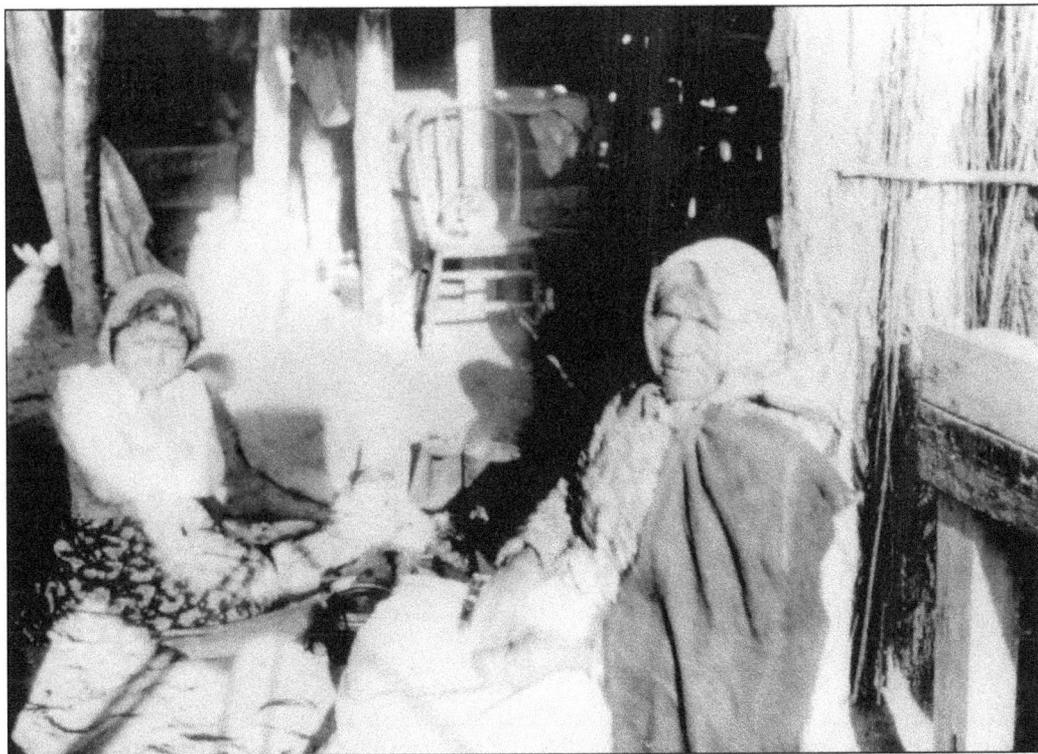

This elder and child greet the photographer inside their home. Elders used their homes as schools, teaching children important lessons, including creation stories about Ocean Woman and the mother of Louse who made a basket that held the first people on earth. (Courtesy of Twenty-Nine Palms Band of Mission Indians.)

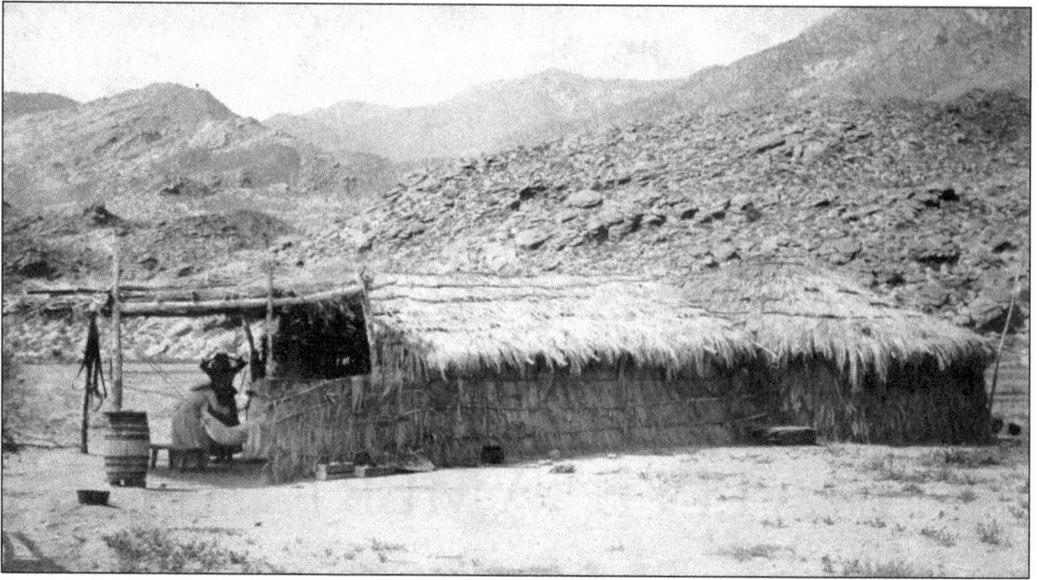

Despite the superficially barren appearance of the landscape in Riverside County, Native Americans rarely suffered from an insufficient supply of food. In fact, many tribal elders refer to this arid land as a supermarket of traditional foodstuffs. Native Americans had a sophisticated knowledge of their environment. (Courtesy of A. K. Smiley Public Library.)

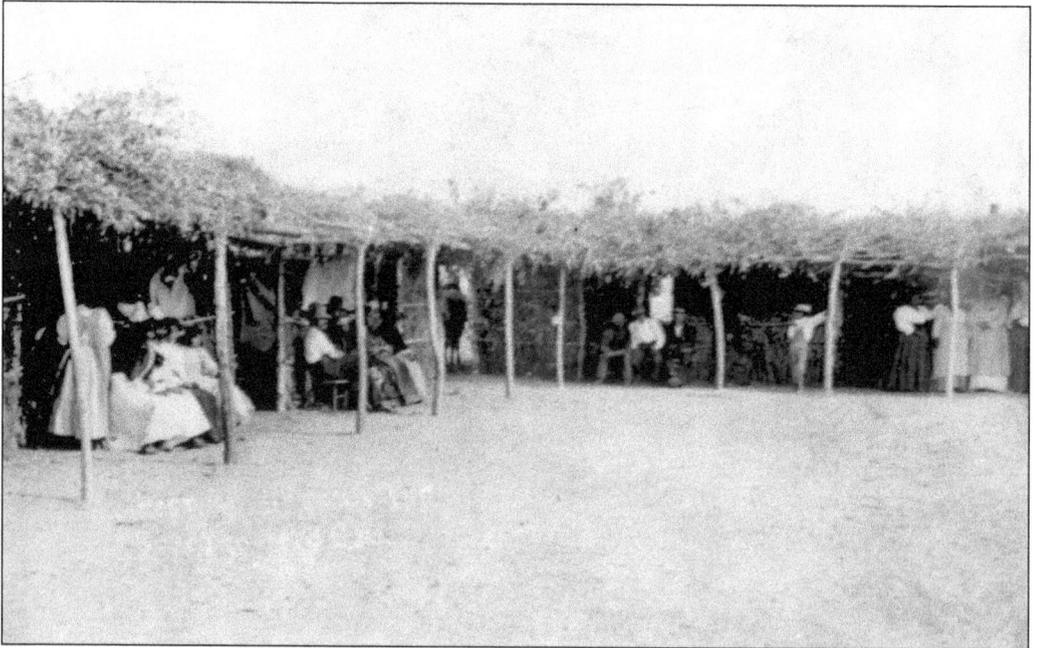

The strong winds associated with Riverside County sometimes compelled Indians to thatch the sides of ramadas to provide protection from gusts of hot air and flying sand. The traditional knowledge of building ramadas is used today. The Malki Museum on the Morongo Reservation includes several ramadas that the museum staff uses for its fiesta and other functions. (Courtesy of A. K. Smiley Public Library.)

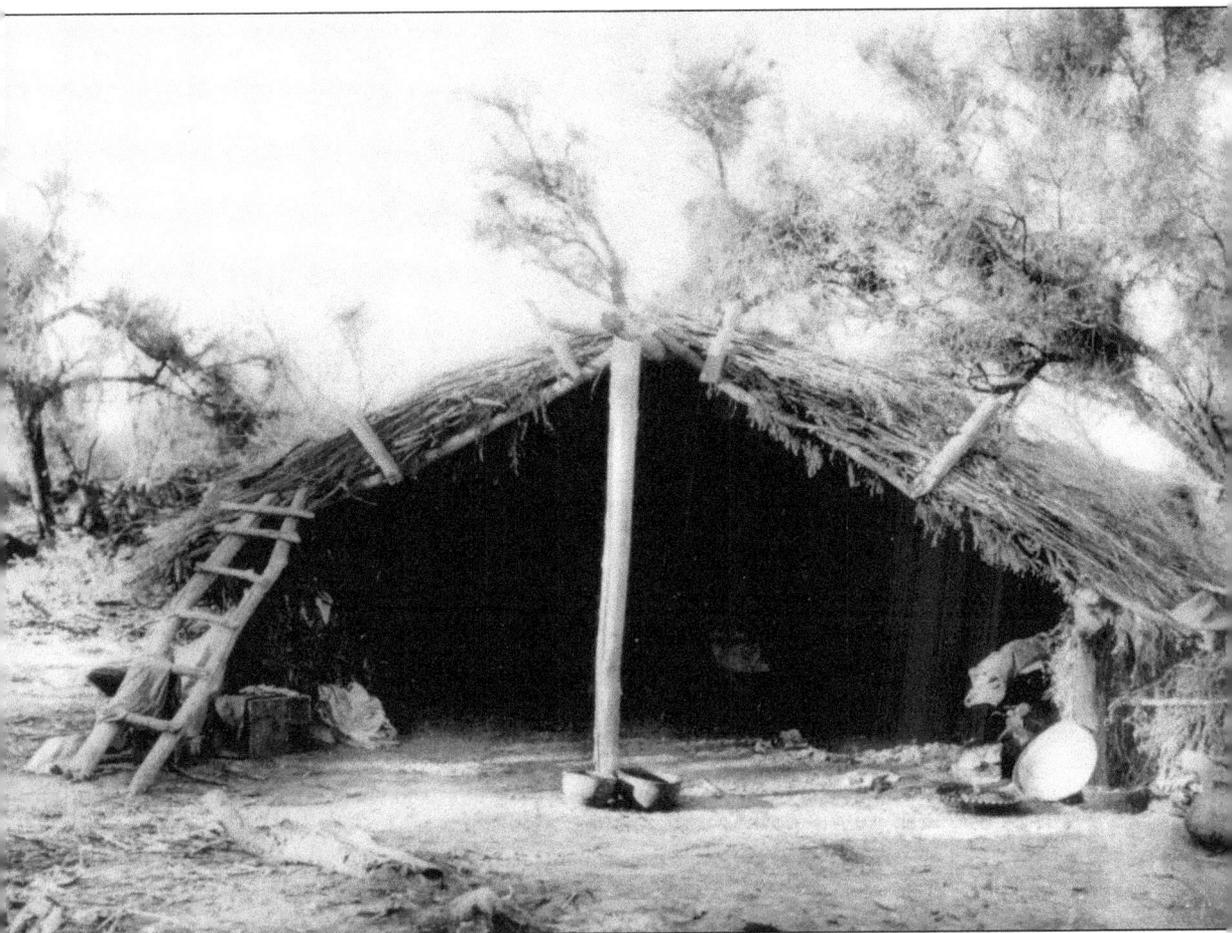

In the 20th century, Riverside Country extended east to the Colorado River where Chemehuevis and Mojaves lived in many kinds of dwellings. Usually Mojaves lived in rectangular dwellings, but Chemehuevis lived in different forms of housing, including this semicircular home with a central, sturdy post that has radiation branches forming the ribs of the lodge. Note the baskets, pottery, and other material culture surrounding the lodge. (Courtesy of Twenty-Nine Palms Band of Mission Indians.)

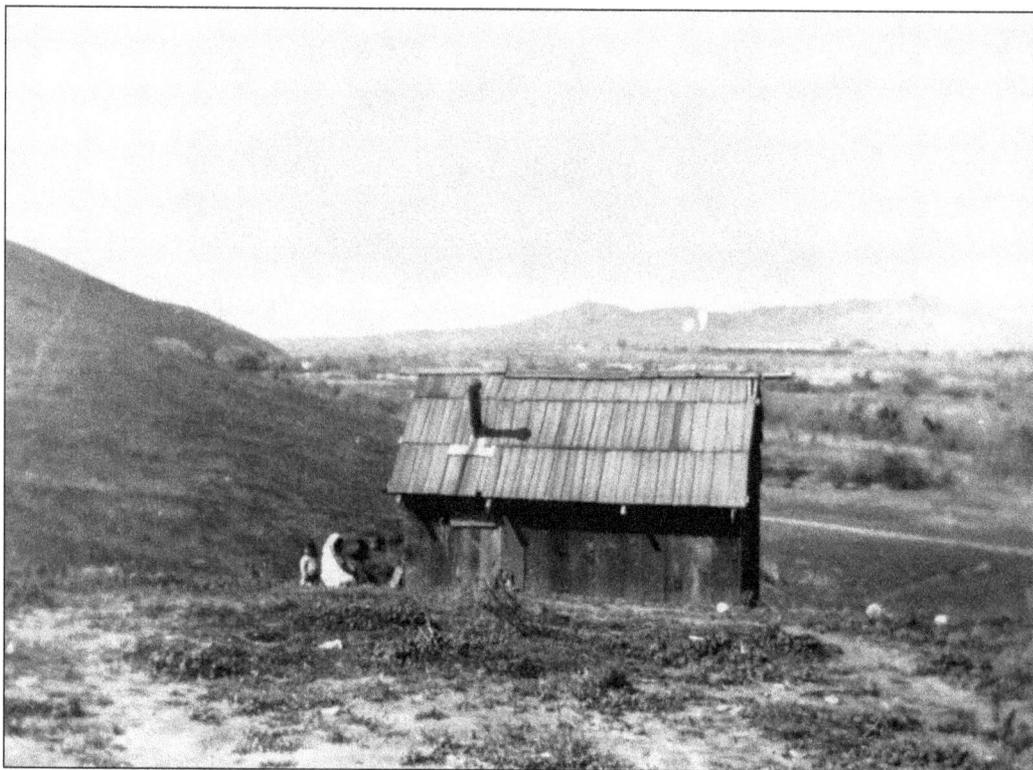

Over the years, Native Americans in Riverside County changed their housing types to wood-framed houses with gabled roofs. This home has wood siding and a wood-plank roof. Note the metal chimney. (Courtesy of Riverside Metropolitan Museum.)

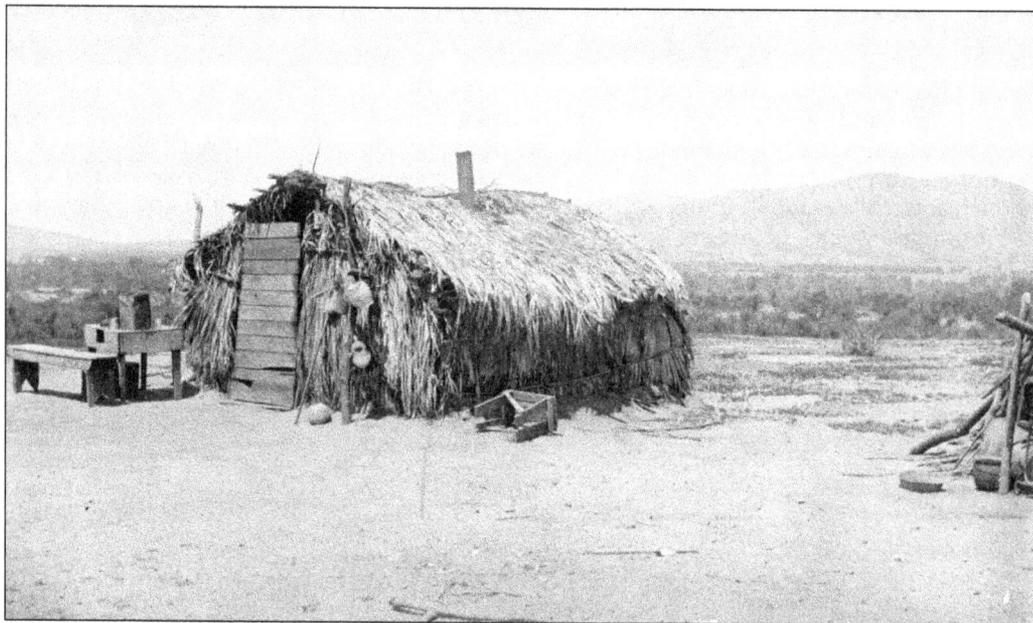

This Indian house in Riverside County has a thatched roof on a wood frame. Note the wood-plank door. (Courtesy of Riverside Metropolitan Museum.)

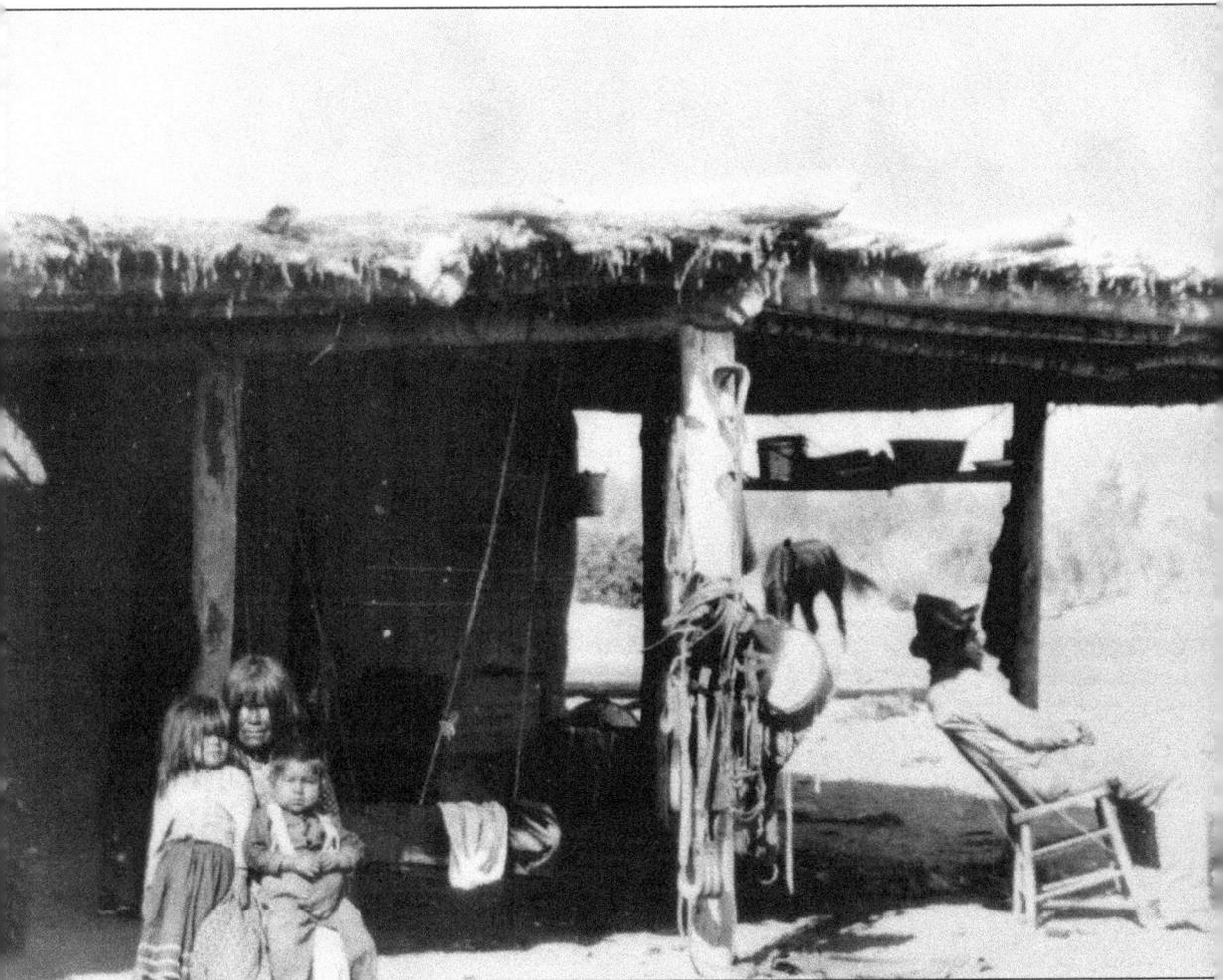

Chemehuevi, Cahuilla, Serrano, Gabrielleno, and other Native Americans of Riverside County lived in single-family dwellings. They cherished monogamous relationships and prized their children. In this photograph, a mother holds her girl and boy while her husband rests in a chair on the right. This family enjoys some wealth by owning a fine horse (in the background) and a saddle that they have mounted on the post in the center of the photograph. Many Indian families owned little more than horses, but they treasured the sites that held the bones of their ancestors. (Courtesy of Twenty-Nine Palms Band of Mission Indians.)

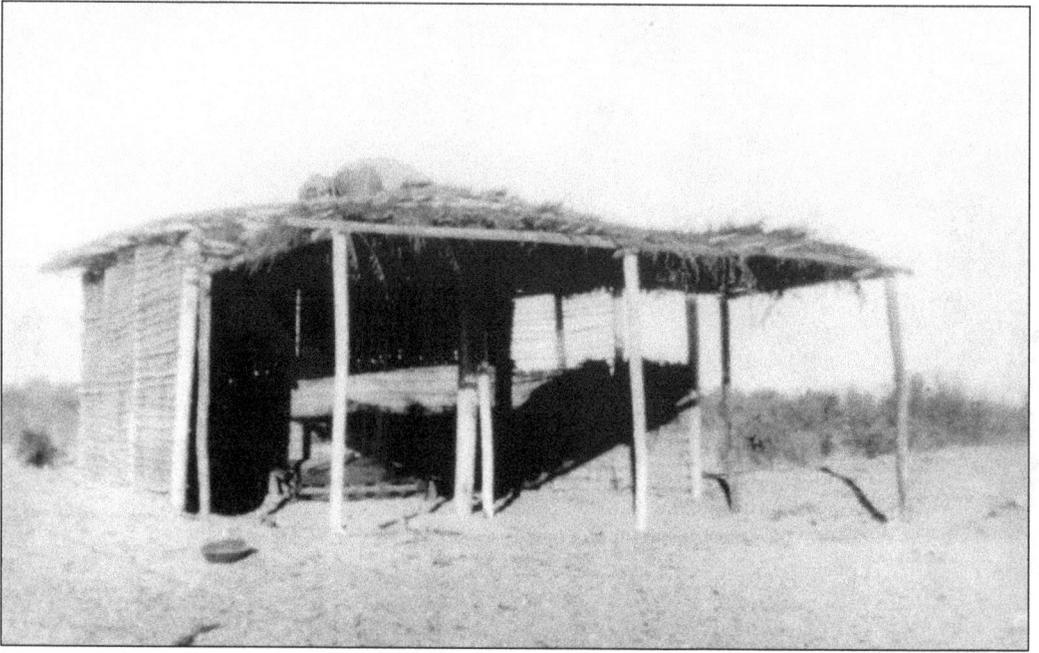

Many tribal people in Riverside County created rectangular homes made of posts, sticks, and adobes. Because of the intense sun in Southern California, Native Americans made large shade areas where they could live during the hot summer months. The adobe helped cool the dwelling in the summer and when heated, provided warmth in the winter months. (Courtesy of Twenty-Nine Palms Band of Mission Indians.)

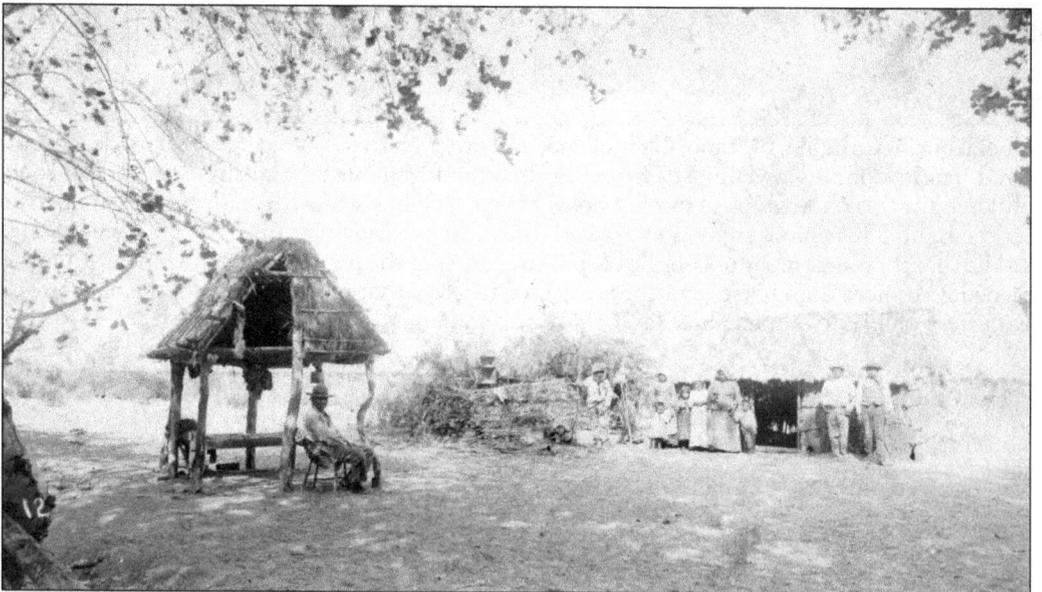

Native Americans of Riverside County sometimes built small shades like gazebos where they sat to tell stories, make baskets, or shape arrowheads. (Courtesy of Twenty-Nine Palms Band of Mission Indians.)

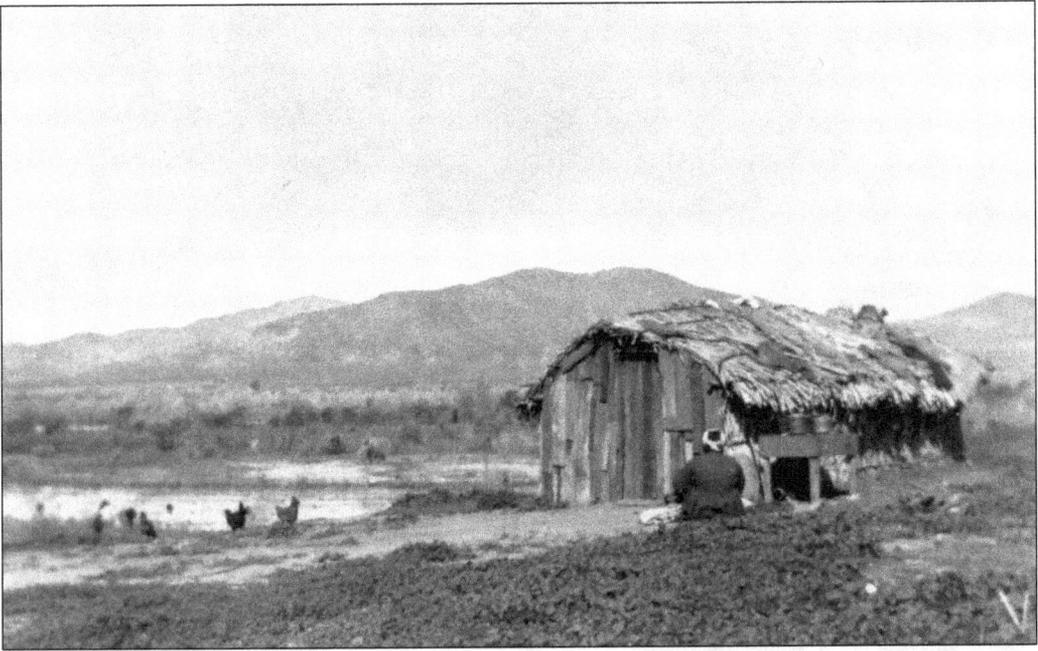

A man sits outside his house looking at a few chickens and a small pool of water. It contains elements of traditional homes, including the thatched and gabbled roofs introduced by settlers. (Courtesy of Riverside Metropolitan Museum.)

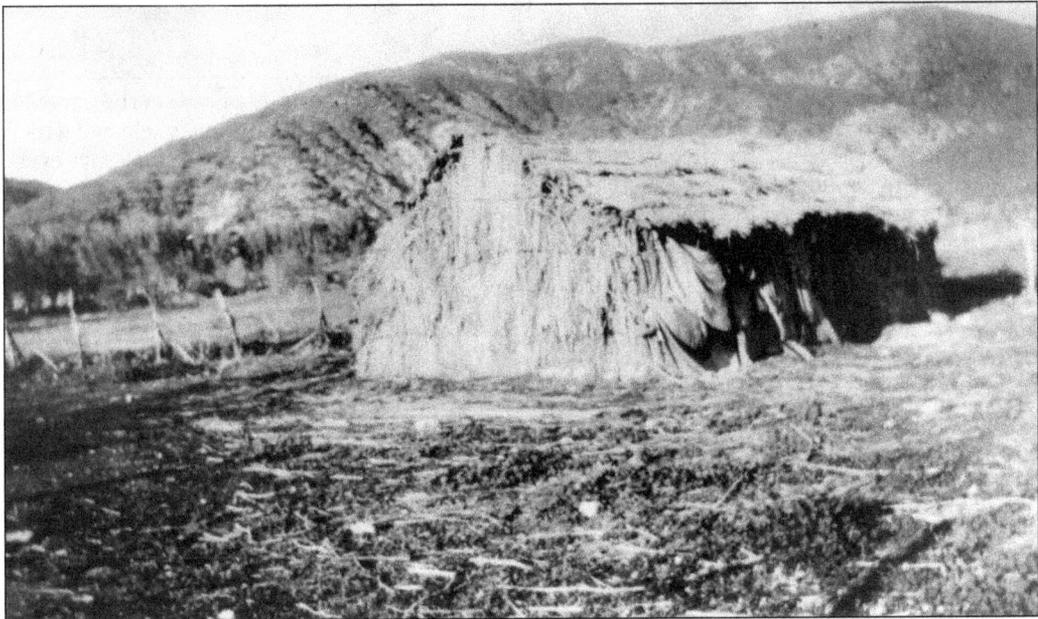

Native Americans of Riverside County lived in many different kinds of houses. Native people have constructed this house with a gabled roof so that rain will fall more easily off the roof. The women have used tight-knit thatching to make the sides and roof of the dwelling, tying the materials together with twine and cordage. The layers of thatch on the roof prevented most rain from entering this well- constructed home. (Courtesy of Twenty-Nine Palms Band of Mission Indians.)

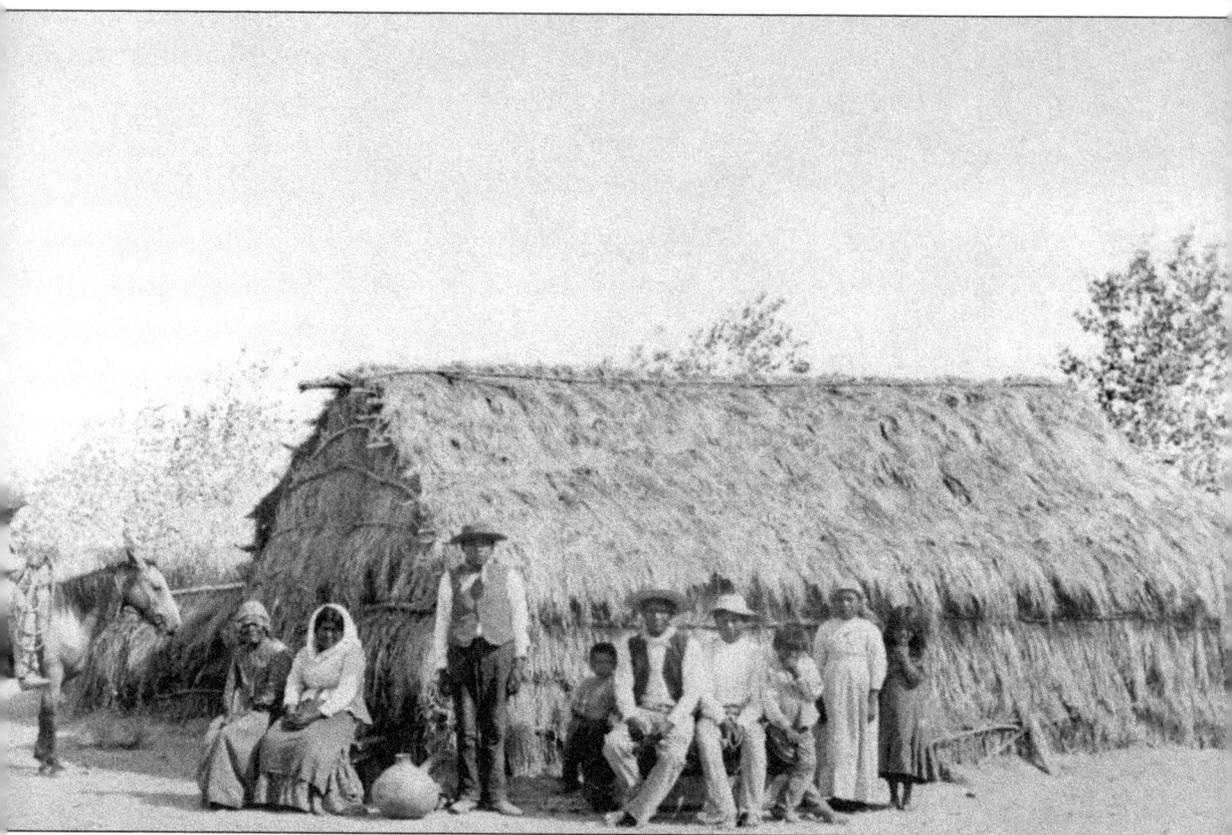

This 1888 photograph was taken of a family of Native Americans in front of a house at the Cahuilla Indian Village in Palm Springs, California. Natives in Riverside County routinely selected which aspects of non-native society they wished to incorporate into their daily lives. Note that every member of the family wears Western-style clothing. Still the Cahuilla retain traditional housing techniques and materials in addition to pottery and basketry as seen by the olla and basket at the corner of the house. (Courtesy of A. K. Smiley Public Library.)

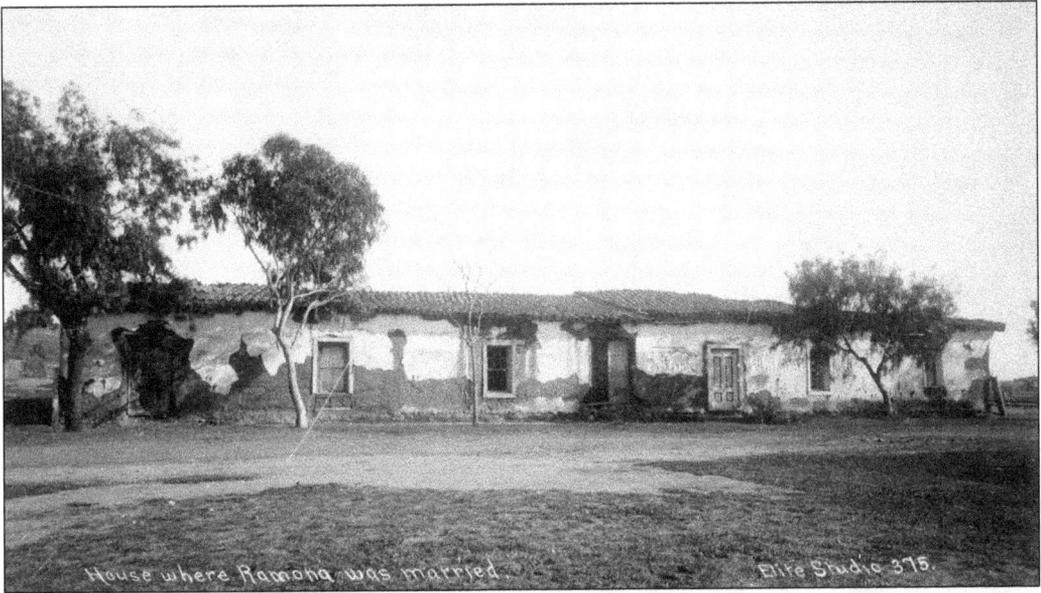

House where Ramona was married. Elite Studio 375.

Many aspects of Ramona's life became amplified after Jackson's publication of her famous book *Ramona*. This is the adobe house where Ramona was married in Riverside County. (Courtesy of A. K. Smiley Public Library.)

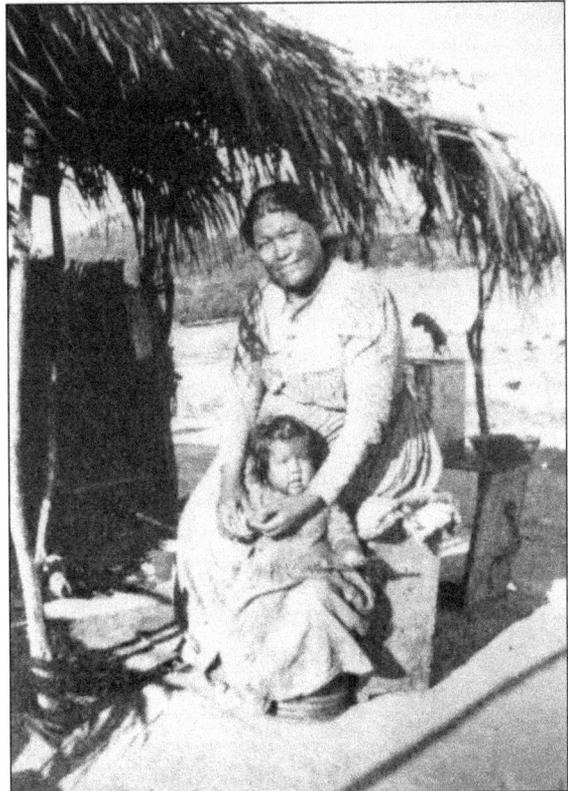

Native Americans of Riverside County have always treasured their children and used their homes as the space in which to educate them. This mother tenderly holds her daughter, and they both communicate in the shade outside their home. (Courtesy of Riverside Metropolitan Museum.)

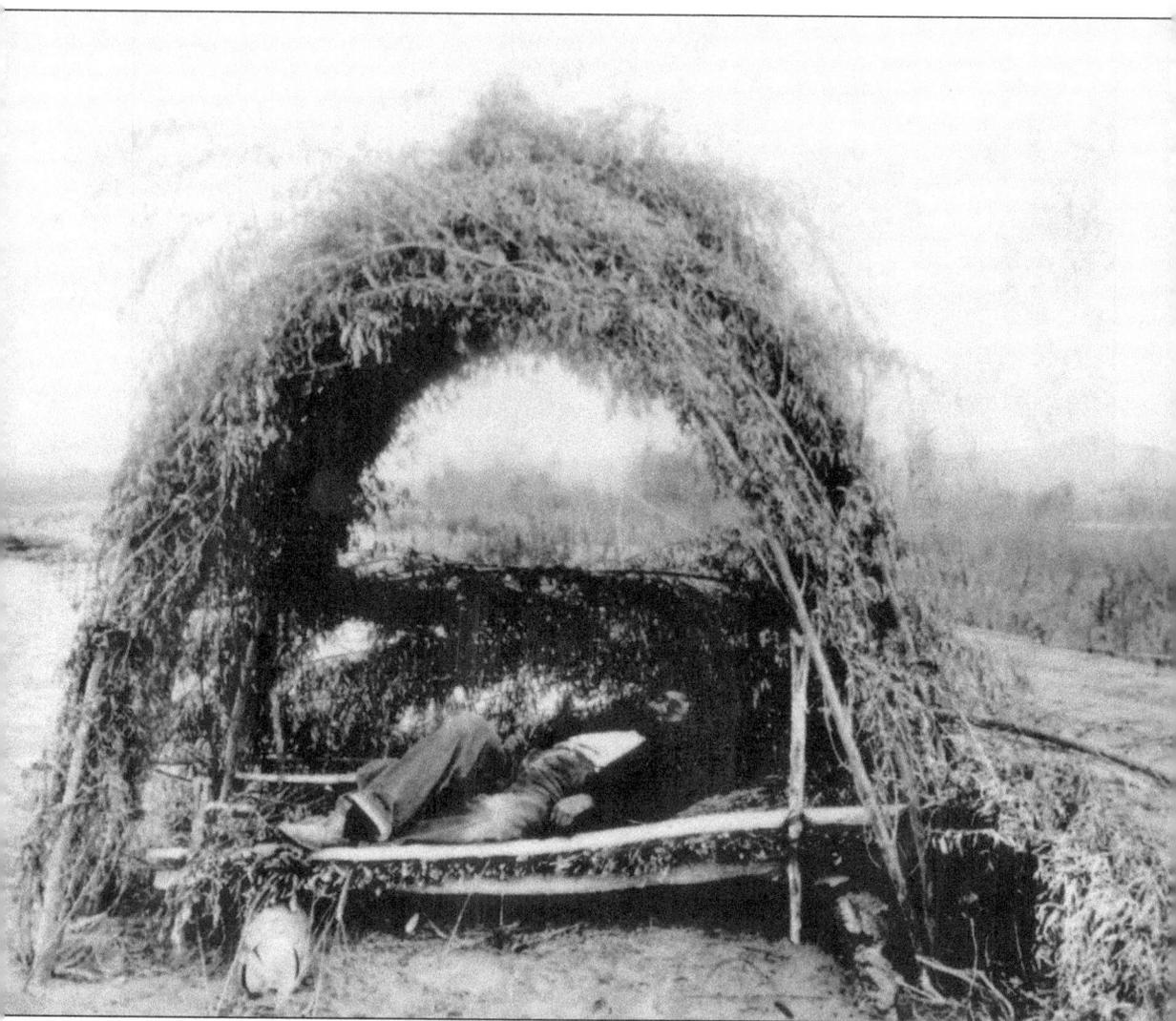

Native Americans of Riverside County were always innovative and adaptive. The Chemehuevis of the eastern portion of the county created small sleeping and resting dwellings made of willows, which provided shade but allowed the wind to blow through in every direction—including the bottom of the lodge. Making this dwelling from fresh willows provided a coolness from the newly cut green trees. Indians slept and rested in these dwellings. (Courtesy of Twenty-Nine Palms Band of Mission Indians.)

Three

NATIVE AMERICANS AT WORK

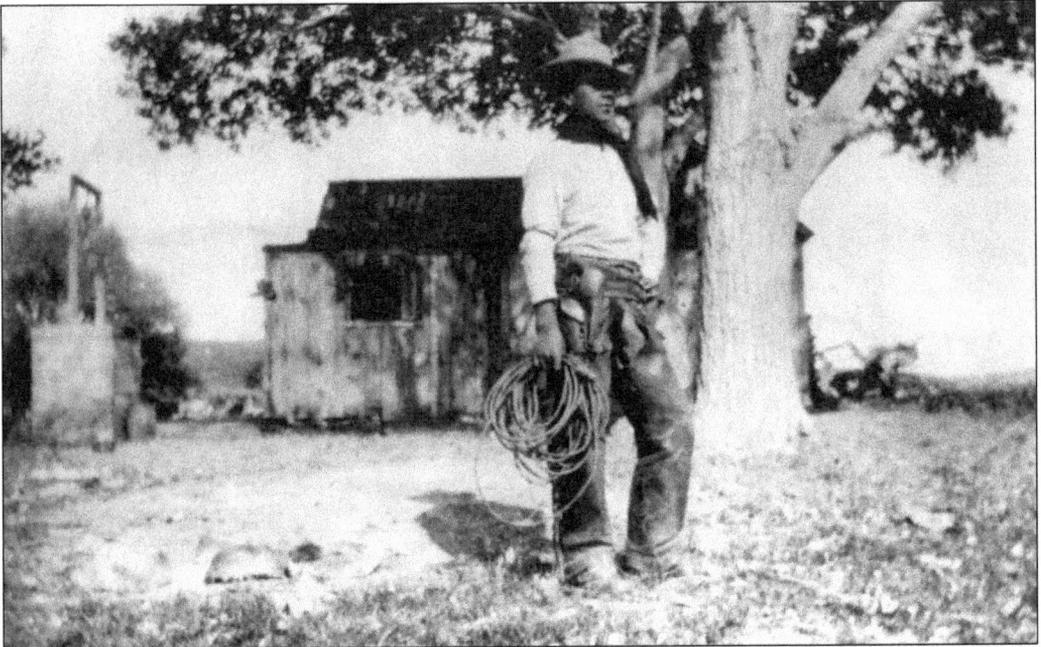

Raphaul Tortes was an outstanding cowboy. His relatives took this photograph on August 31, 1931. Tortes was a famous Peon player and used to get gambling medicine from Pablo Ormego. Pablo Ormego was a noted medicine man who was born on the Torres Martinez Indian Reservation but who lived on the San Manuel Indian Reservation with his wife, Martha, the mother of Pauline Ormego Murillo. (Courtesy of Pauline Ormego Murillo.)

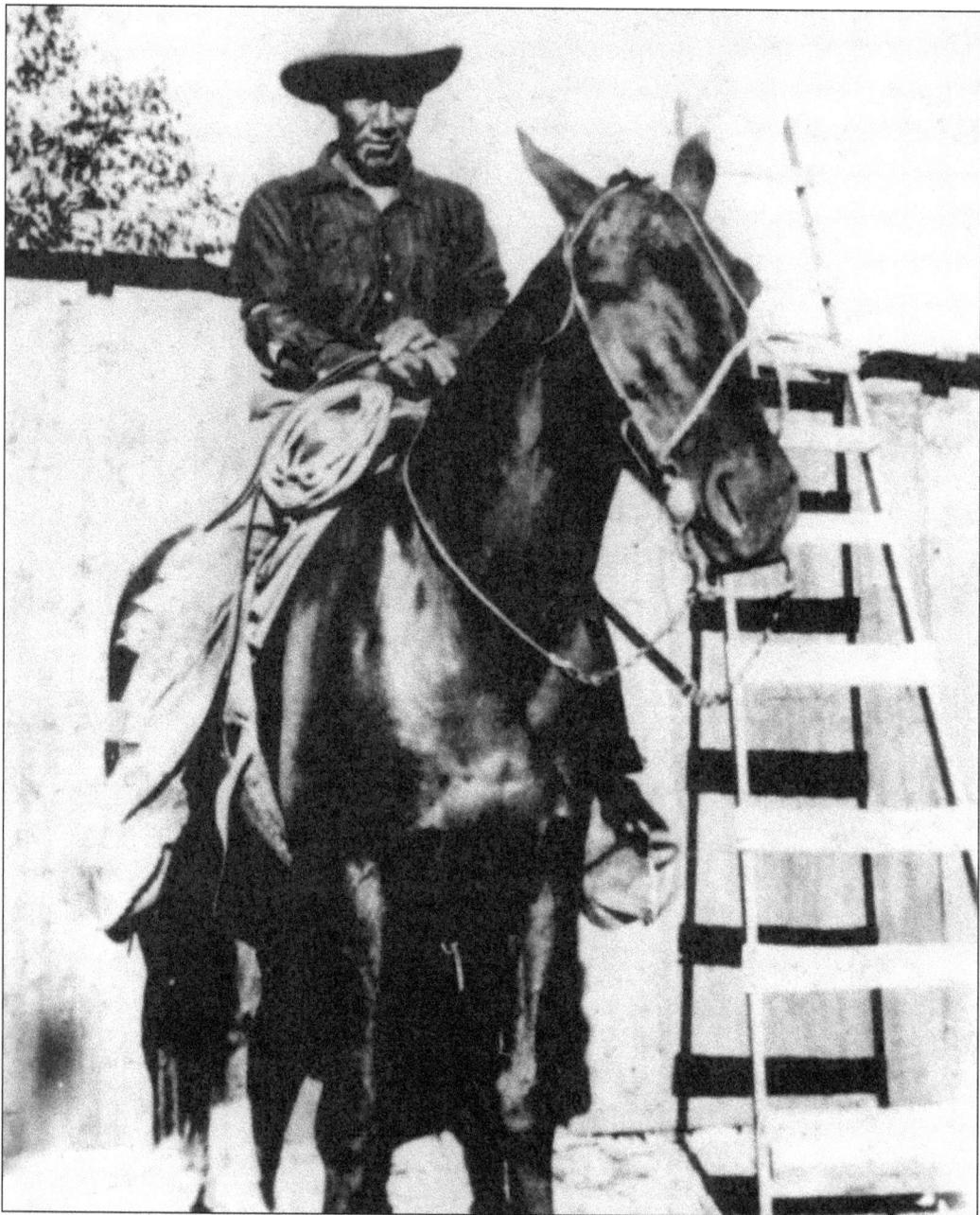

Sullivan Sebatcho was a cowboy from the Morongo Indian Reservation. He ran his own herd of horses and cattle and was famous for his work as a vaquero. (Courtesy of Pauline Ormego Murillo.)

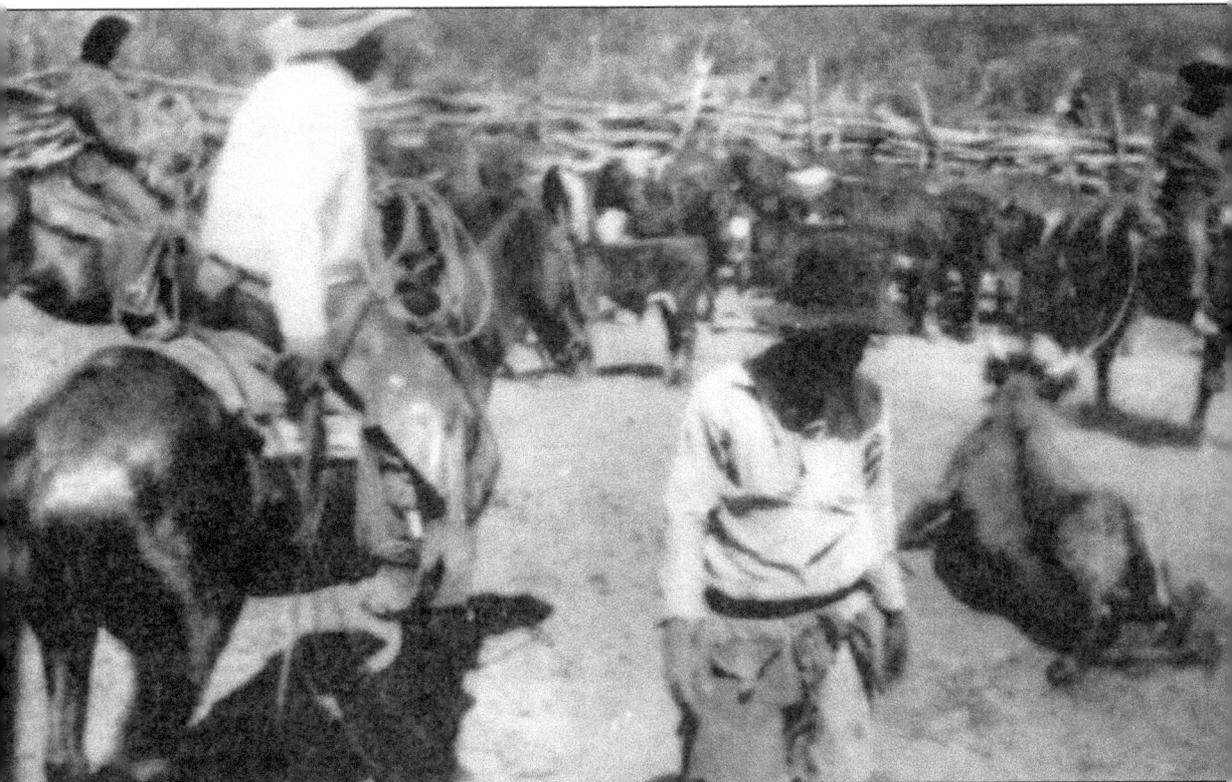

The Ormego family preserved this photograph of a cattle roundup on the Torres Martinez Reservation. Pauline Murillo, the daughter of Pablo Ormego, preserved this image in her extensive archive. (Courtesy of Pauline Ormego Murillo.)

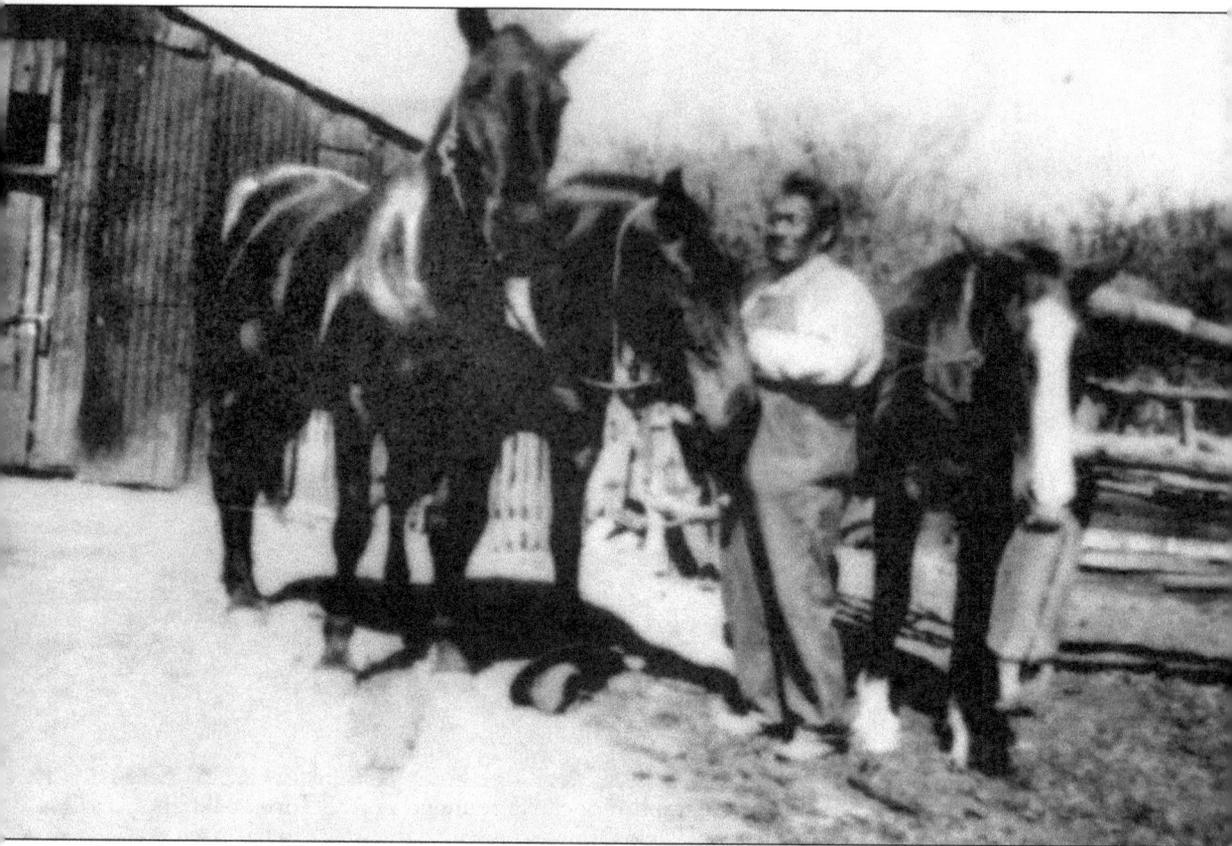

Miguel Sebatcho is tending three horses at his home on the Morongo Indian Reservation. The Sebatcho family was famous for their excellent livestock and their skill as wranglers. (Courtesy of Pauline Ormego Murillo.)

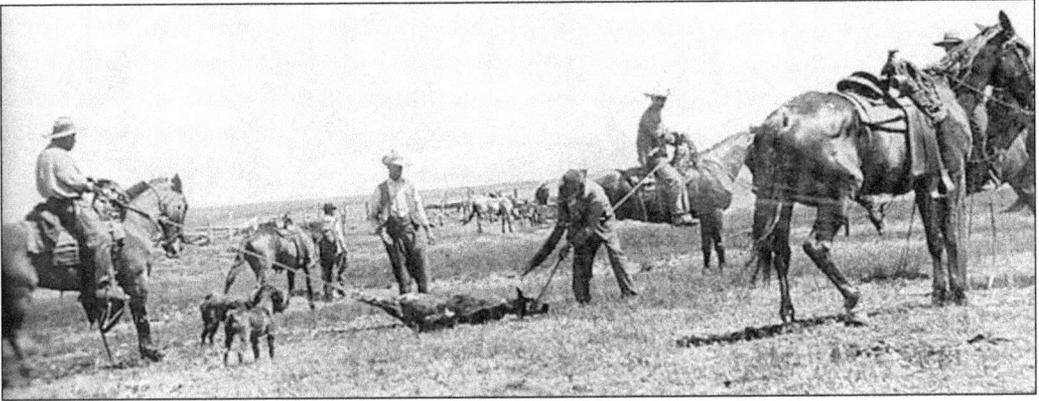

As a result of the Spanish mission system and the ranchos, many Native Americans in Riverside County became cowboys. This photograph depicts Cahuilla cowboys from the Cahuilla Indian Reservation near Anza, California, in 1910. (Courtesy of Leleua Loupe.)

A Native American man makes cordage in front of his home that his family has constructed from posts and branches used as tying materials on the outside of the structure. The family then formed mud from local soil to plaster the outside of the branches to create the walls of the building. Note the mud in between the branches and the thickness of it toward the top of the building. Riverside County Indians used native materials to create their home, and they used this method to make many of their homes. (Courtesy of Twenty-Nine Palms Band of Mission Indians.)

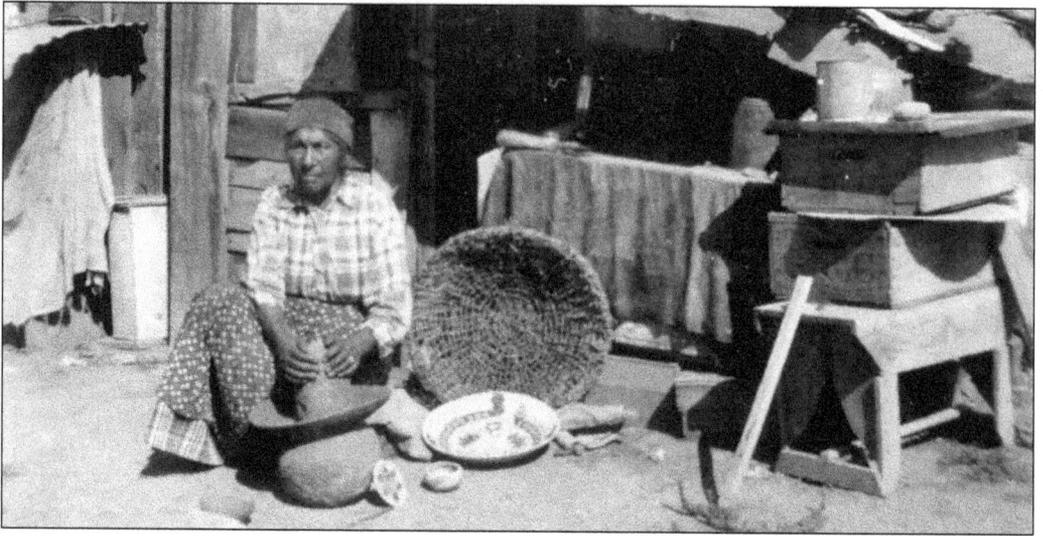

Carlota Lubo would grind native foodstuffs with a pestle and basket-rimed mortar as did most Indian women in Riverside County. Native American women like Carlota selectively adapted Western influences into their everyday lives. For example, note the change in housing material from brush or adobe to wooden planks, the introduction of steel objects, and her dress of Western style and geometric patterns. However, the assortment of granite grinding stones at her feet and native basketry beside her display continued reliance on traditional native lifeways. Lubo was Luiseño and famous for her baskets and lace. She is a relative of Charlene Ryan, who currently heads the cultural program on the Soboba Reservation. (Courtesy of A. K. Smiley Public Library.)

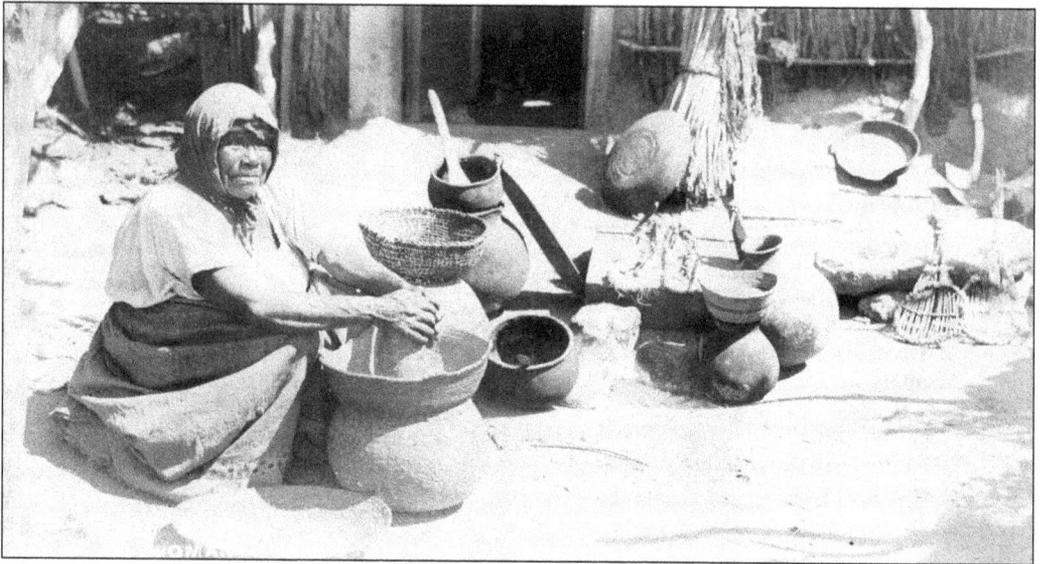

The milling and food preparation routinely performed by women, such as what this Luiseño woman is doing at Soboba, served many functions. Primarily it provided the nutritional and dietary foundation of the diet for natives in Riverside County. The hunting conducted by men did not supply a dependable source of food. Days or weeks could pass between successful hunts. During these periods, the vegetables prepared by women sustained the family and sometimes the village. The continual collection and preparation of edible foodstuffs by women afforded men the opportunity to hunt. (Courtesy of A. K. Smiley Public Library.)

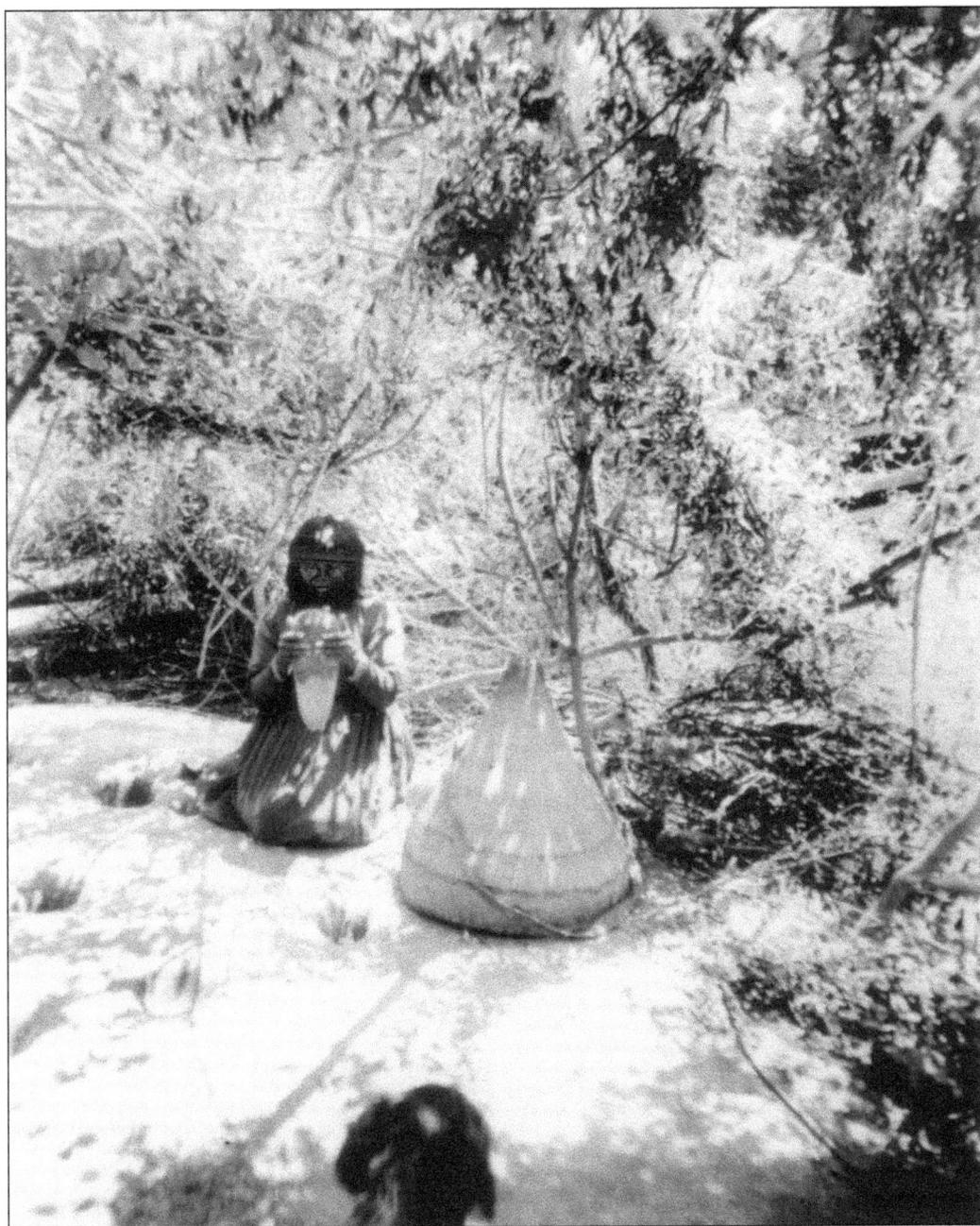

Throughout Riverside County, Indian women used outcroppings of bedrock in order to mill seeds and nuts. Here a woman uses a large and heavy granite pestle to smash acorns into meal. The large basket to the right is a burden basket, used to haul quantities of foodstuff. Note the strap running across the front of the basket. Women would place it on their foreheads to support the basket on their backs, using the strap to bear the weight. In this way, women could have both hands free and still carry a great deal of weight to milling or village sites. (Courtesy of Twenty-Nine Palms Band of Mission Indians.)

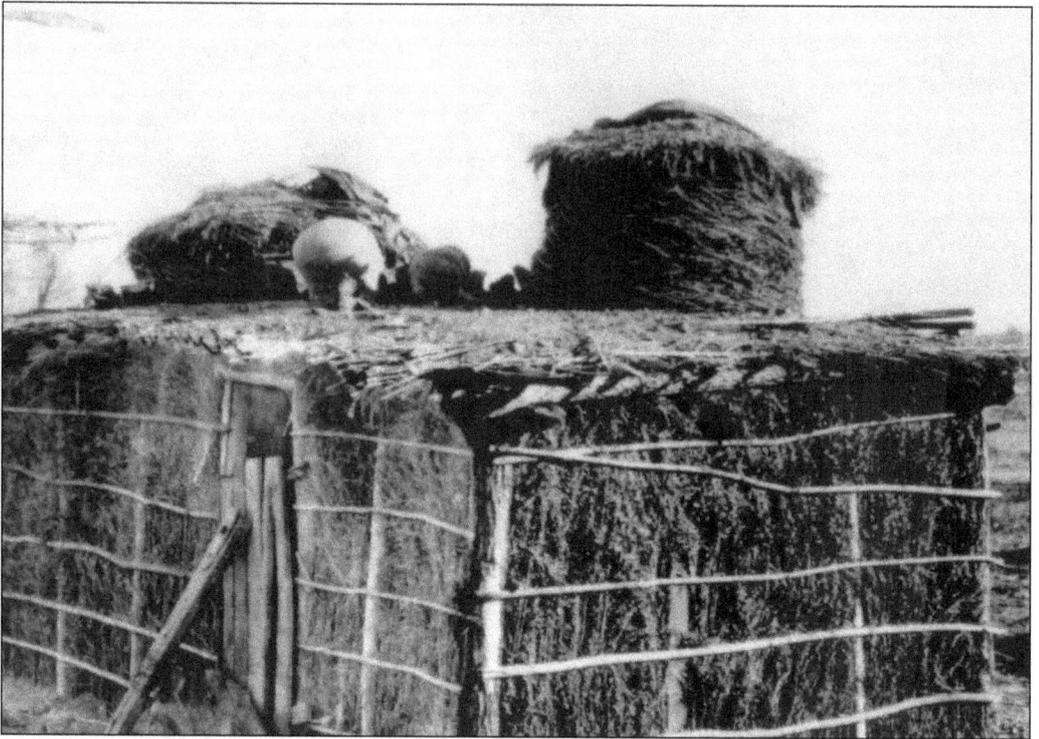

In order to protect food resources in granary baskets, where acorns, seeds, and pods were stored so animals could not reach them, large baskets were often placed on top of the homes. This photograph depicts the rectangular home of a Mojave or Chemehuevi family along the Colorado River. (Courtesy of Twenty-Nine Palms Band of Mission Indians.)

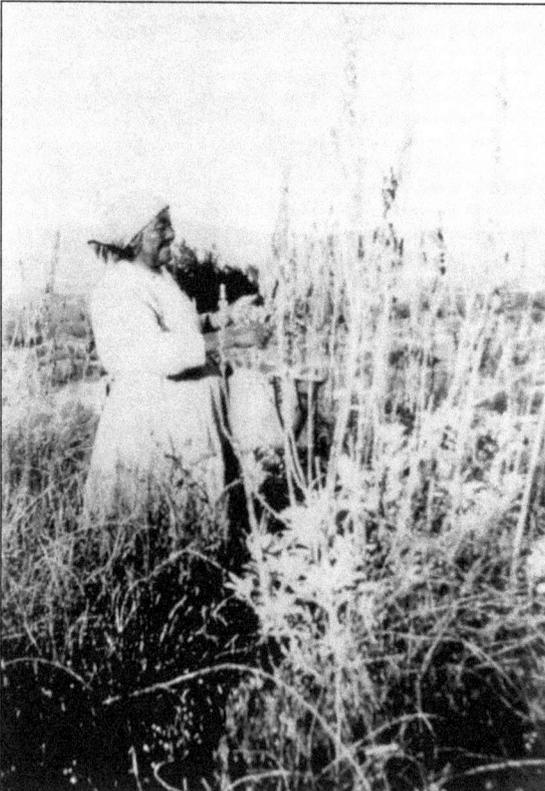

The Indians of Riverside County used native plants for food, medicine, basketry, and housing. They carefully used their environment and took care not to overuse or threaten the health of plants and animal habitats. Here Cahuilla Indian elder Louisa Rice Costo collects a native plant. (Courtesy of A. K. Smiley Public Library.)

Beneath the tall palms of Palm Canyon, three Cahuilla Indian women gather willow around 1890. Native Americans in Riverside County understood the seasonal changes in their environment intimately. As a result, every tribal member knew when it was time to gather or harvest specific natural resources and where they could be found. Some areas were held in common, but most hunting and gathering areas belonged to specific families, clans, or tribes. (Courtesy of A. K. Smiley Public Library.)

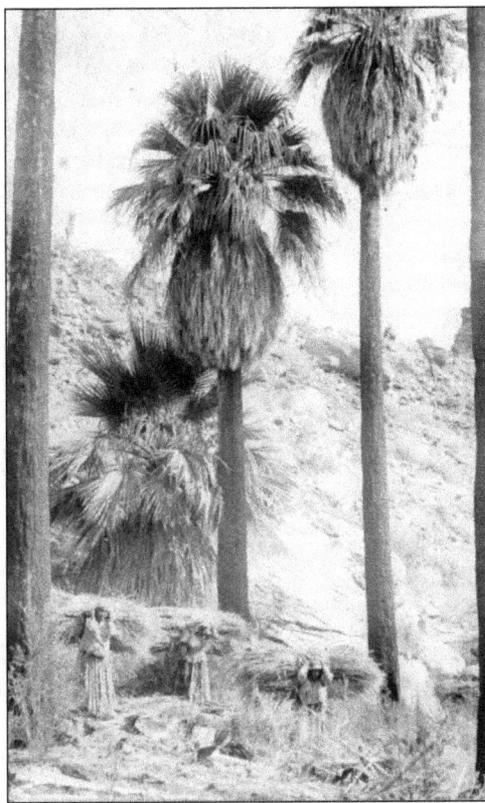

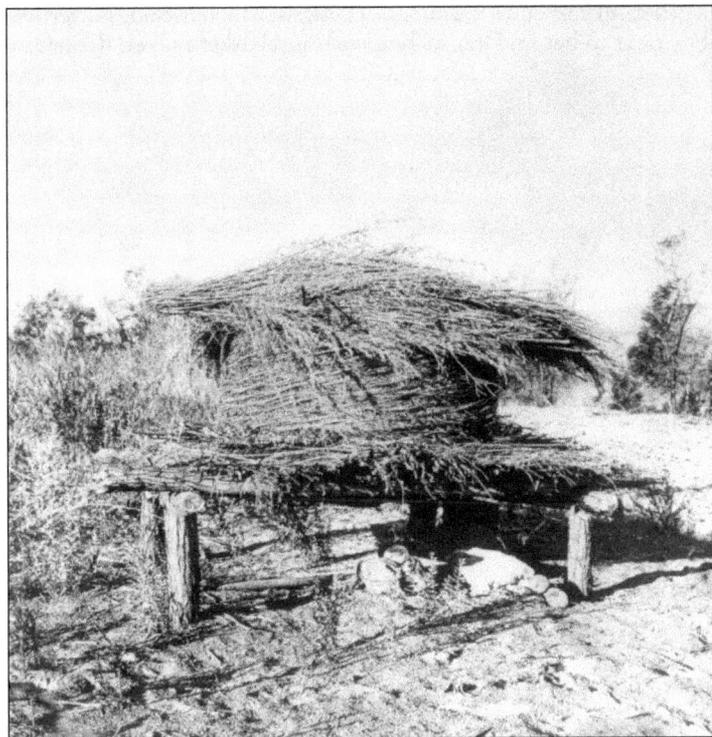

Indians throughout Riverside County made large baskets to hold foods, which they stored until they processed them for consumption. All of the indigenous peoples of the county made large granary baskets that they placed outside of their homes and filled them with acorns, mesquite beans, and other grains and seeds. When people needed the produce, they obtained them from the granary baskets. Note that the granary baskets are placed on stilts so that mice, rats, squirrels, and other animals would have a difficult time reaching the produce. (Courtesy of Twenty-Nine Palms Band of Mission Indians.)

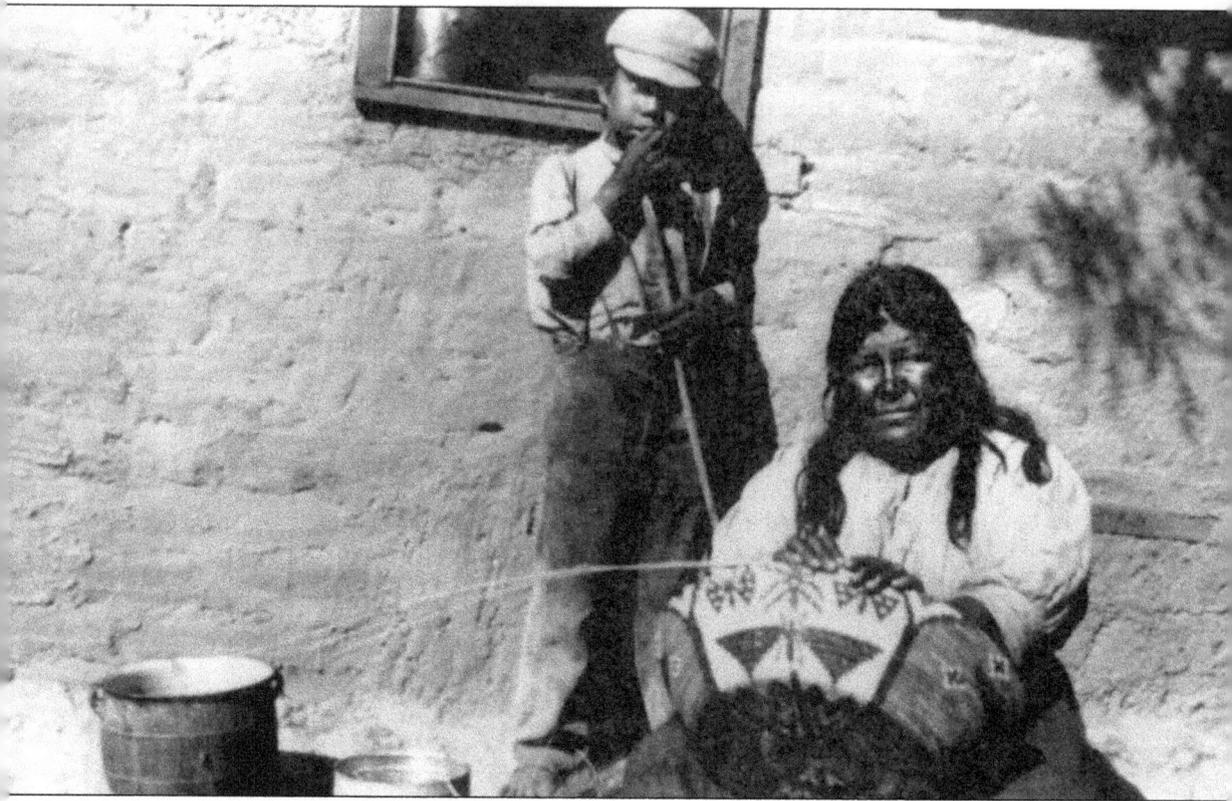

This tribal elder is constructing a beautiful basket with wonderful designs, which include butterflies and a spider. She instructs the boy next to her and enjoys her work as a basket maker. (Courtesy of Pauline Ormego Murillo.)

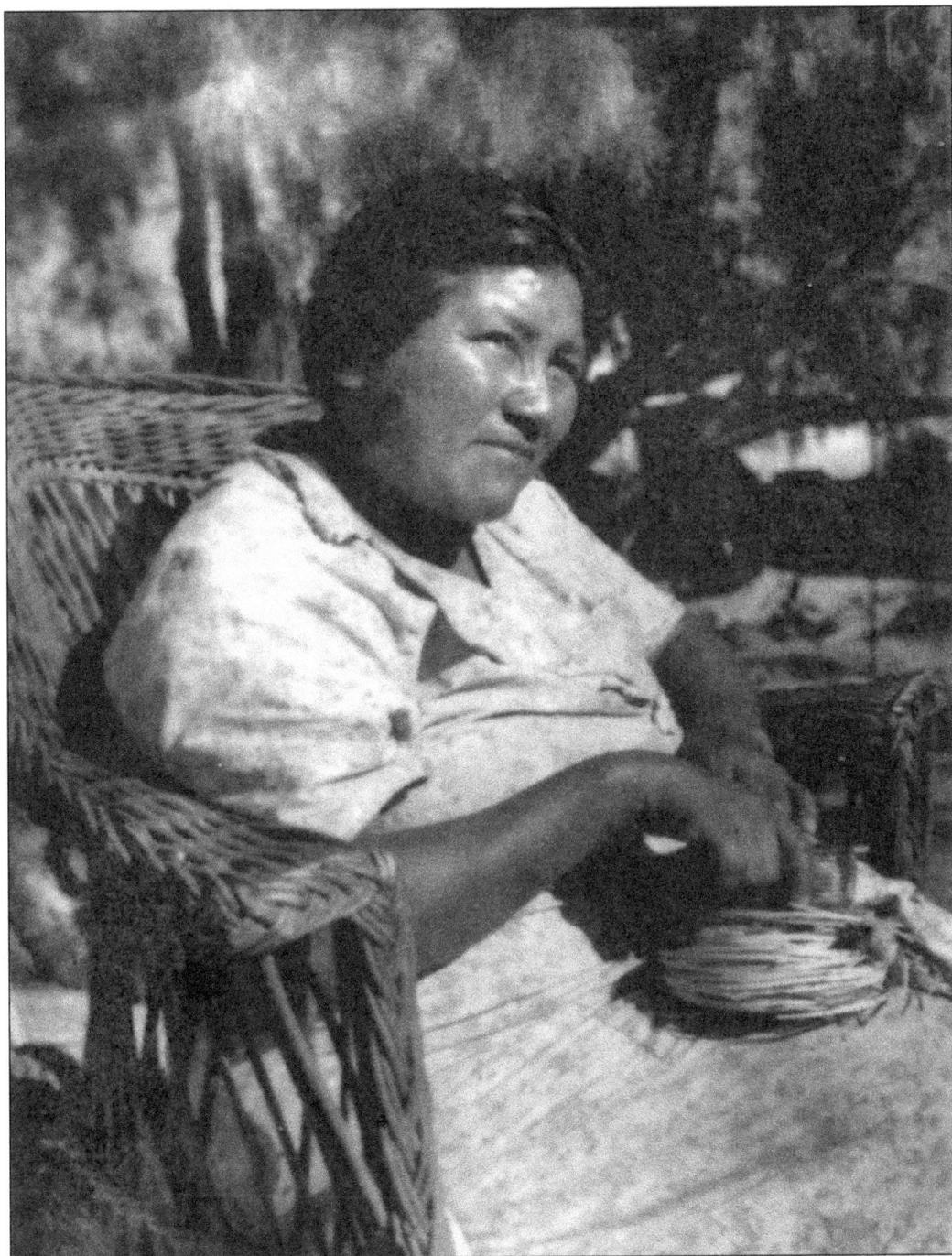

Philemona Even, a Cahuilla woman from Palm Springs, California, was an excellent basket maker. Here she is preparing raw materials from which she will make a basket. (Courtesy of Pauline Ormego Murillo.)

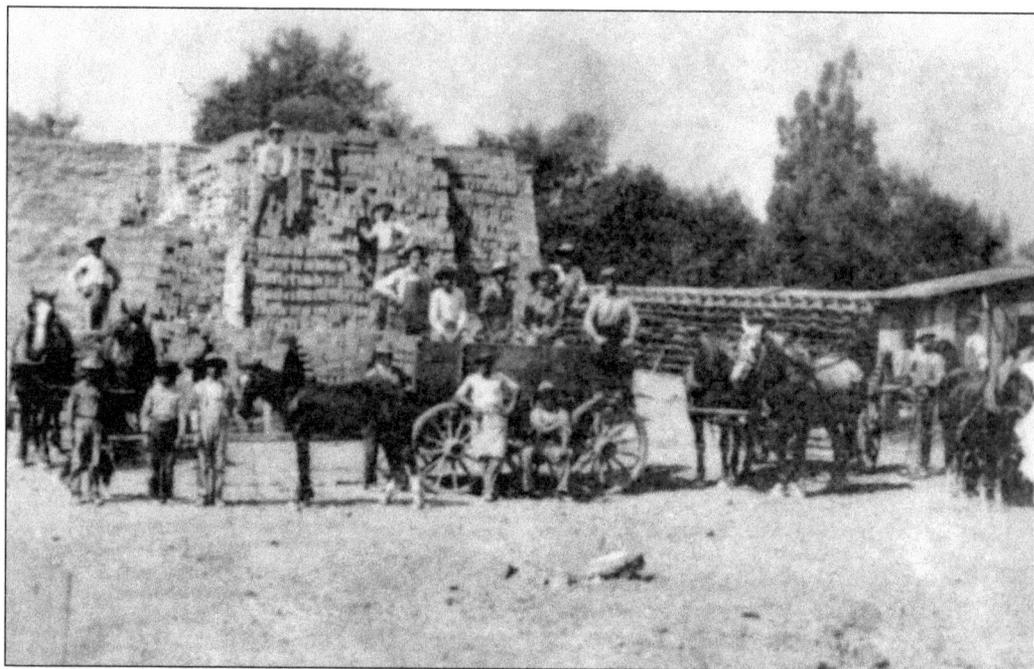

Indians from Riverside County worked in many occupations, including brick making and laying. This is a brick factory in High Grove, California, where Native Americans worked. (Courtesy of Pauline Ormego Murillo.)

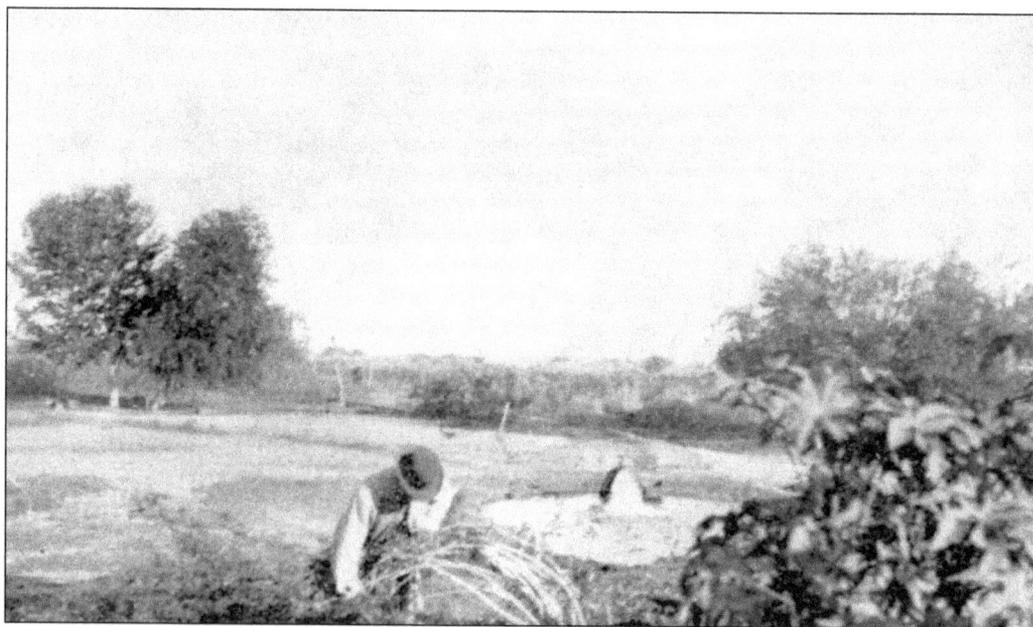

A farmer works on the Torres Martinez Reservation. Agriculture work was one of the few vocations that the Office of Indian Affairs encouraged indigenous peoples in Riverside County to conduct. Unlike other professions, such as house cleaning or janitorial work, farming allowed Native Americans to work on or near their reservations. (Courtesy of A. K. Smiley Public Library.)

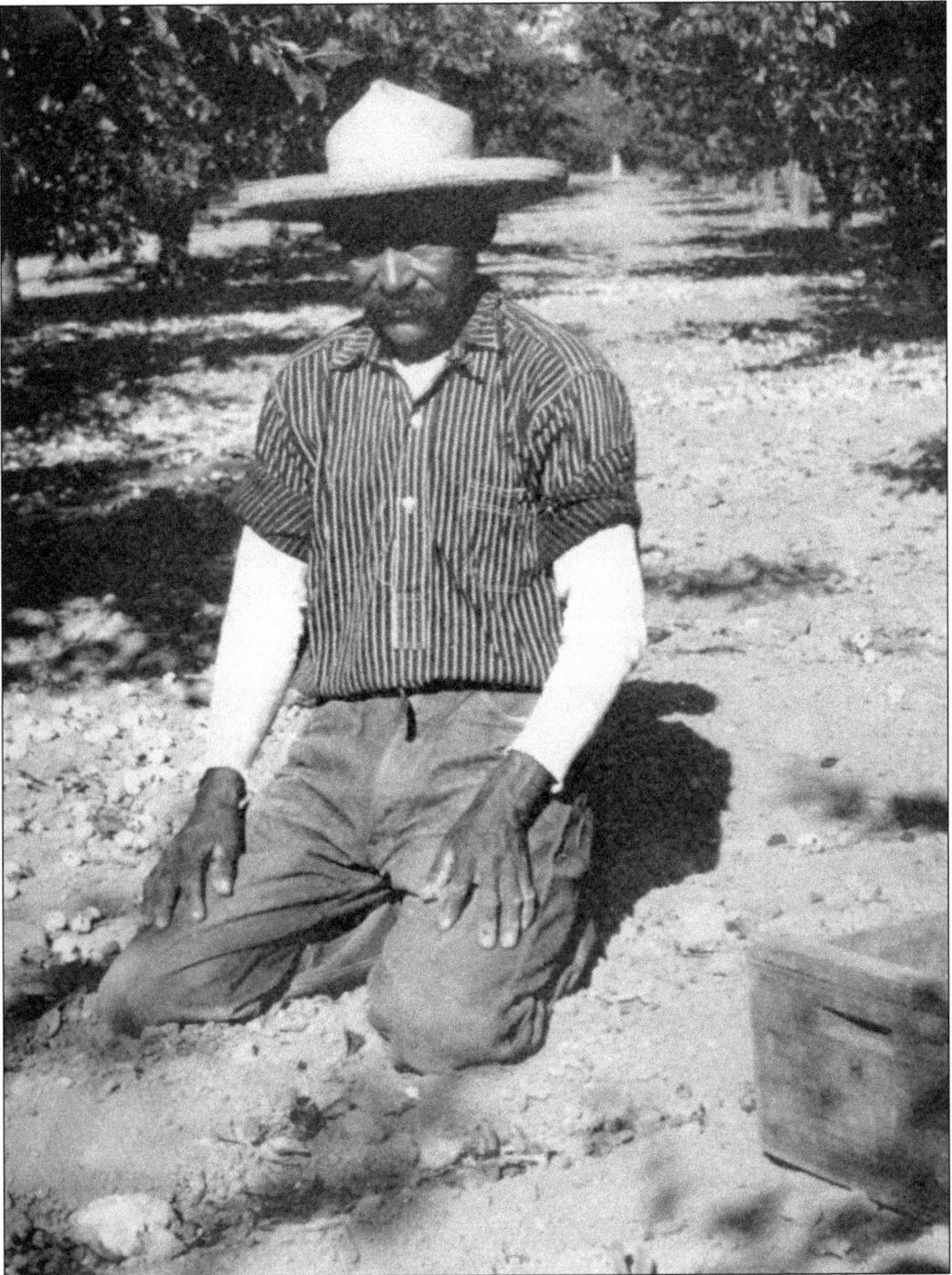

Billy Mike worked on several ranches in Riverside County, including the Gillman Ranch. He worked as a cowboy until a shotgun accidentally went off and killed him while he drove a horse-drawn wagon. (Courtesy of Twenty-Nine Palms Band of Mission Indians.)

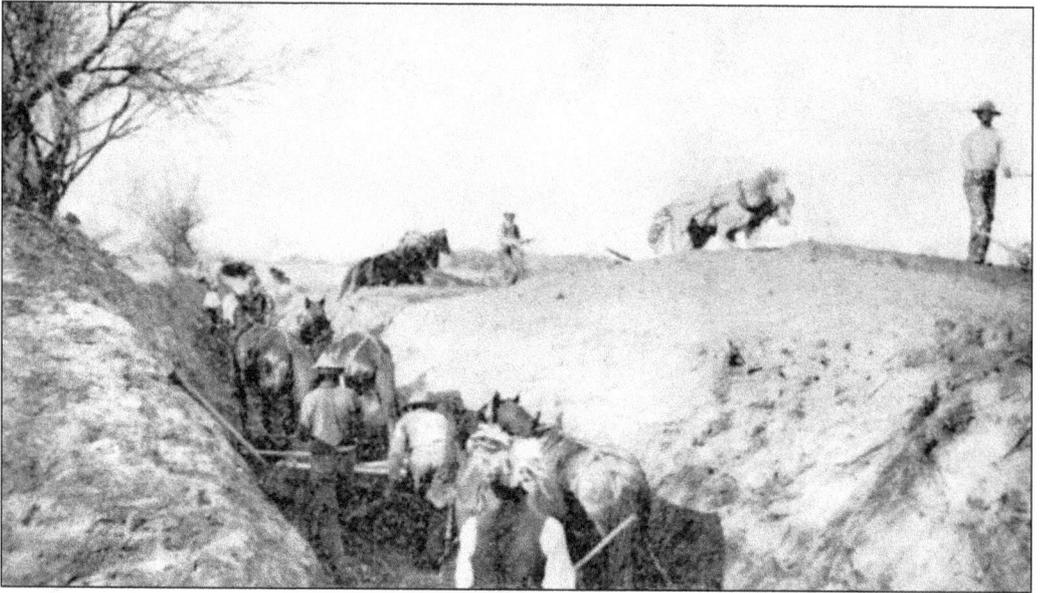

This is an irrigation ditch being dug by Indians from Riverside County. Numerous Native Americans toiled in the summer heat of Southern California creating complex irrigation systems that served the burgeoning agricultural business. Unfortunately, only a fraction of the wealth generated from their labor, or harvested from what was their lands, ever returned to them. (Courtesy of A. K. Smiley Public Library.)

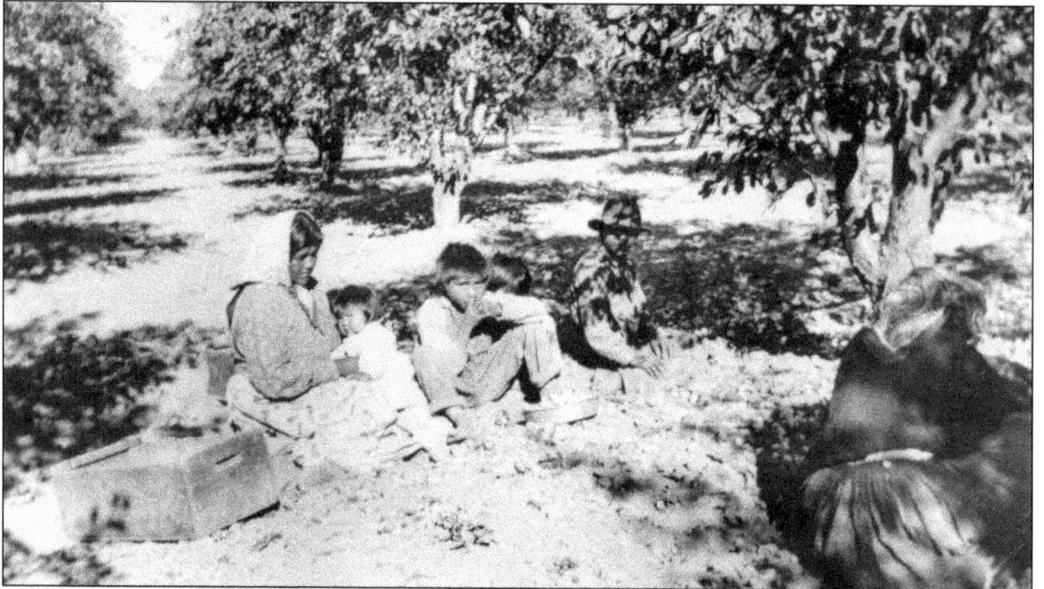

Maria Mike works at the Gillman Ranch with three of her children close by. Each year, Maria's husband, William Mike, accepted a position as the foreman of Indian workers at the ranch. In 1909, another Chemehuevi, named Willie Boy, murdered William Mike and fled the Banning ranch for the Mojave Desert to the north. When William Mike died at the ranch, Maria, her children, and other tribal members moved first to the Morongo Indian Reservation and later to the Cabazon Indian Reservation in Indio, California. (Courtesy of Twenty-Nine Palms Band of Mission Indians.)

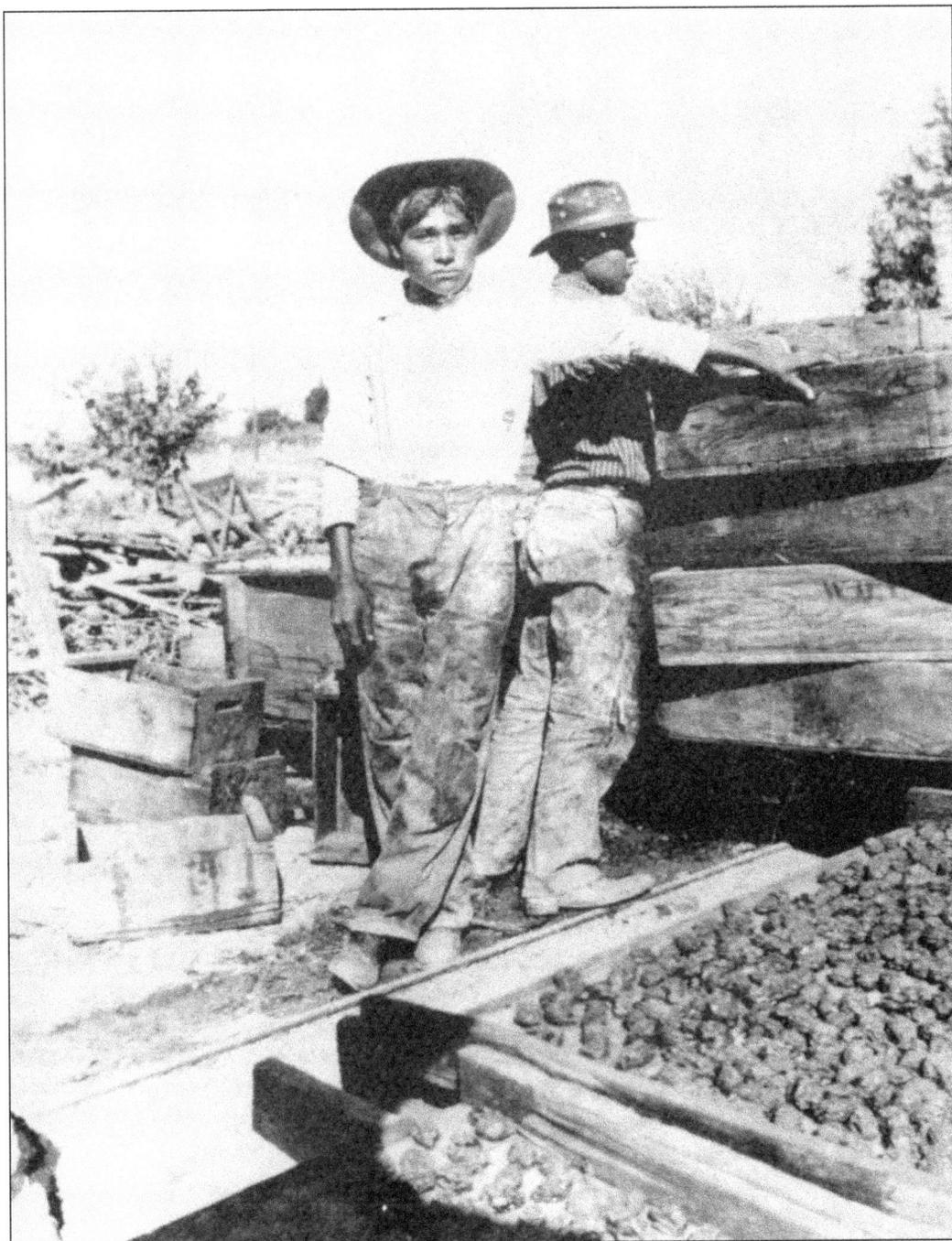

Native Americans lost their traditional economies when non-Indians took over plant and animal habitats in Riverside County. As a result, they sought wage-earning jobs. The sons of William Mike dry fruit on the Gillman Ranch in Banning, California. (Courtesy of Twenty-Nine Palms Band of Mission Indians.)

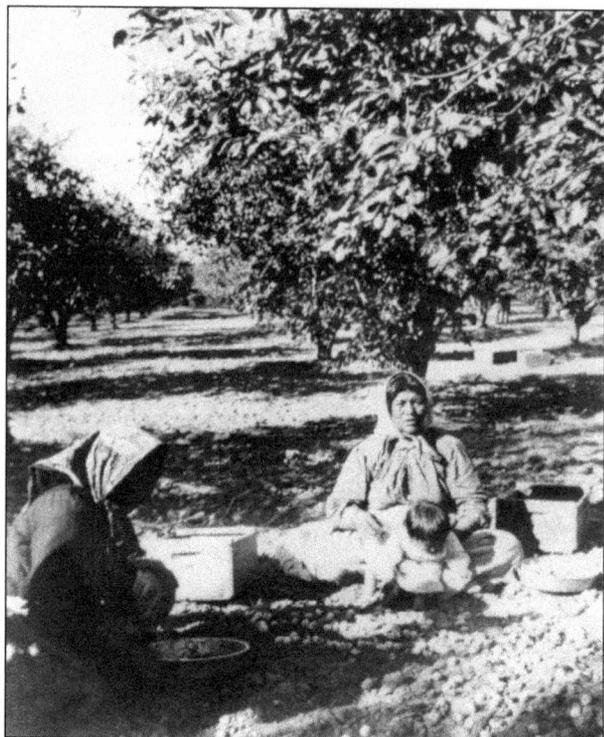

Maria Mike, a member of the Indian community at the Oasis of Twentynine Palms, is photographed while working at the Gillman Ranch in Banning, California. During the late 19th century, Indians throughout the region began earning money and participating in the market economy because newcomers destroyed the resources they once used to survive. Here women sort apricots at the ranch while their children play nearby. (Courtesy of Twenty-Nine Palms Band of Mission Indians.)

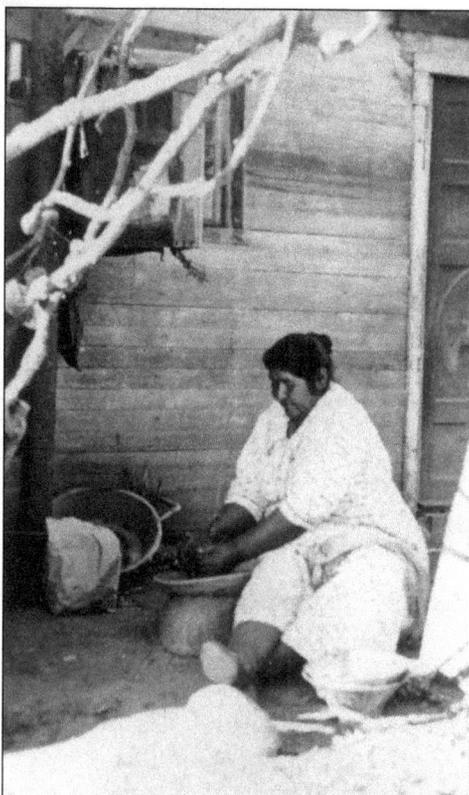

Beneath the cool shade of her house, Louisa Pino prepares foodstuffs using traditional grinding implements. In most native cultures of Riverside County, women primarily performed the milling of foodstuffs for their families. However, the concept of women's work did not carry with it any of the derogatory or misogynistic underpinnings found in contemporary usage. The preparation of foods by women was fundamental to the survival of the Cahuilla and Chemehuevi. (Courtesy of A. K. Smiley Library.)

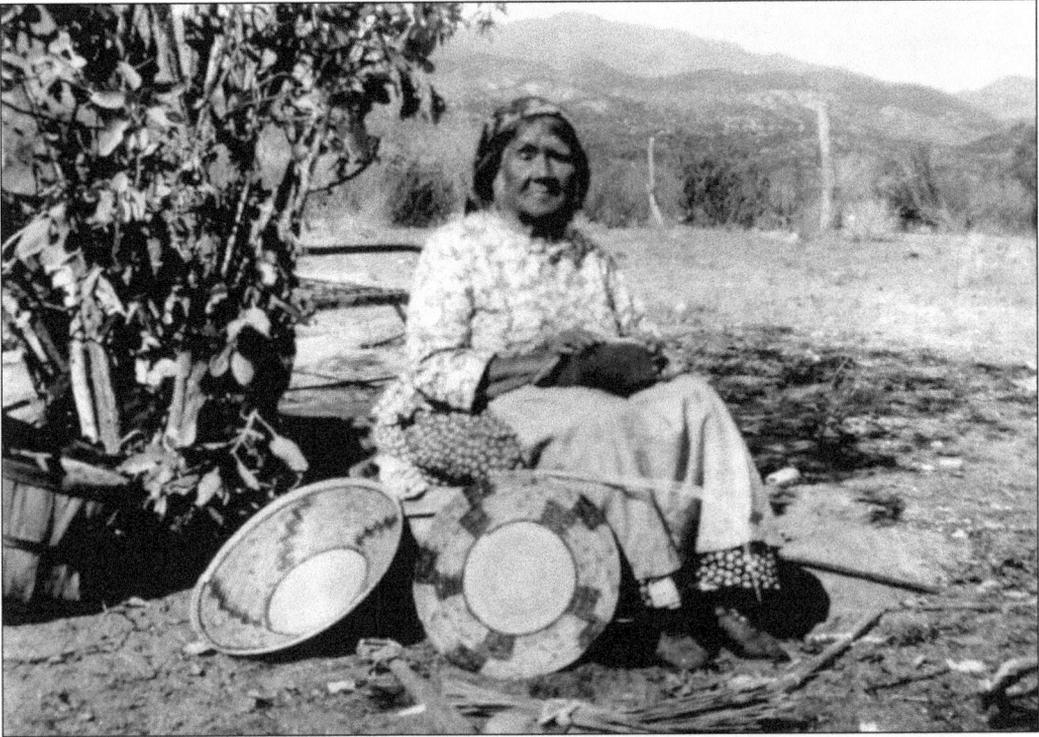

This Cahuilla Indian basket maker sits near her home surrounded by basket-making materials and two examples of her work. To the far left is a non-native bushel basket that Indians used when picking fruit for farmers. The Indian basket on the right displays the design of zigzag lightning. (Courtesy of A. K. Smiley Public Library.)

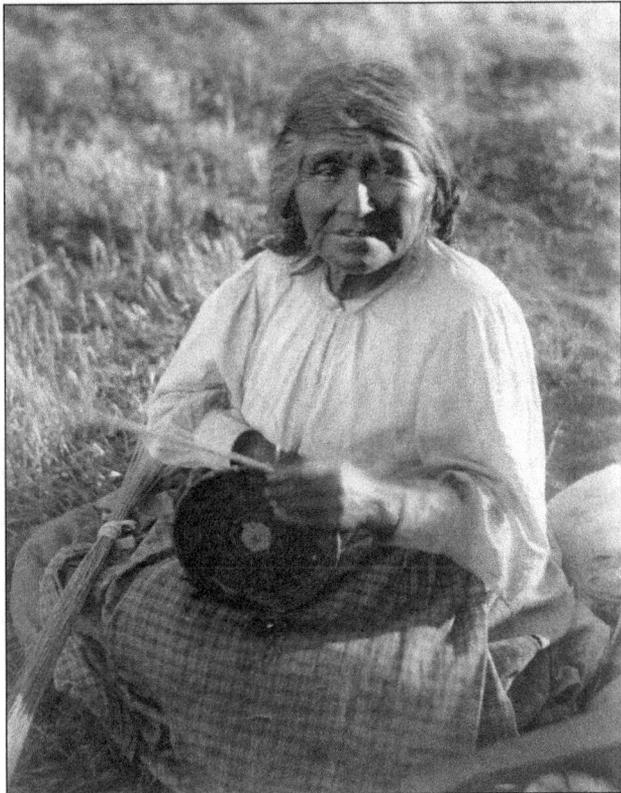

A Cahuilla woman makes a basket, an art form given to the Cahuilla from Menily the Moon Maiden. The skill and patience required to produce coiled Cahuilla basketry earned women respect and income. Collectors around the world continue to prize baskets from Riverside County. (Courtesy of A. K. Smiley Public Library.)

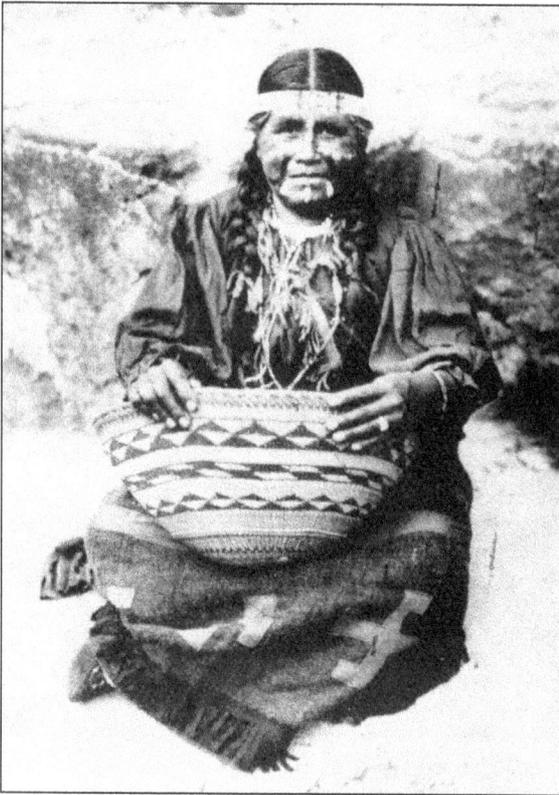

Native American women took great pride in their baskets, which were functional within their villages and offered a means of making cash for families. This Chemehuevi woman smiles with pride as she shows her excellent work. (Courtesy of A. K. Smiley Public Library.)

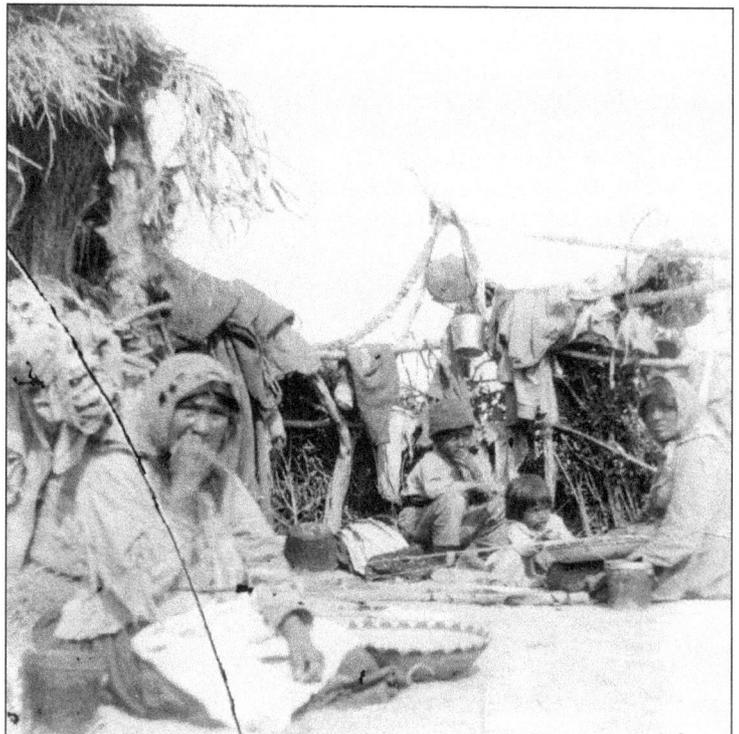

Two Chemehuevi Indian women make baskets in front of their home. Both women look defiantly into the camera while children play in the background. The women have constructed their home from logs, sticks, and thatch. Note the manufactured items they use, including pots, pans, canteen, burlap sacks, and clothing. Their basketry materials, set out in front of the women, are all natural items that they had gathered. (Courtesy of Paul Smith, Twentynine Palms Inn.)

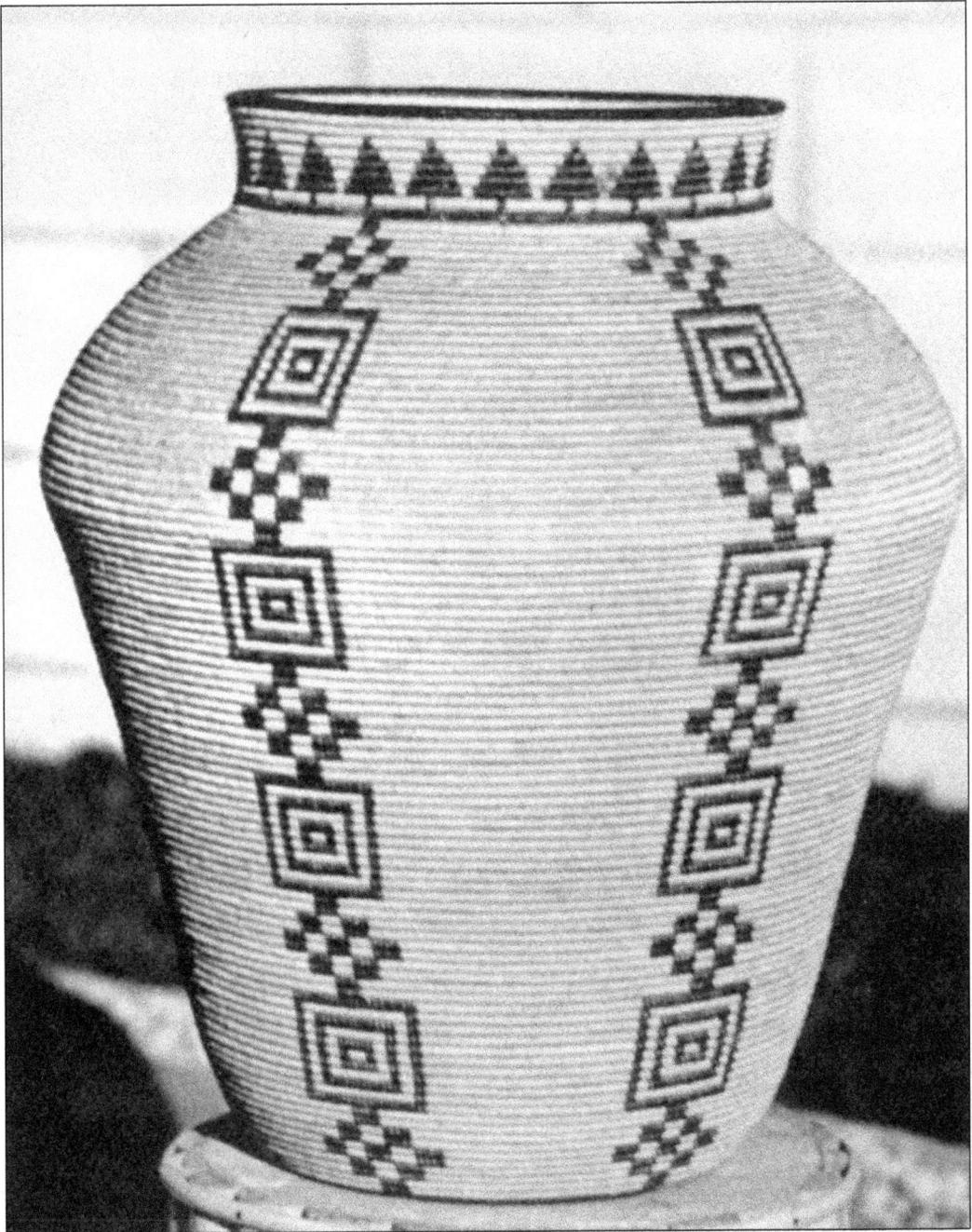

The Native Americans of Riverside County are famous for their baskets. This is a large, exquisite Chemehuevi basket made by an unknown woman who masterfully presented the form, function, and design of it. (Courtesy of A. K. Smiley Public Library.)

Jesusa Manuel was a master basket maker. Born on the Los Coyotes Reservation, Jesusa married into the Manuel family. She was the mother of Martha Manuel Chacon and grandmother of Pauline Murillo. (Courtesy of Pauline Ormego Murillo.)

Alex Siva was a Cahuilla man from Los Coyotes, but he lived on the San Manuel Indian Reservation where he could get work in nearby San Bernardino. Like many Native Americans, he made a living through his labor and lived away from his aboriginal home. (Courtesy of Pauline Ormego Murillo.)

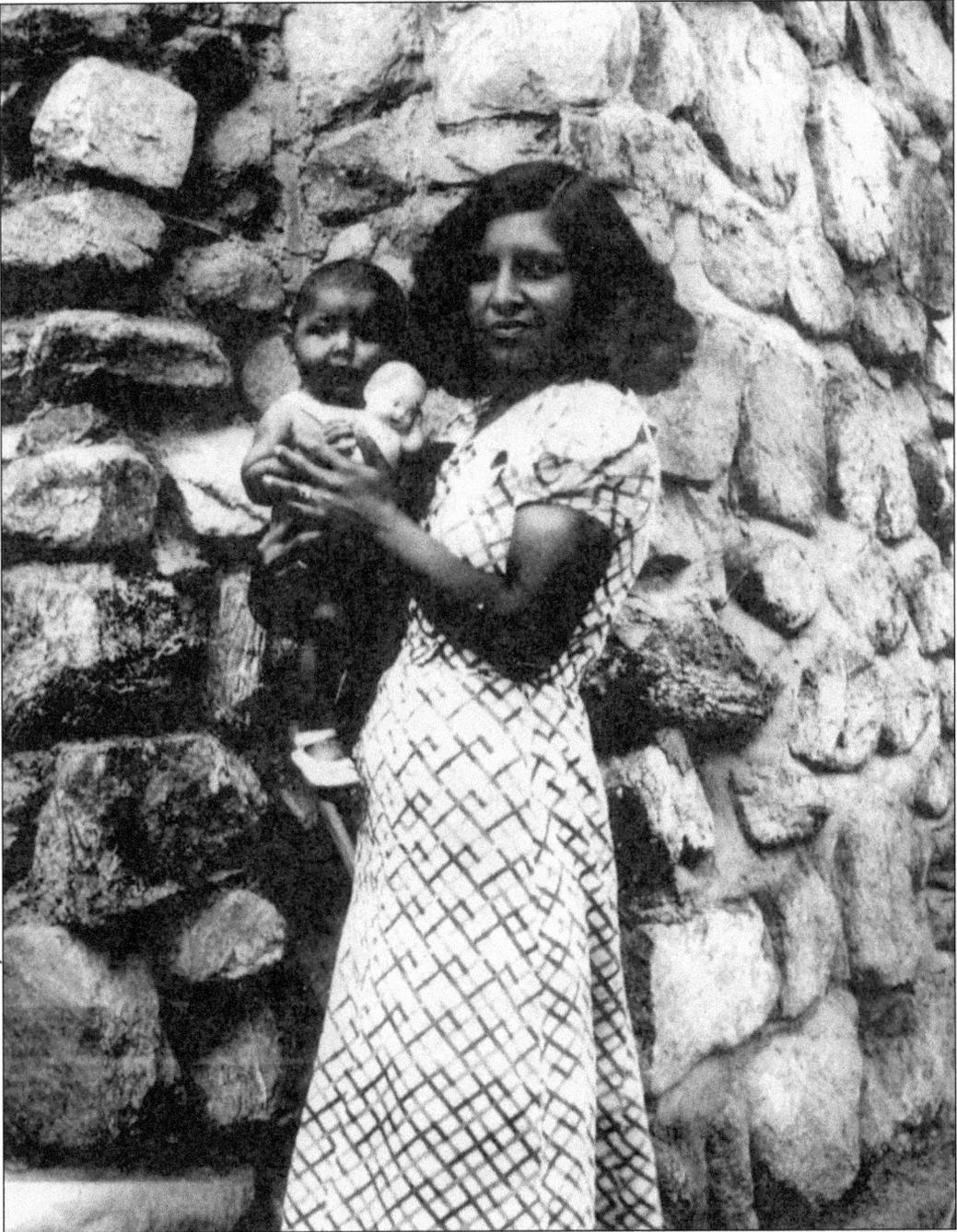

Martha Chacon is holding her daughter Pauline Murillo. Martha's brothers worked in many trades, including construction, and they made this sturdy home for their mother. The home still stands. (Courtesy of Pauline Ormego Murillo.)

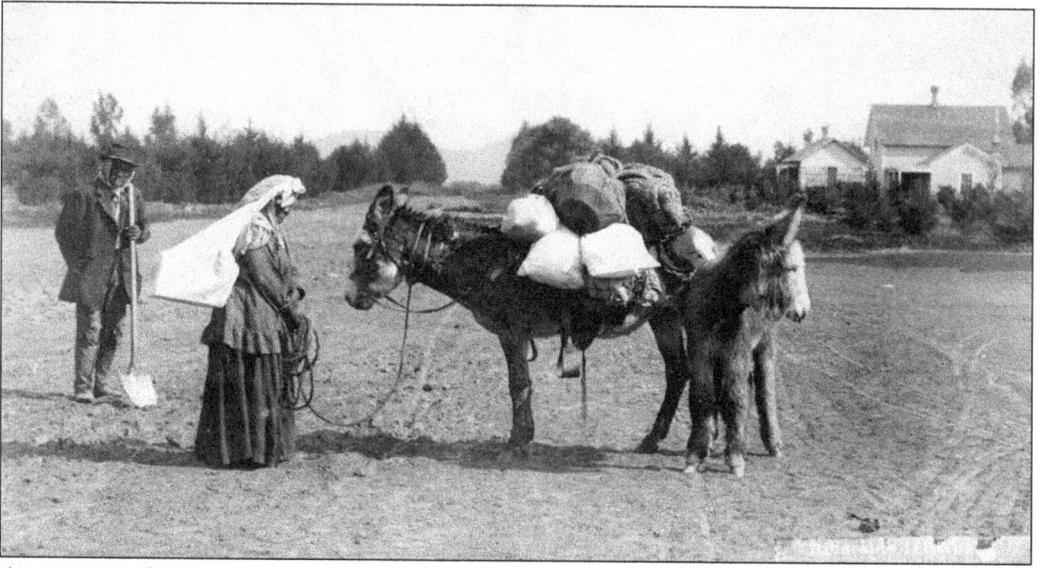

A migrant Indian worker couple with two pack mules underlines the hardships endured by many Native Americans in Riverside County and elsewhere during the early 20th century. Numerous Indians toiled for little pay in fields that possibly only one generation previous had been theirs. Displaced by non-native encroachment, these Indians had little choice. They could either leave to work in unfriendly cities or work for meager wages on large ranches and farms. (Courtesy of A. K. Smiley Public Library.)

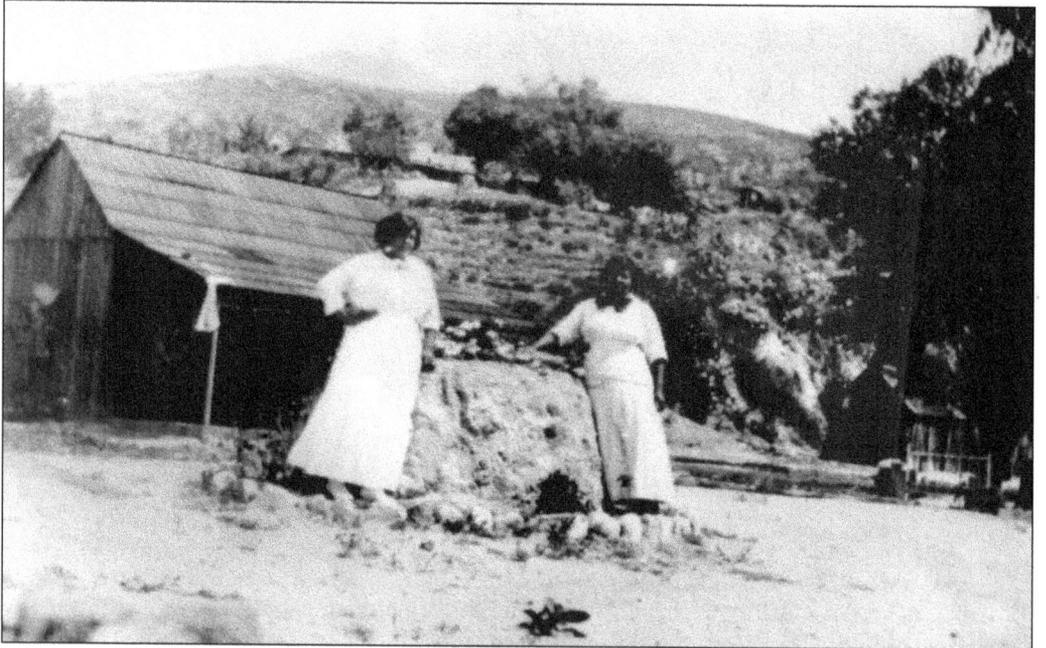

Two women stand in front of their wood-framed home, leaning against an *orno*, an oven made outside of a home from adobe and used to bake bread and other foods. Note the hole in front of the *orno* where bakers placed their bread using a long wooden spatula. Women generally did most of the cooking, although men helped prepare some foods before women cooked them. (Courtesy of Twenty-Nine Palms Band of Mission Indians.)

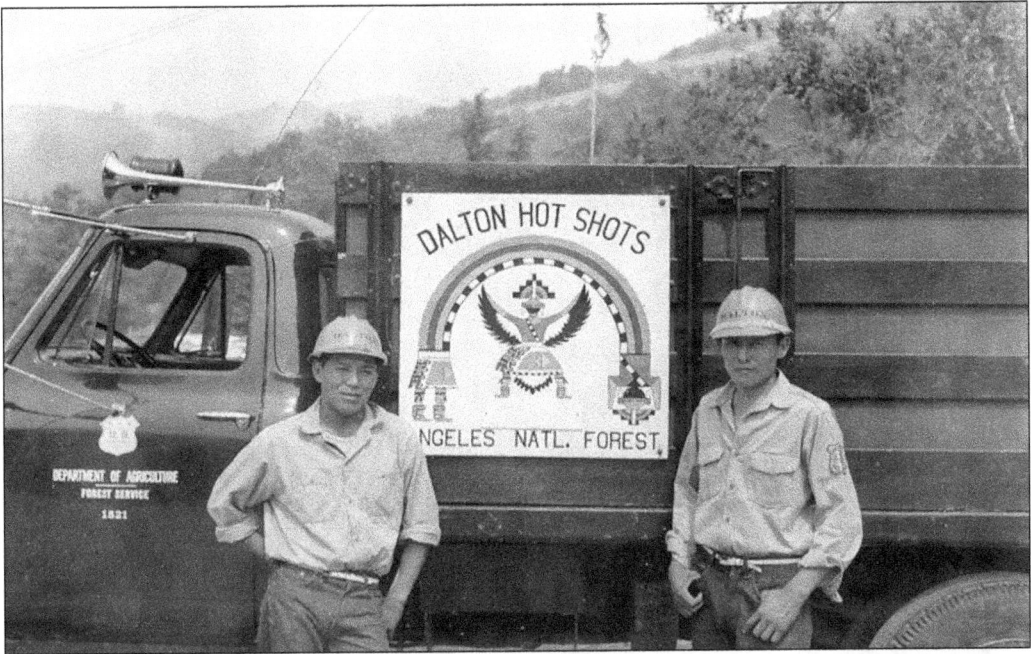

Two students, who trained to be Dalton Hot Shots, fight fires in the Los Angeles National Forest. These Hot Shots were from a team of Navajo Indian students the United States Forest Service dropped into "hot" fire areas to fight the flames on foot. Hot Shots still fight fires in Southern California. Some students also worked in the San Bernardino National Forest near the San Manuel, Morongo, and Soboba Reservations. (Courtesy of Sherman Indian School Museum.)

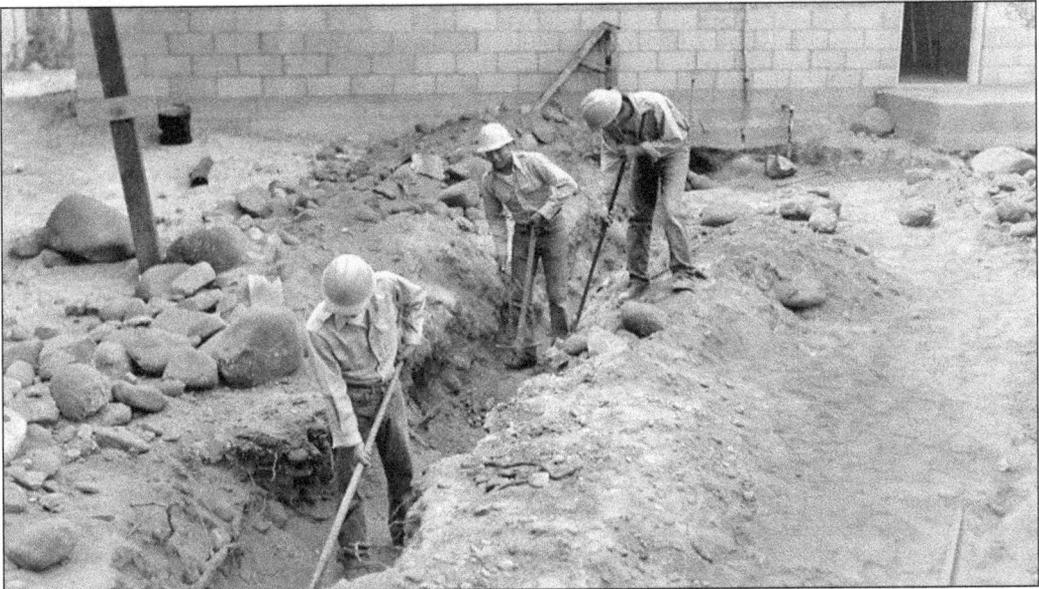

In the mid-20th century, federal school officials expanded Indian school curriculum to include firefighting. Here three young men dig a trench. Specially trained Indian firefighters, or "hot shots," routinely assisted local and regional firefighters in wildfires of all sizes. The long, dry, hot summers in Riverside County created fertile ground for them to learn firefighting. (Courtesy of Sherman Indian School Museum.)

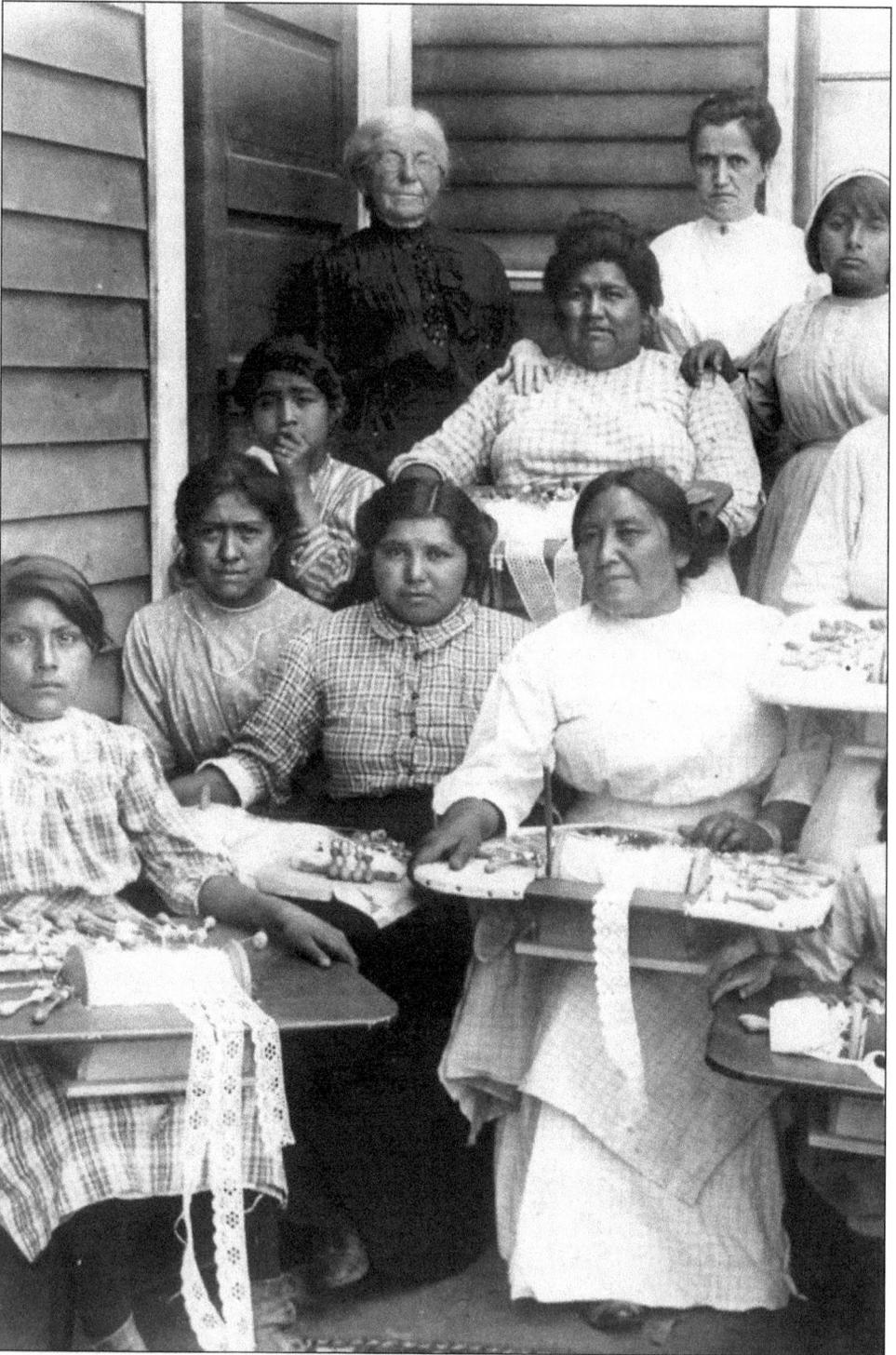

In the early 20th century, several Indian women in Riverside County and beyond took up the art of lace making. Lace making by Native Americans, a favorite art form, became well recognized throughout the world. (Courtesy of Riverside Metropolitan Museum.)

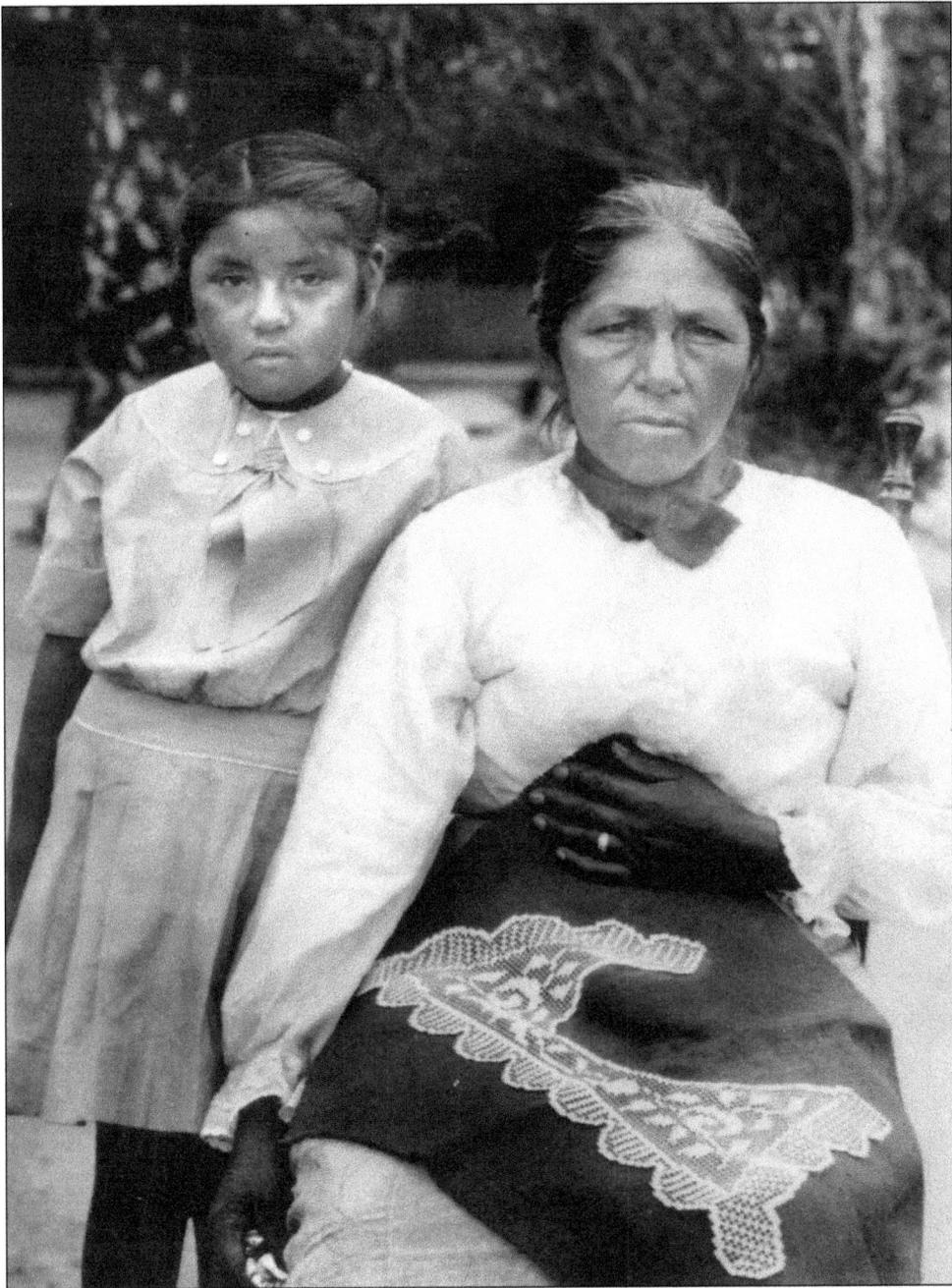

Carlota Lubo, the grandmother of Charlene Ryan (Director of Cultural Programs) of the Soboba Indian Reservation, participated in a project to make outstanding examples of lace. The lace makers from Riverside County, California, became famous the world over. Here Lubo sits for the photograph with her daughter, displaying a sternness or apprehension. Both the mother and her daughter are dressed in fine clothing, offering the viewer a glimpse of beautiful lace work that emerged among Native Americans of Southern California in the 19th and 20th centuries. In addition to lace making, Lubo was a famous basket maker and tribal leader. (Courtesy of Twenty-Nine Palms Band of Mission Indians.)

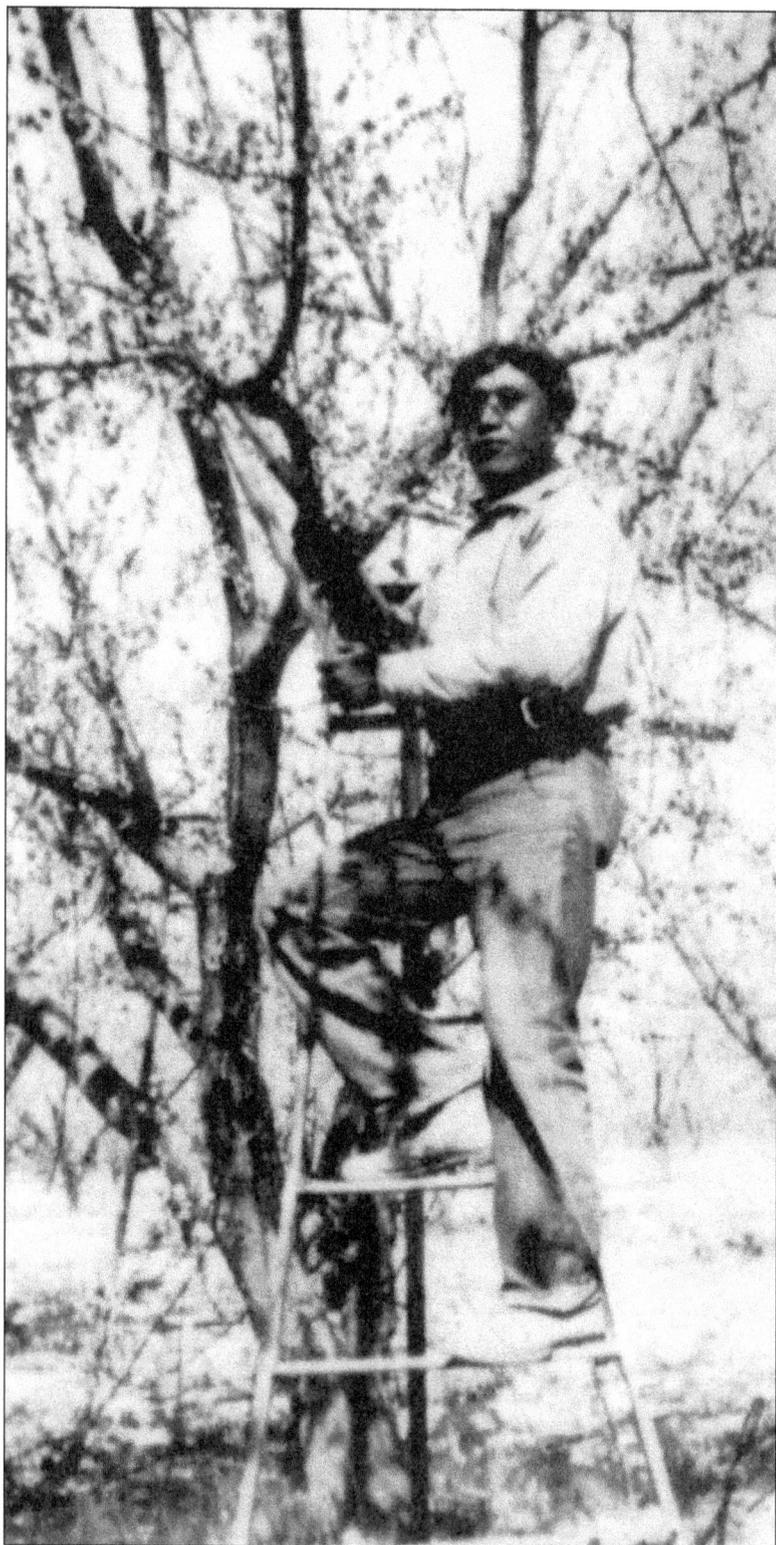

Vincent Morongo sometimes lived on the Morongo Indian Reservation but he often worked on the San Manuel Reservation picking apricots. Here he is tending the traditional orchard. (Courtesy of Pauline Ormego Murillo.)

Four

NATIVE AMERICAN EDUCATION

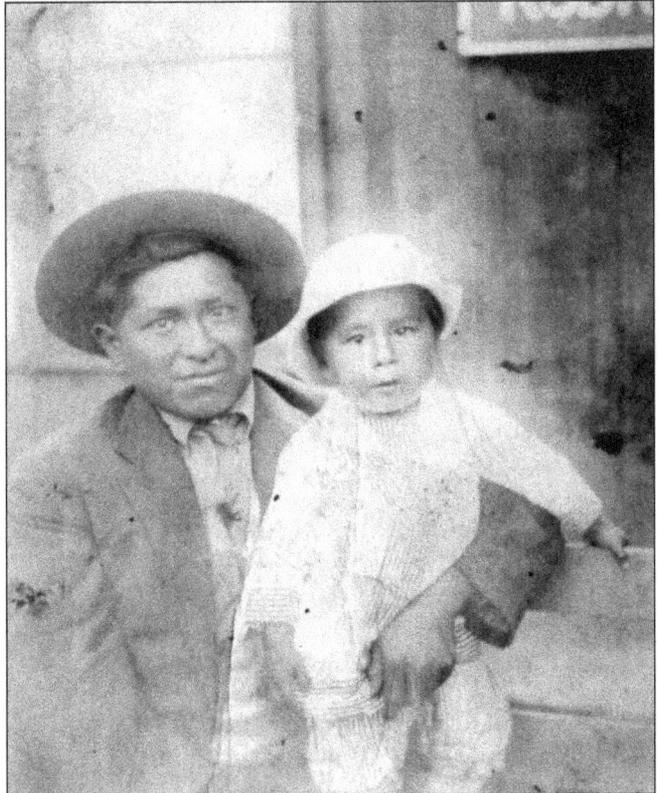

Before the arrival of newcomers, Native Americans used the oral tradition to teach their children. Henry Morongo believed in the old way of Indian education, teaching his son Daniel many things about history and culture. (Courtesy of Pauline Ormego Murillo.)

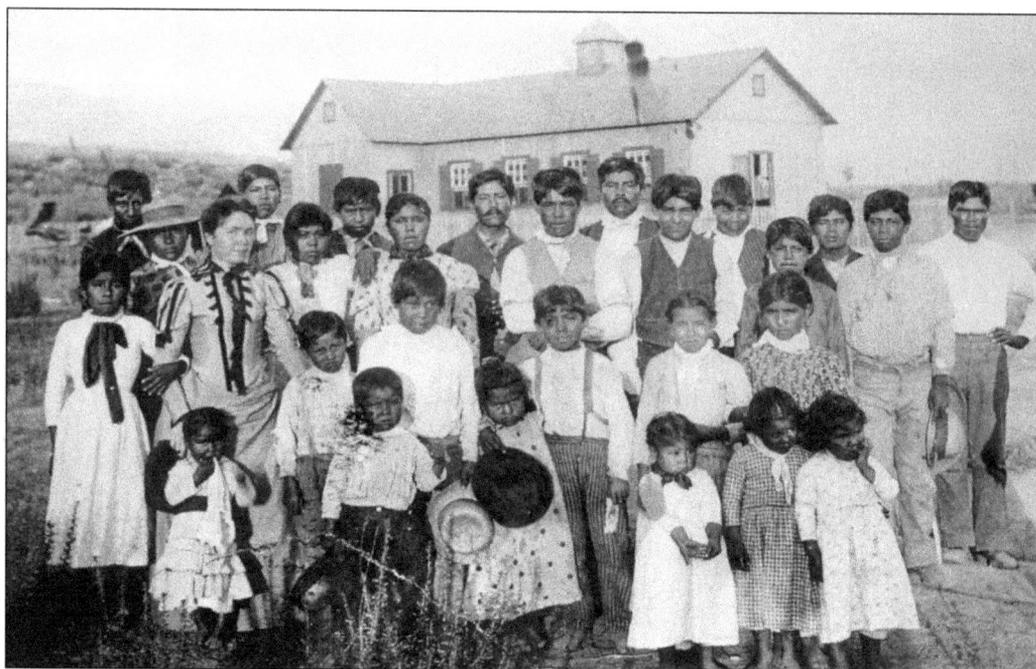

A class of native students poses at the Soboba Indian School. Note the hair of every student is short and pulled back. Furthermore, all the students wear long sleeves even though summer temperatures can easily exceed a 100 degrees Fahrenheit for weeks at a time. The government used schools as institutions of assimilation on and off the reservation. (Courtesy of A. K. Smiley Public Library.)

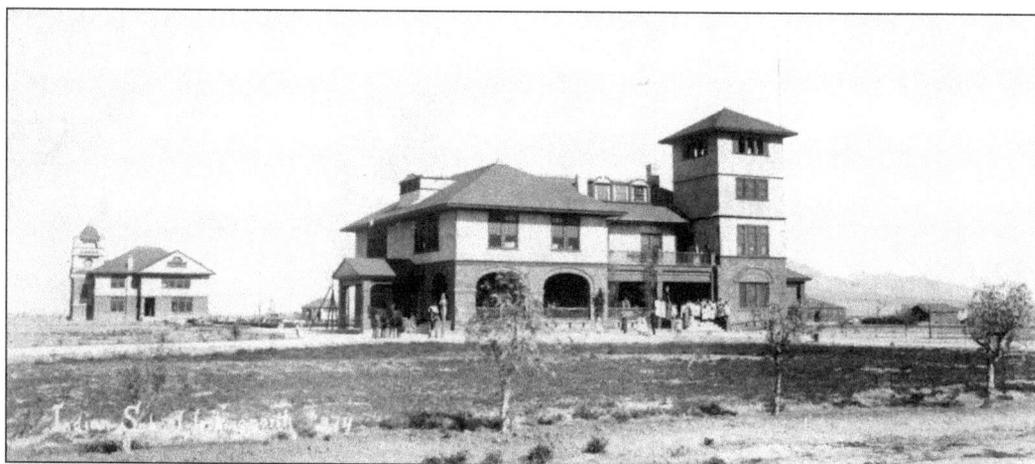

This photograph offers a distant shot of two buildings on the campus of Perris Indian School. The school superintendent used the lands around the school as a farm and ranch that provided food and educational experiences for children. Students worked the farm, dairy, and ranch at the school, raising many fruits and vegetables as well as beef, pork, and mutton. Perris also had a dairy from which children received milk, butter, and cheese. (Courtesy of Riverside Metropolitan Museum.)

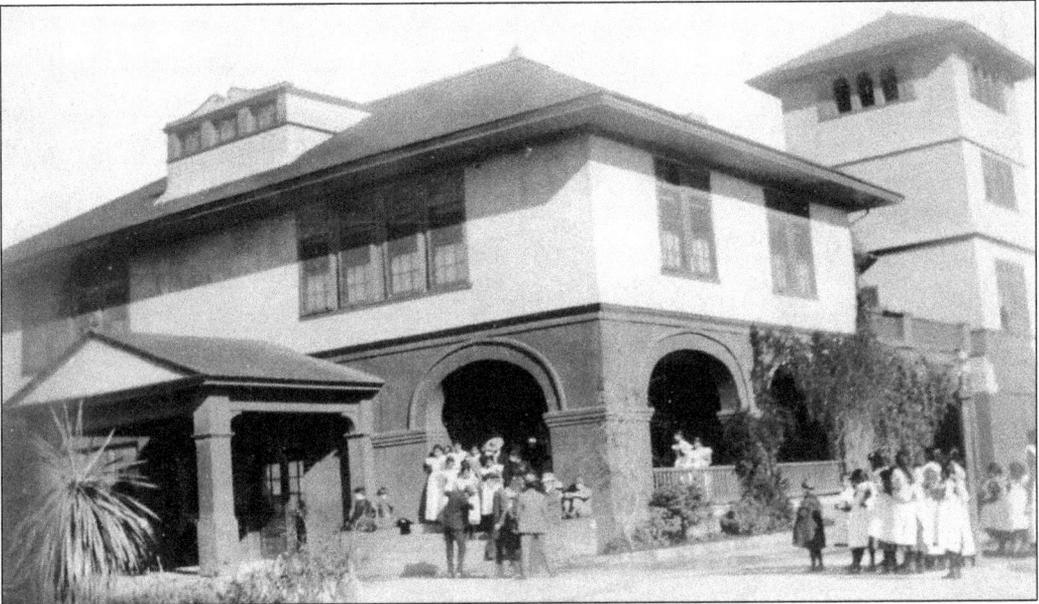

This is a close-up photograph of the main building on the campus of Perris Indian School. The teachers held classes in reading, writing, and arithmetic; they also emphasized vocational education. Note that the girls and boys wear school uniforms. Teachers trained these children to march, salute, and keep quiet, behavior similar to that found in military academics of the era. (Courtesy of Riverside Metropolitan Museum.)

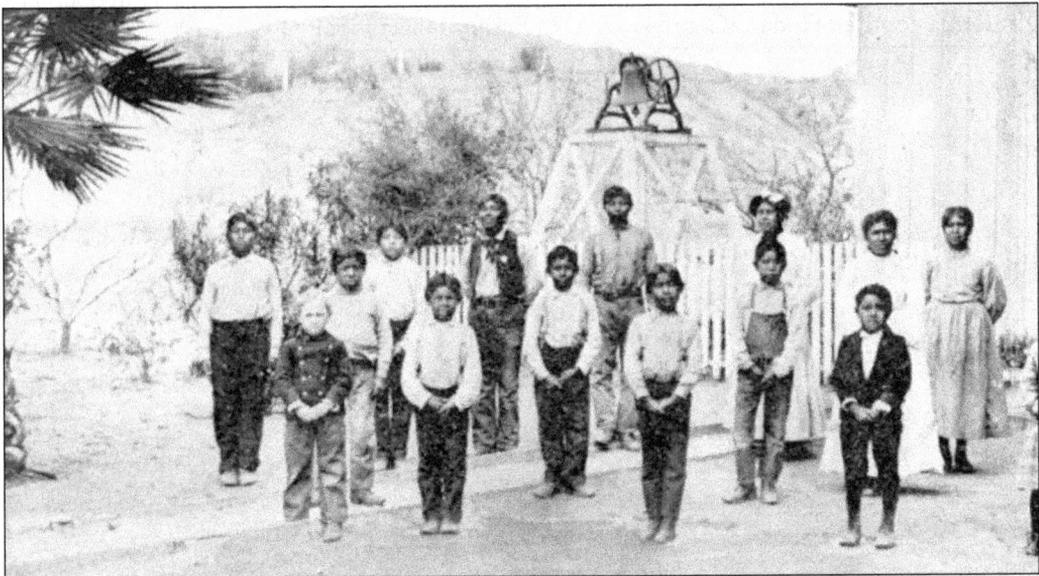

A photograph of Indian schoolchildren entitled, "Soboba Scholars," was taken on the Soboba Indian Reservation in San Jacinto, California. Note that despite the obviously arid desert climate, the stereotypical and impractical themes of assimilation persist. For example, regardless of the noticeable lack of trees, the schoolhouse is constructed of wooden planks. In addition, the wooden white-picket fence is not only impossible to duplicate without importing wood but proves inferior to native brush fencing in protecting against rodents, wind, or sand. (Courtesy of A. K. Smiley Public Library.)

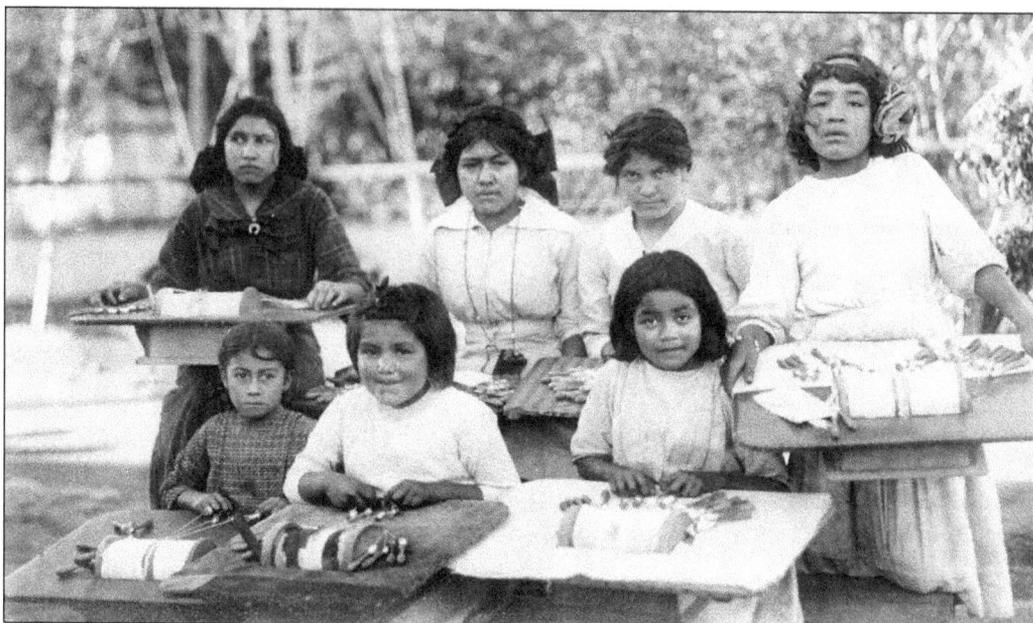

A group of Indian schoolgirls learns to work with cotton textiles. Unfortunately, most Native American schools did not place any value on traditional weaving of baskets. Instead, they taught children rudimentary skills of cotton weaving, which soon would be replaced by automated machines. Fortunately, native weaving, especially basketry, persisted in the home as mothers continued the legacy of passing the art form down to their daughters. Indian basketry in Southern California continues today. (Courtesy of A. K. Smiley Public Library.)

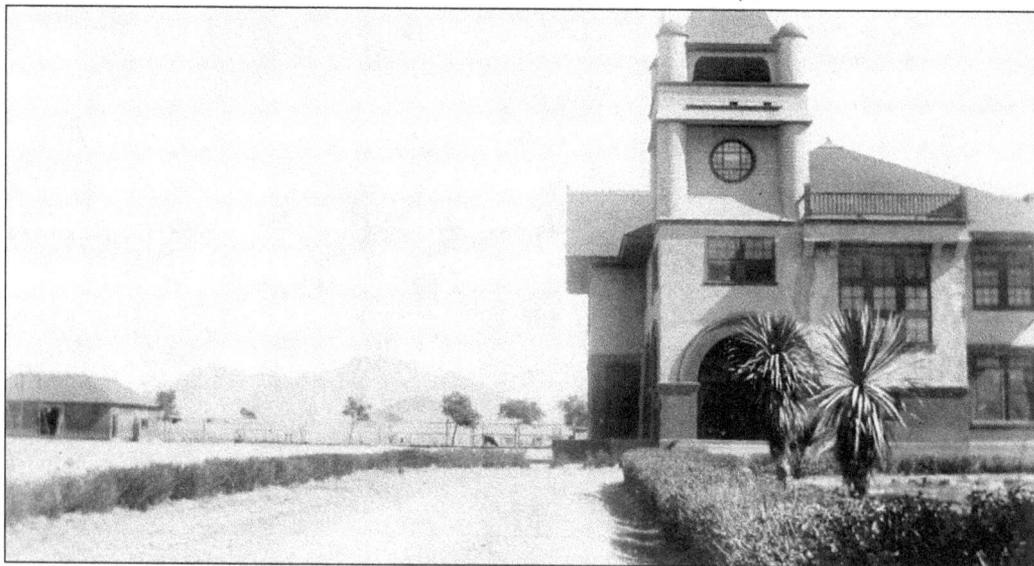

The Office of Indian Affairs established the Perris Indian School south of Riverside, California. The federal government set up the boarding school off the reservation where it could remove children from their families, homes, and communities in an attempt to assimilate Native American children from Riverside County and beyond. In 1902, the federal government moved many pupils from Perris to the newly established Sherman Institute in Riverside. (Courtesy of Riverside Metropolitan Museum.)

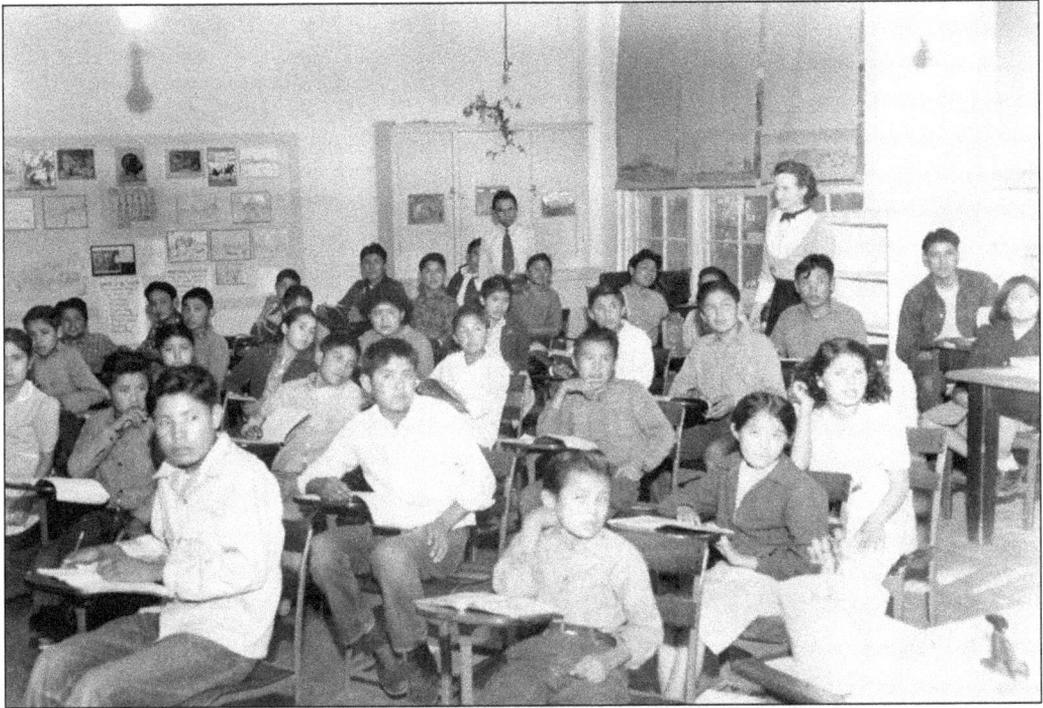

This photograph depicts a class of male and female Indian schoolchildren, of all ages, receiving instructions from a non-native female teacher. Sherman Institute hired only a few Native American teachers, including the mother of Toni Largo, the Apache grandmother of Lori Siquoc. (Courtesy of Sherman Indian School Museum.)

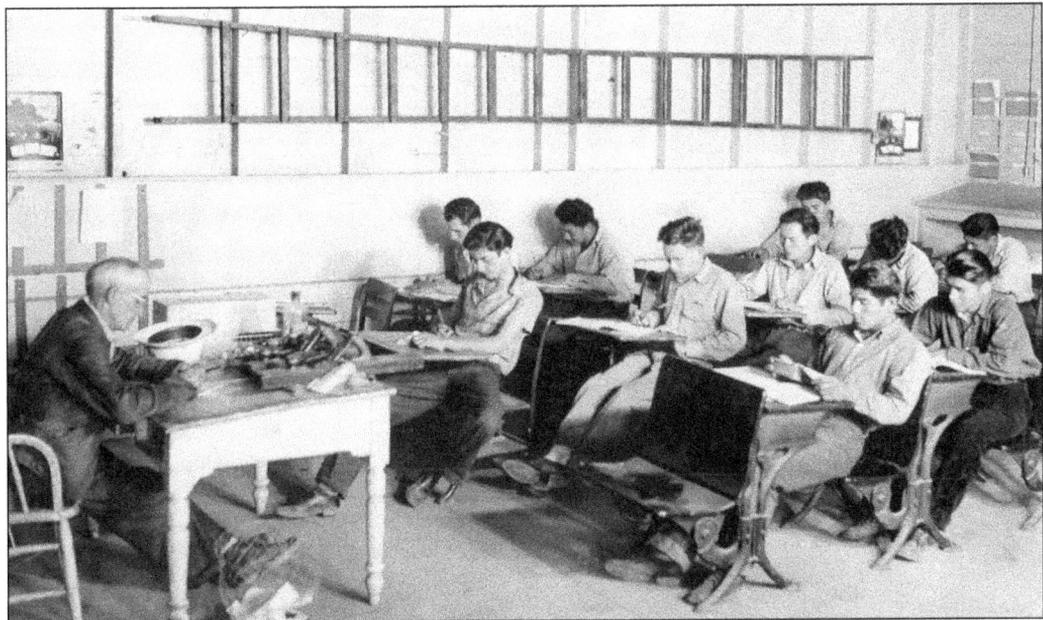

These are Indian boys in a farm and house carpentry class at Sherman Institute. The boys learned basic construction techniques so that they could work in the housing industry upon completion of their formal education. (Courtesy of Sherman Indian School Museum.)

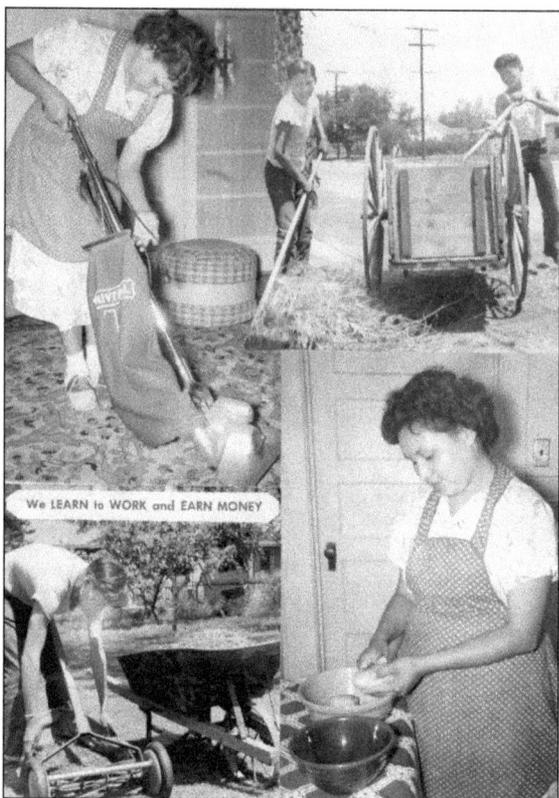

"We LEARN to WORK and EARN MONEY," reads the caption for this photographic montage promoting the benefits of the Sherman Institute "outing program." Boarding school administrators created a work-study program called "outing" that placed students in businesses, on farms, or in homes for half of every day or for extended periods of time. Native American schools primarily trained students in the industrial arts and domestic sciences. (Courtesy of Sherman Institute Museum.)

A class of Native American boys and girls perfect their typing skills at Sherman Institute. Note that the native pupils are learning to type handwritten notes, not their own thoughts. (Courtesy of Sherman Indian School Museum.)

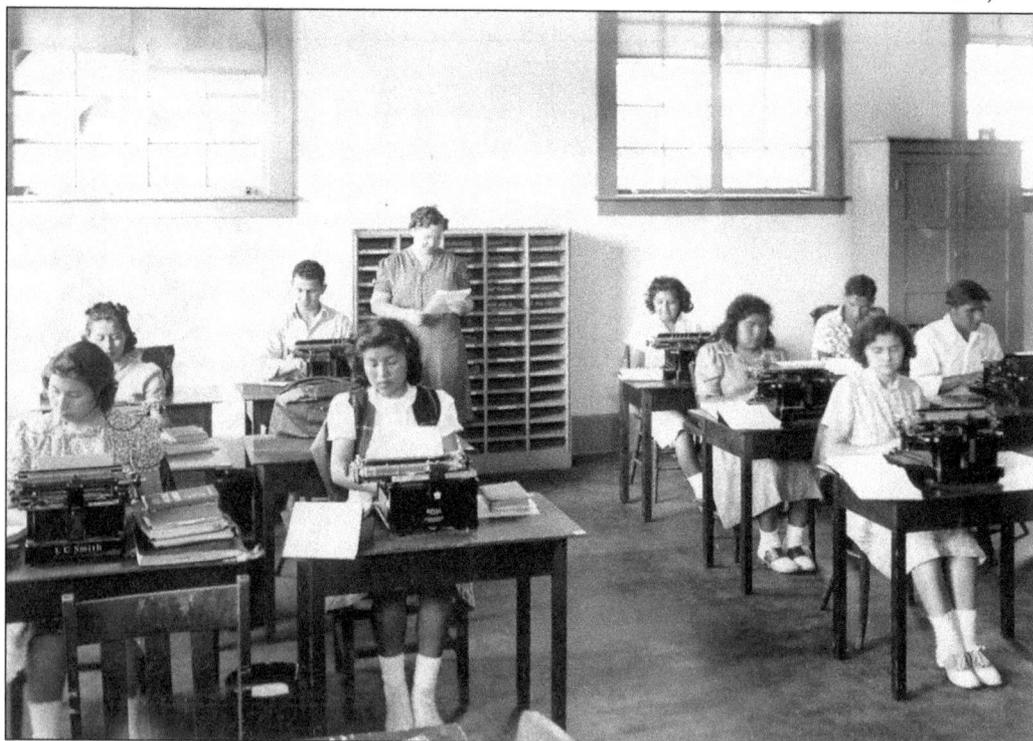

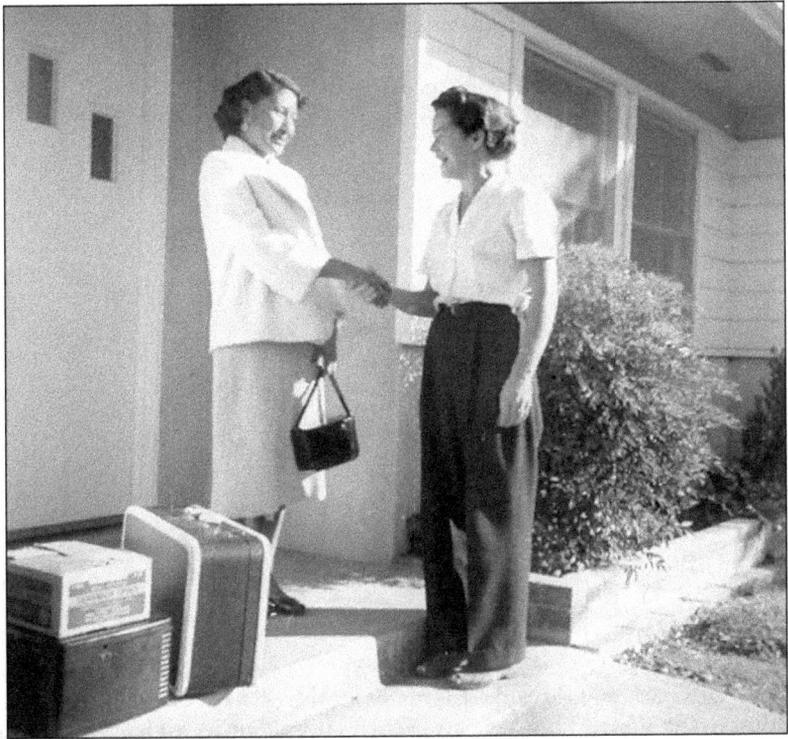

Elena Ariselno, a Sherman Institute graduate, thanks Mrs. Mount for allowing her to work as Mrs. Mount's maid. Many students enjoyed working for non-Indians, while others resented their position. (Courtesy of Sherman Indian School Museum.)

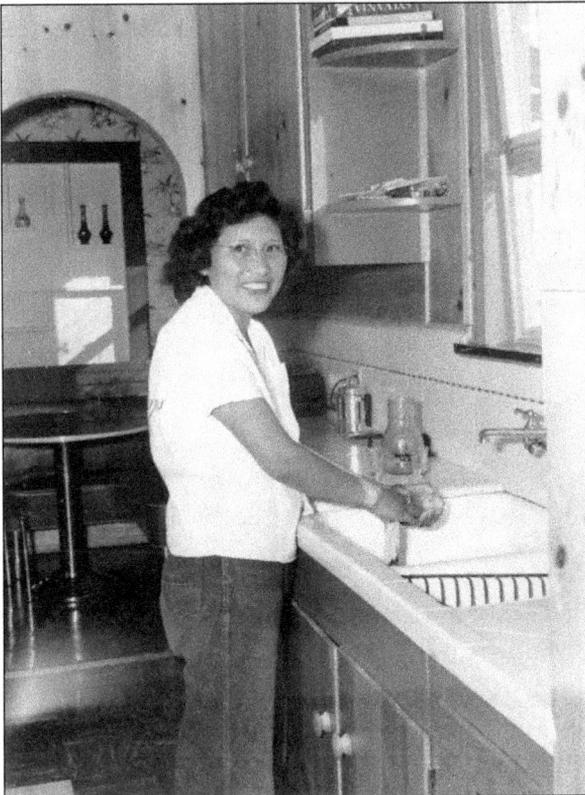

A woman in her fifth year of training at Sherman Institute washes glasses at a sink in a non-native house. Native American boarding schools sponsored off-campus employment for students as part of the school's curriculum. (Courtesy of Sherman Indian School Museum.)

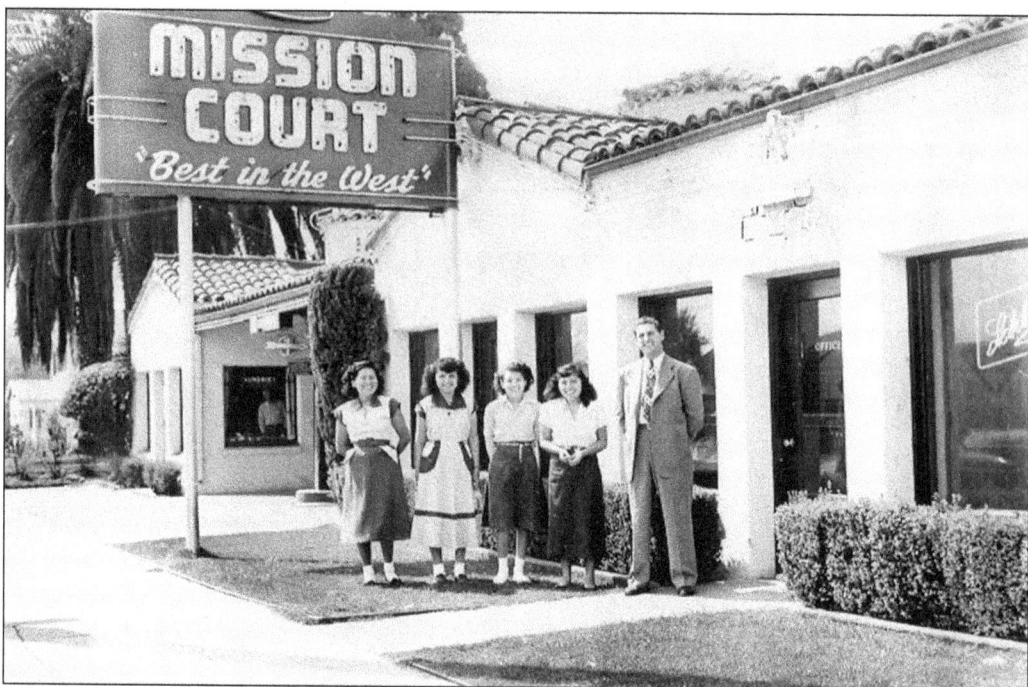

Four native schoolgirls worked as maids for the Mission Court Inn, which proclaimed itself as the "Best in the West." This was part of their curriculum as students at Sherman Institute. (Courtesy of Sherman Indian School Museum.)

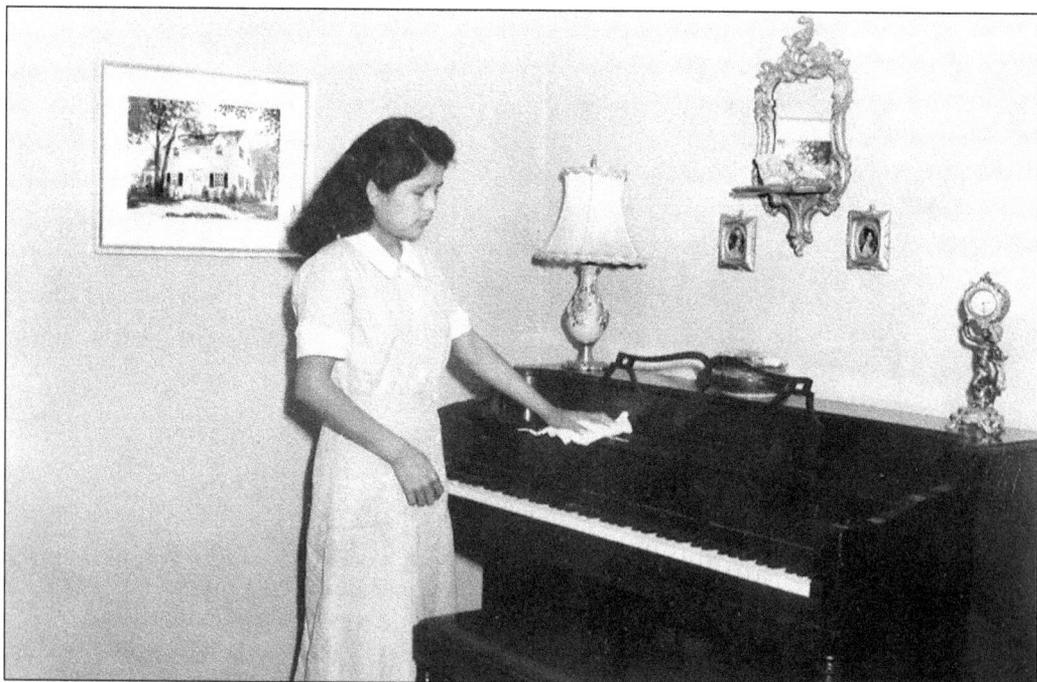

This Native American girl is in her fifth year of training at Sherman Institute. She is dusting a piano in a non-native house decorated with western European décor as part of her "outing program" to train her to be a maid. (Courtesy of Sherman Indian School Museum.)

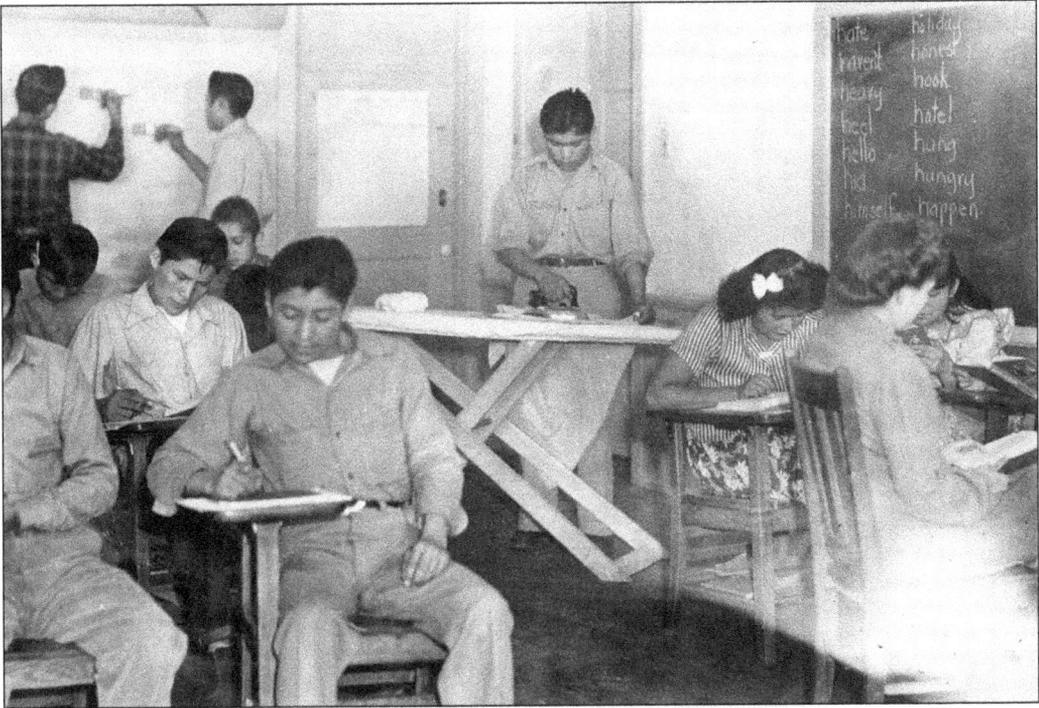

Indian school adolescents learn in a multipurpose room, and this posed photograph depicts the many skills taught to students in Riverside County, including, painting, ironing, penmanship, and reading. (Courtesy of Sherman Indian School Museum.)

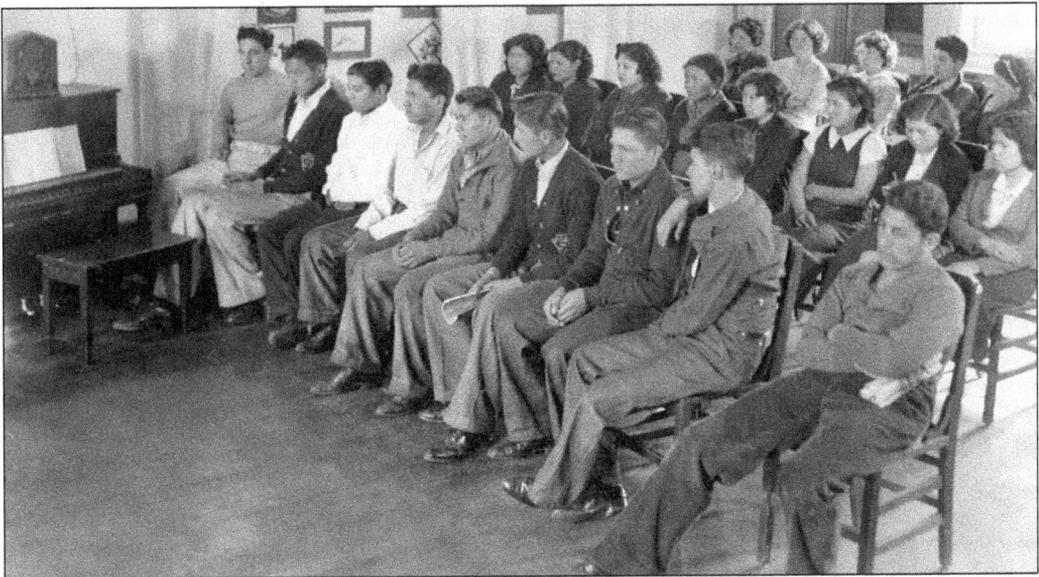

Indian high school students wait for the commencement of their choir class. Generally these classes instructed students in singing patriotic and Christian songs. It took decades before the school administration allowed Native Americans of Riverside County to sing their Bird Songs at Indian schools. (Courtesy of Sherman Indian School Museum.)

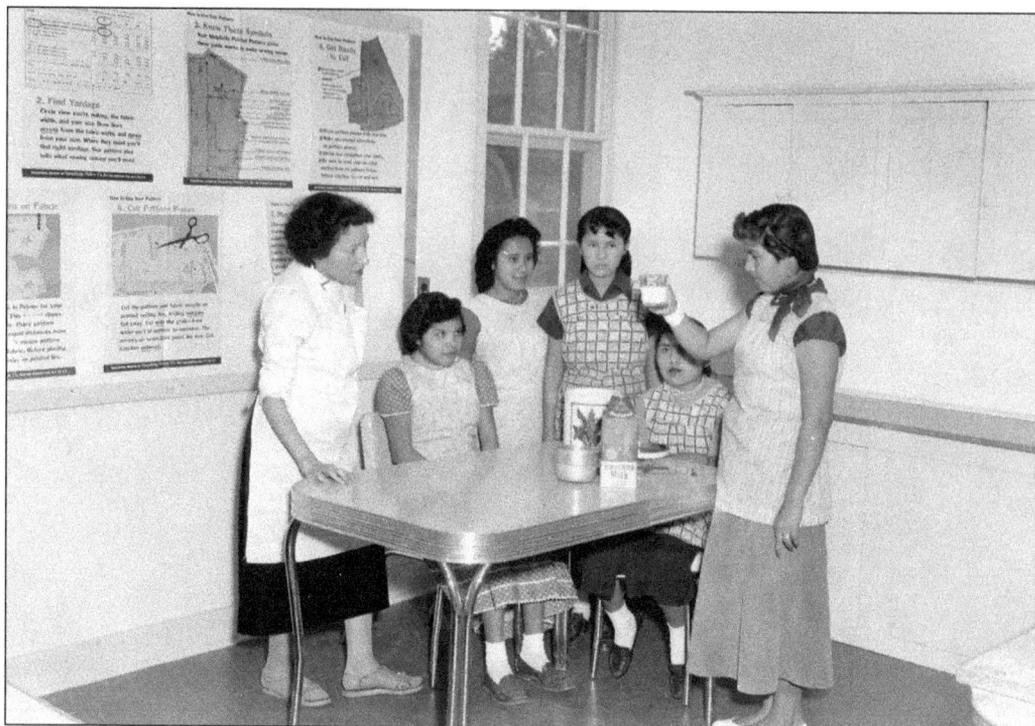

Off-reservation boarding schools emphasized domestic science (home economics) classes for girls so they could become housewives, cooks, and maids. Here the girls are learning about measurements. (Courtesy of Sherman Indian School Museum.)

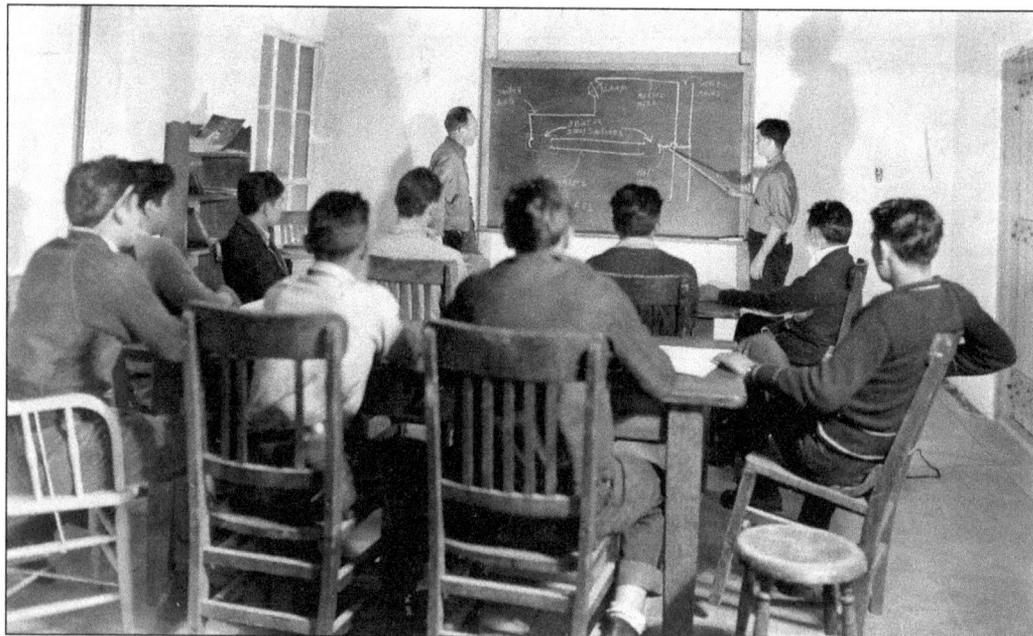

This is a Sherman Institute technical class for electrical engineering. Industrial art teachers taught Indian students about basic electricity in hopes that they might become electricians. (Courtesy of Sherman Indian School Museum.)

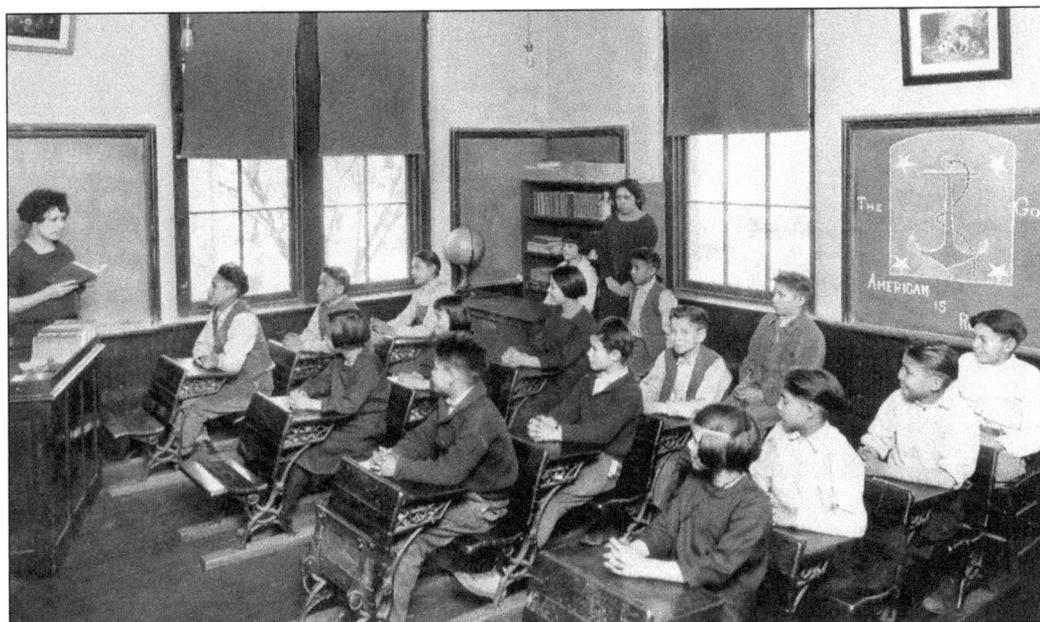

The caption below this photograph reads, "These young Indians are as anxious as the white child. And they have a remarkably keen native ability." Federal education officers used photographs like this as propaganda to promote the benefits of Indian schools within non-native society. In addition, native schoolchildren were routinely paraded out for non-native dignitaries and wealthy visitors. (Courtesy of Sherman Indian School Museum.)

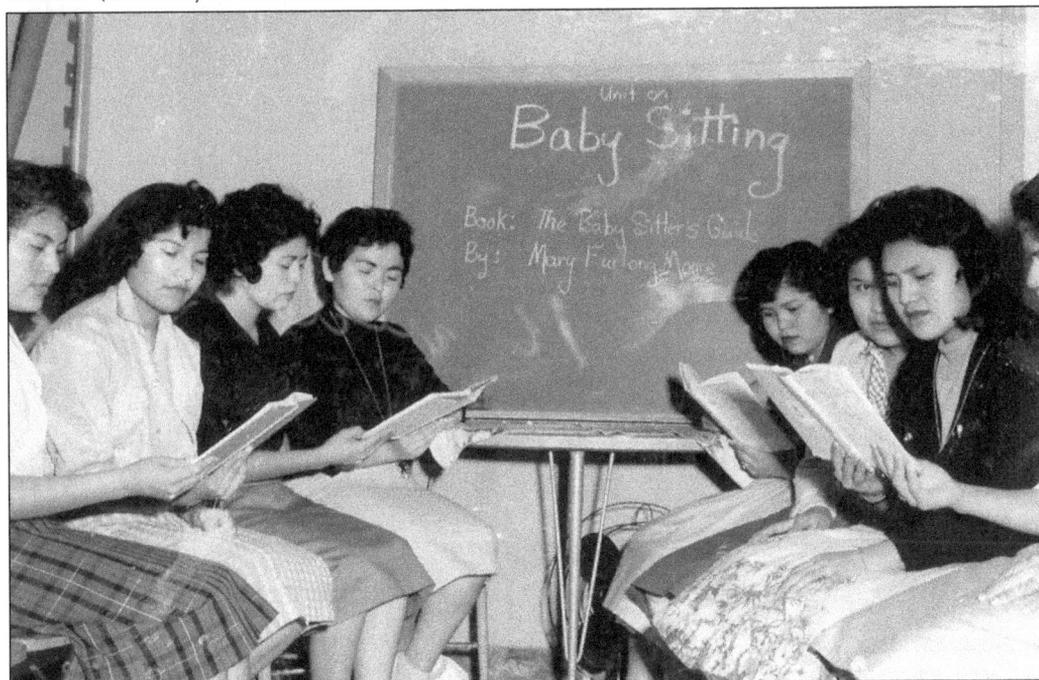

Native American schoolgirls read *The Baby Sitter's Guide* in a class designed to instruct young women on how to watch children. School curriculum for Indian girls throughout Riverside County emphasized domestic science. (Courtesy of Sherman Indian School Museum.)

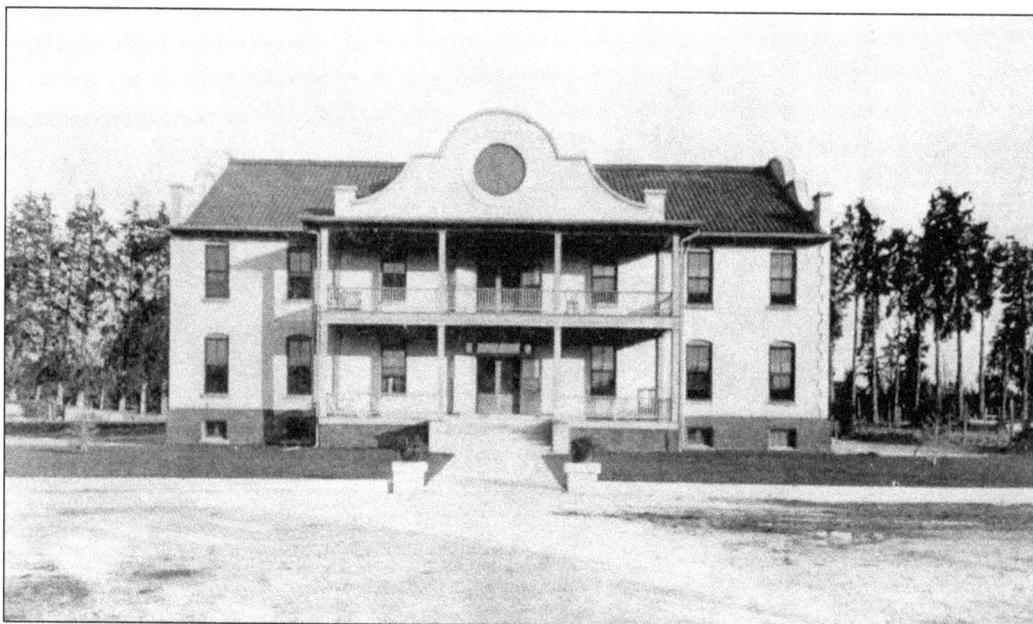

Illness and death visited Sherman Institute, so the administration built this hospital to care for the students. Francis de los Reyes of San Manuel escaped the school from this hospital and walked back to her home on the San Manuel Reservation. (Courtesy of Sherman Indian School Museum.)

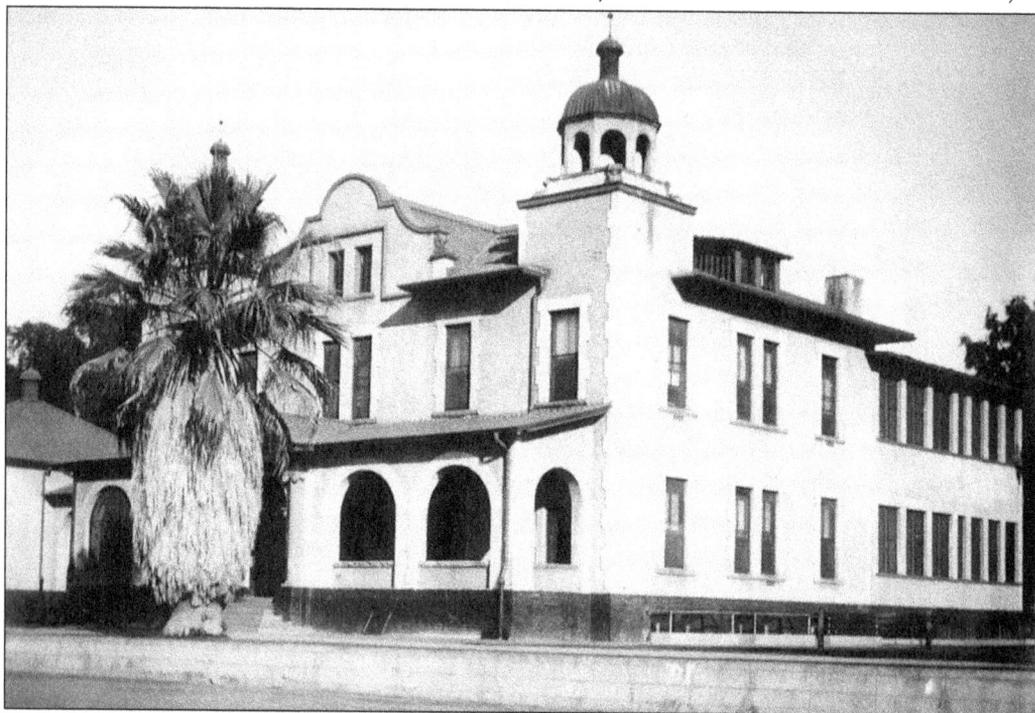

Pictured here is the boy's dormitory, building six, at Sherman Institute. Superintendent Harwood Hall designed Sherman Institute in the neo-Mission style that was popular at the time and in keeping with Frank Miller's Mission Inn, which was built the same year (1901–1902) as Sherman Institute. (Courtesy of Sherman Indian School Museum.)

A non-native teacher reads to Indian schoolboys at Sherman Institute as part of the "Navajo Program." Note the picture of George Washington on the wall. (Courtesy of Sherman Indian School Museum.)

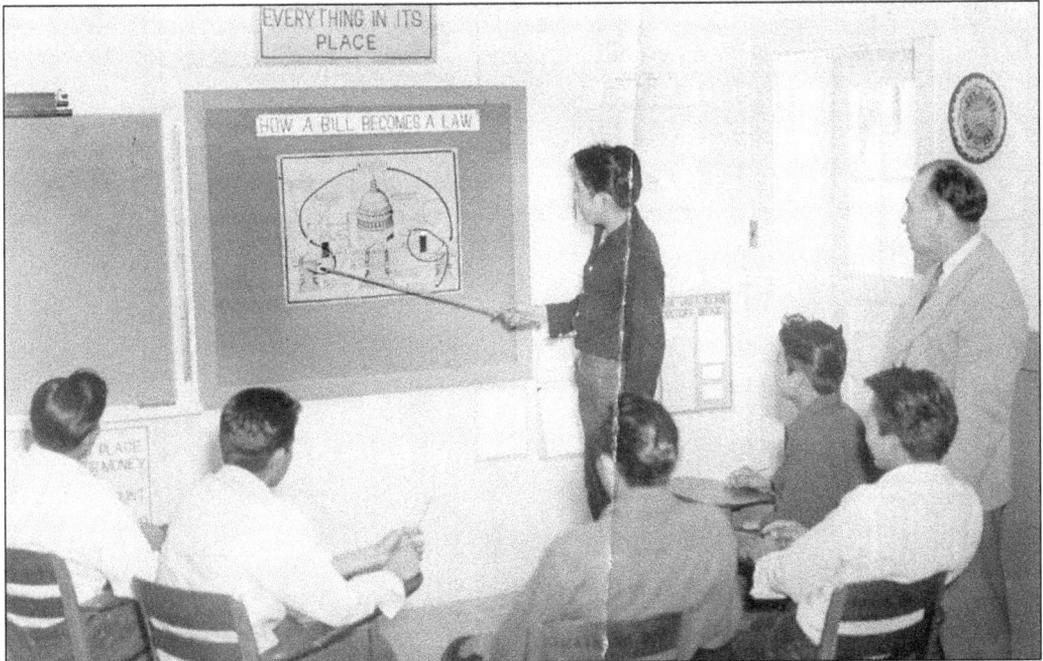

Off-reservation boarding schools taught Native American children of Riverside County to be patriotic. Teachers taught students about the political system of the United Sates in government class at Sherman Institute. A sign hangs above the bulletin board stating, "EVERYTHING IN ITS PLACE," but the school also integrated native imagery like the Indian basket hanging on the wall. (Courtesy of Sherman Indian School Museum.)

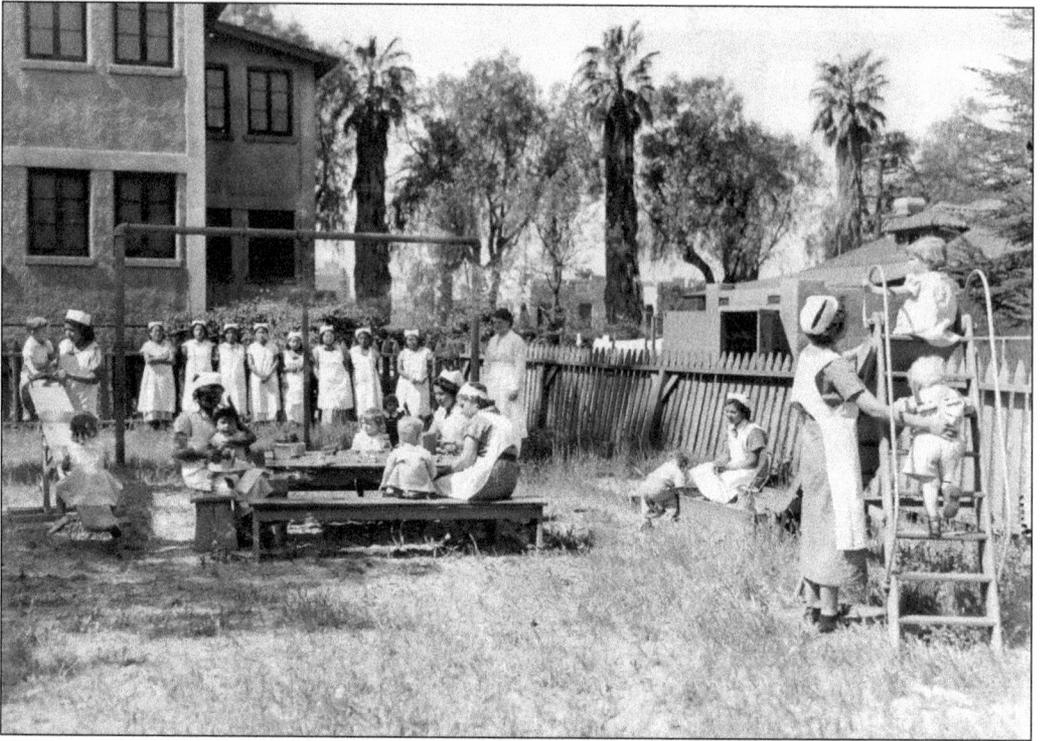

Indian women learn how to babysit non-native children. Sherman Institute created a nursery on the school campus, and girls who enrolled in domestic science classes cared for the children as part of their class work. (Courtesy of Sherman Indian School Museum.)

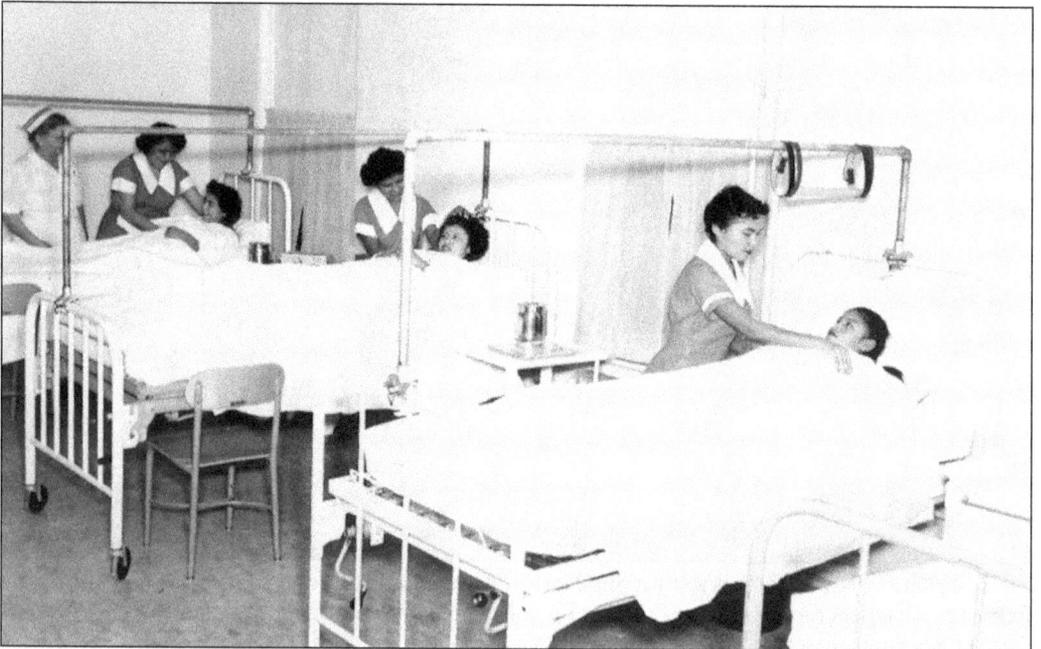

At Sherman Institute, Native American students trained to become nurses and worked in the hospital on campus and at health facilities off campus. (Courtesy of Sherman Indian School Museum.)

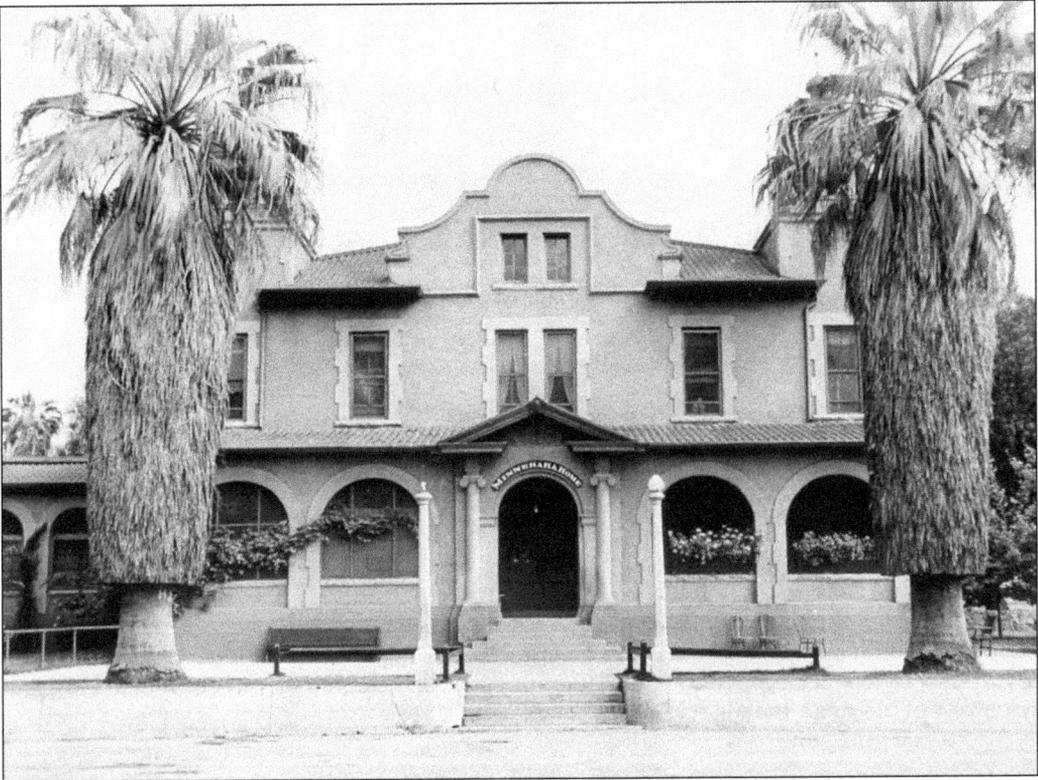

This is the Minnehaha dorm for girls at Sherman Institute. Many Native Americans from Riverside County lived in this complex, including contemporary ones. (Courtesy of Sherman Indian School Museum.)

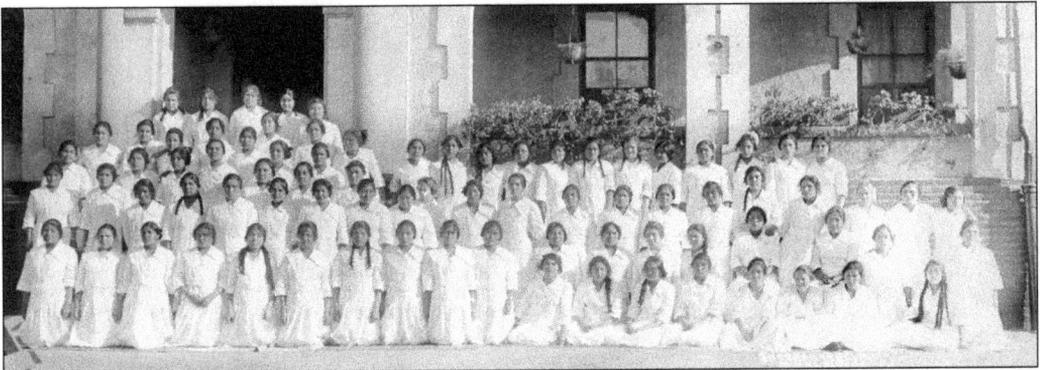

In the early 20th century, Dr. Mary Israel taught girls at Sherman Institute to be nurses, and Indian girls returned home to their reservations in Riverside County to be nurses. This is a large class photograph of nursing school students. (Courtesy of Sherman Indian School Museum.)

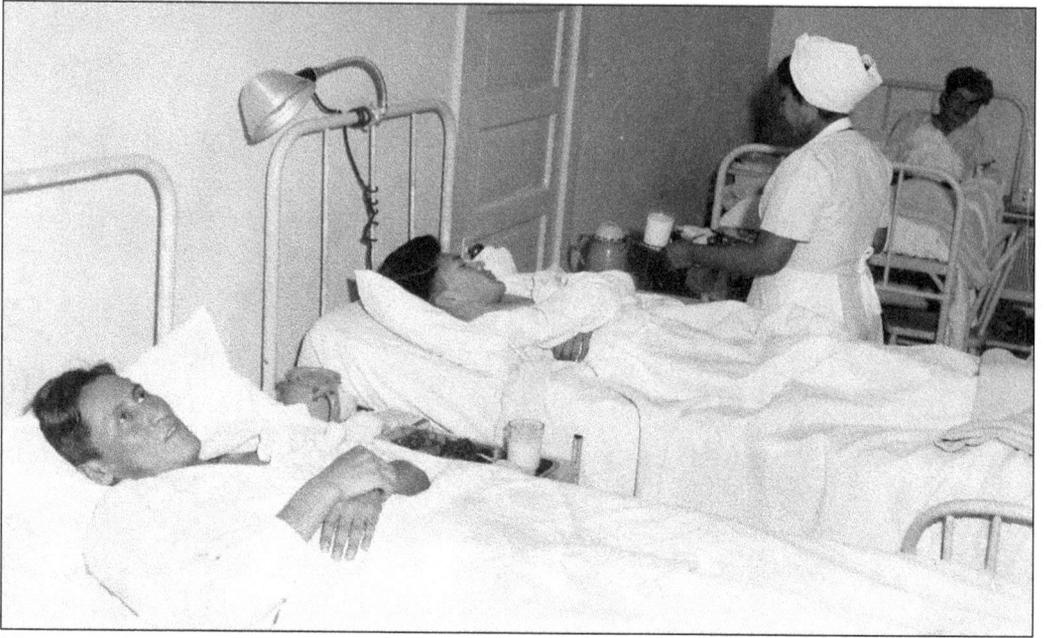

Here an Indian nurse takes care of other Indian students at Sherman Institute. Students trained at the school hospital but worked at other locations as well, including the Soboba Indian Hospital. (Courtesy of Sherman Indian School Museum.)

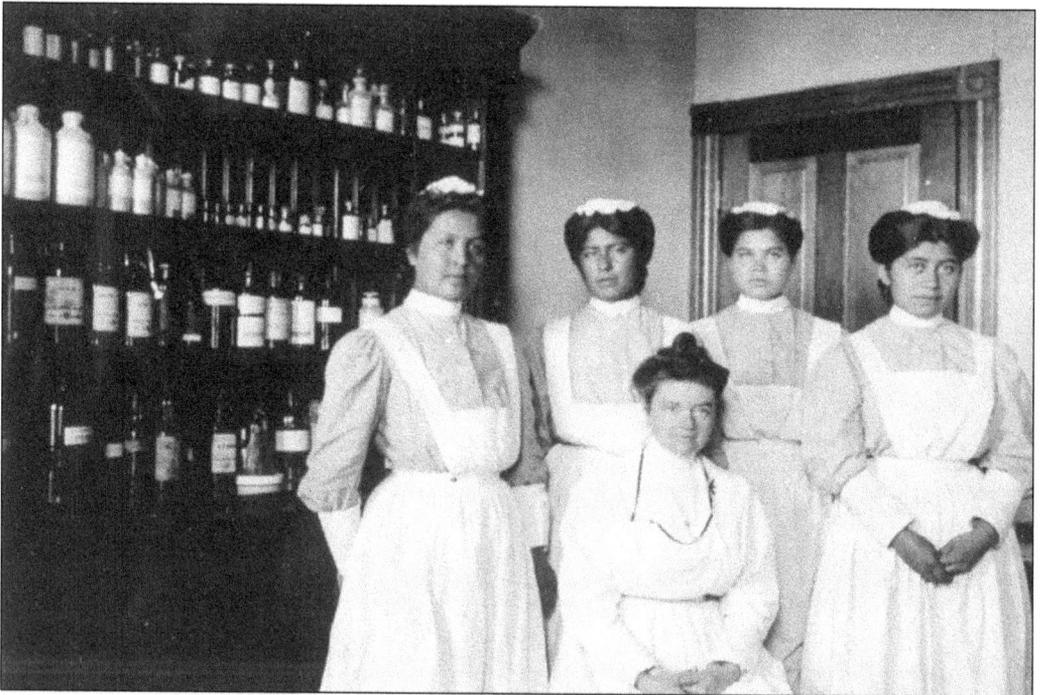

Four native nurse trainees stand behind their non-native instructor at Sherman Institute. Many nurses returned to their homes on reservations in Riverside County to serve their people. (Courtesy of Sherman Indian School Museum.)

By the early 20th century, Indians from Riverside County aspired to join the football team at Sherman Institute. This is one of many photographs of a football team at the school. Note the new padding sewn into their uniforms for added protection in full-contact games and practices. (Courtesy of Sherman Indian School Museum.)

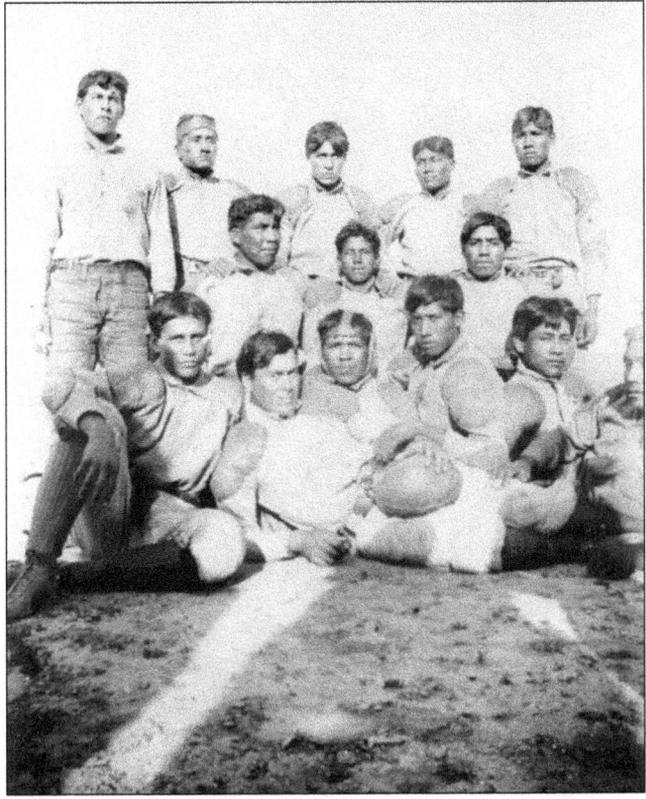

In the late 19th century, Capt. Richard Henry Pratt established the first off-reservation American Indian boarding school in Carlisle, Pennsylvania, and created a football team to popularize it. In 1908, the Sherman Institute team included Native Americans from Riverside County. (Courtesy of Sherman Indian School Museum.)

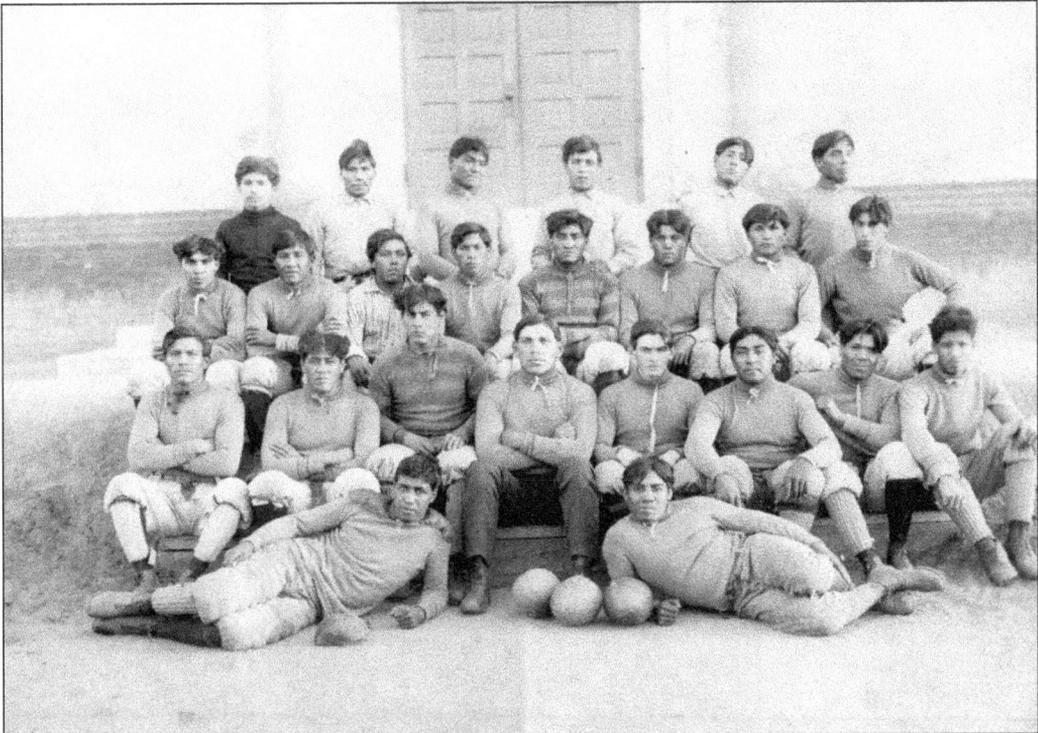

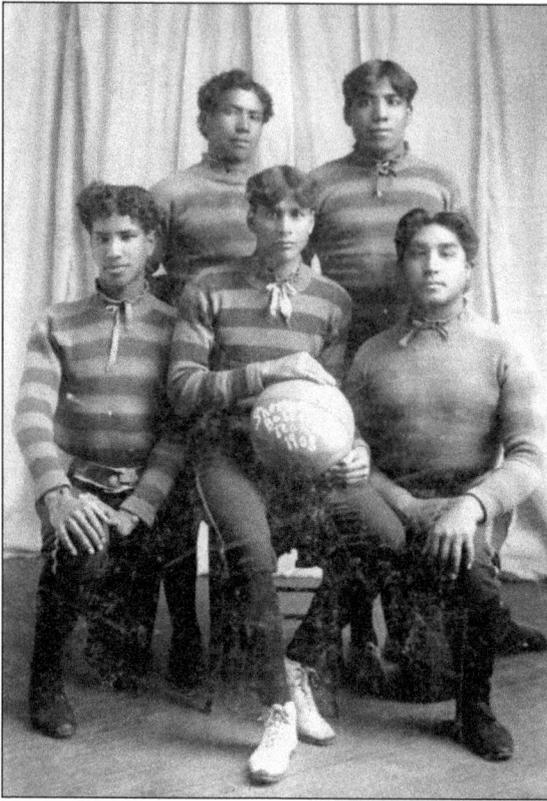

Sherman Institute supported boys and girls sports. In 1903, boy's basketball team members included, from left to right, George Magee, Alex Tortez, Alex Magee, John Pugh, and John Ward. (Courtesy of Sherman Indian School Museum.)

In 1904, Perris Indian School won the girl's championship in basketball. Note the uniforms that closely resemble formal dresses, not traditional basketball uniforms. (Courtesy of Sherman Indian School Museum.)

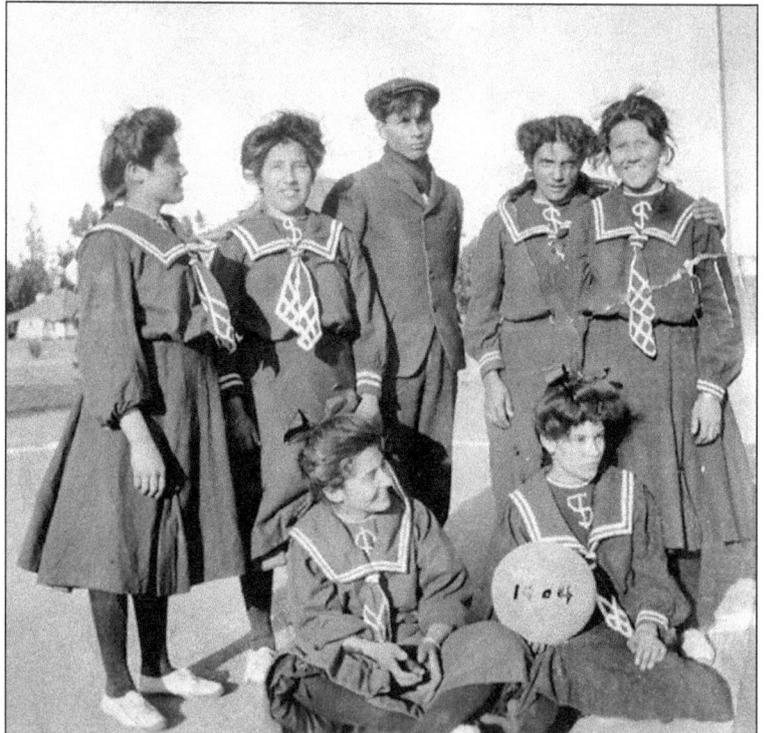

All of the federal boarding schools emphasized physical education for boys and girls. This is the floor plan for the dressing rooms connected to the swimming pool at Sherman Institute. (Courtesy of Sherman Indian School Museum.)

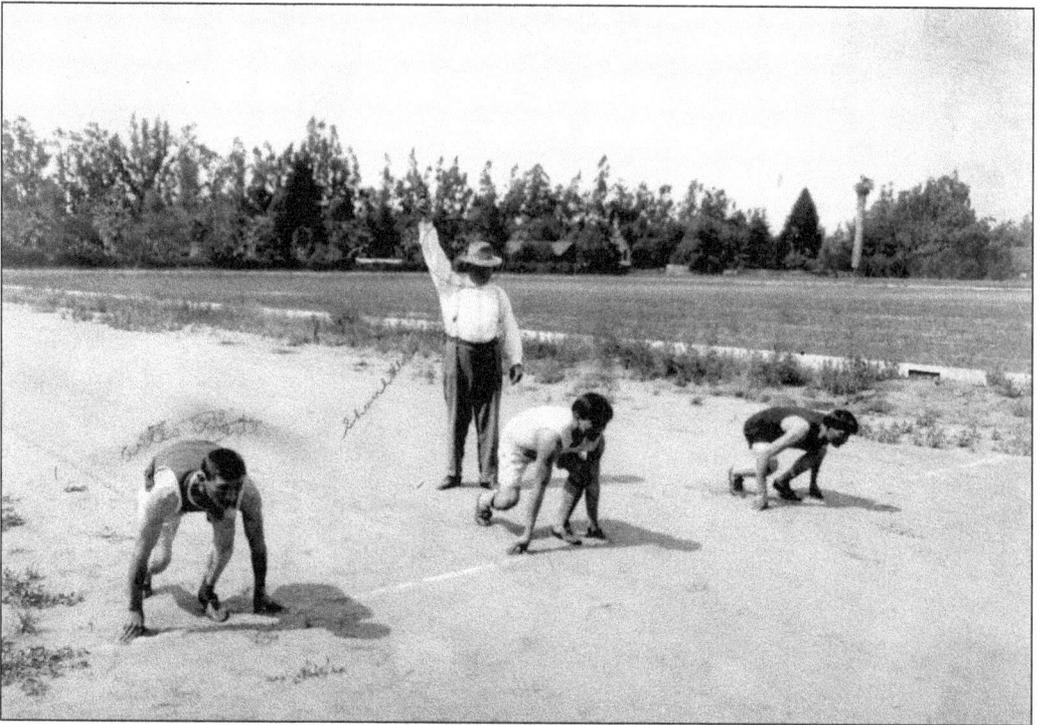

All of the off-reservation Native American boarding schools of the United States sponsored athletic teams, which popularized the schools and supported assimilation. This photograph depicts the boys track team at Sherman Institute. (Courtesy of Sherman Indian School Museum.)

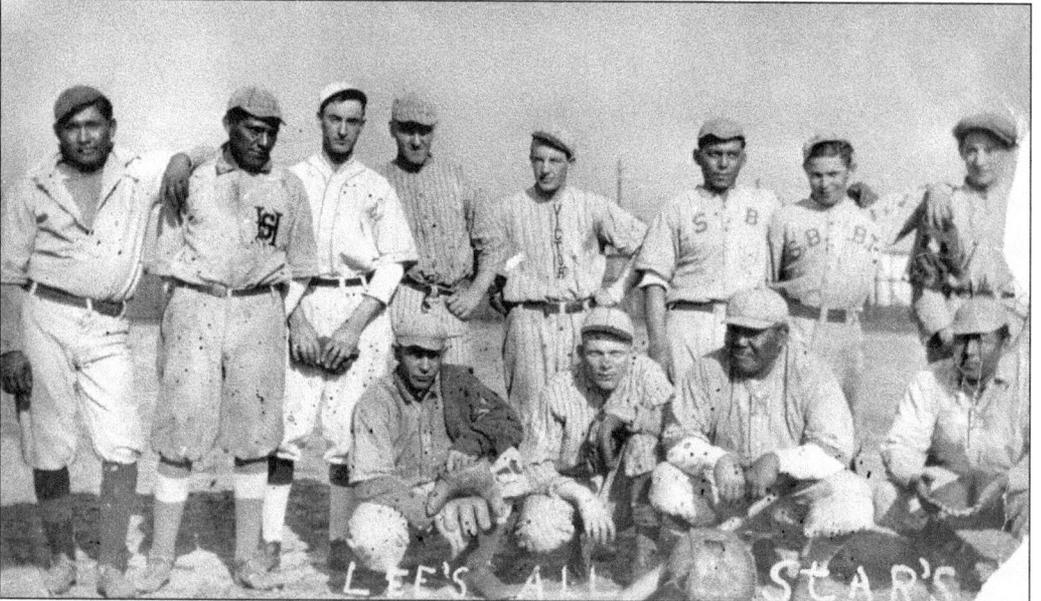

Many Native American men and women attended government, Christian, and public schools where they played sports. During the summers and after graduation, they often formed teams and competed within cities. This photograph depicts "Lee's All Stars" of 1920. (Courtesy of Pauline Ormego Murillo.)

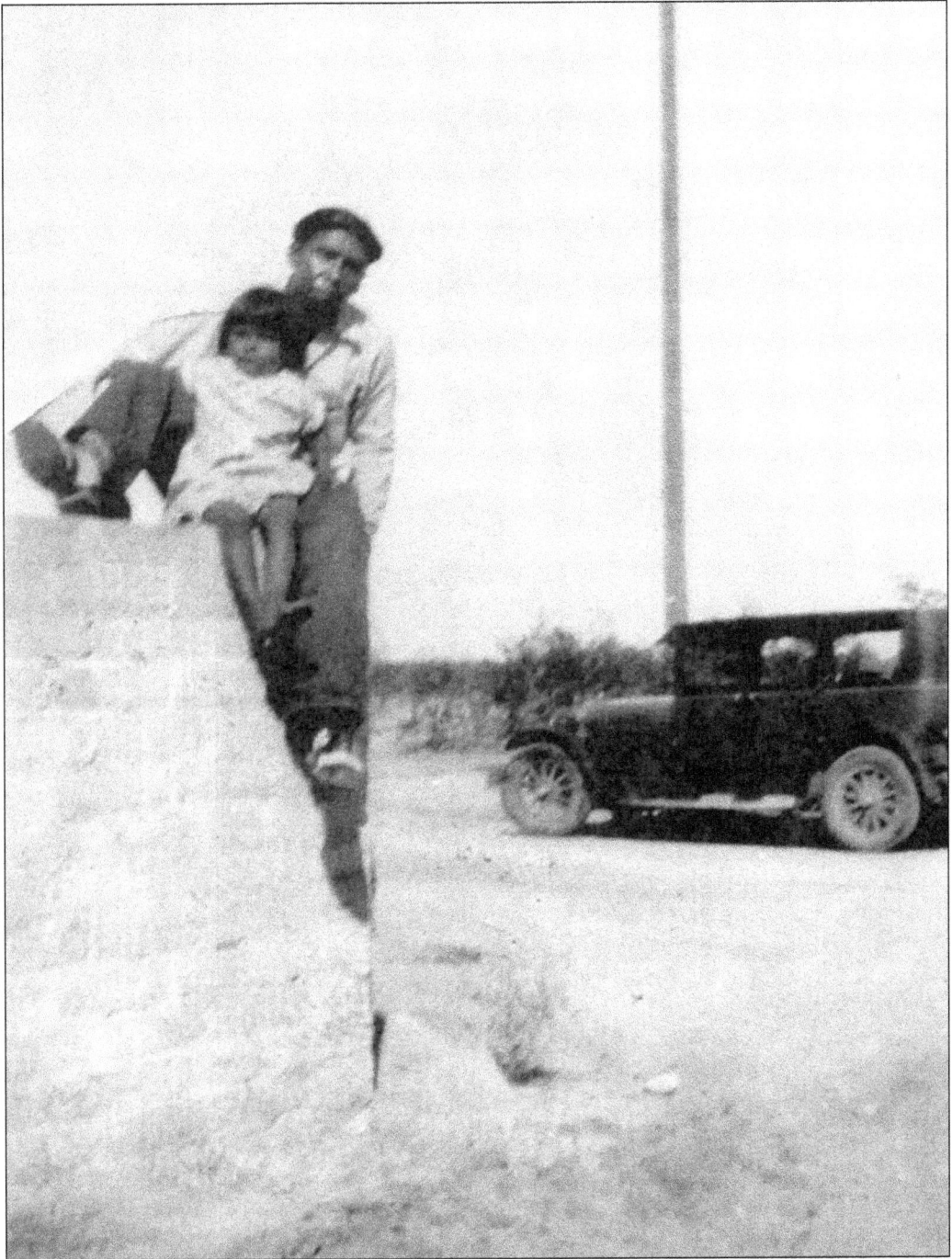

Pablo Ormego was from the Torres Martinez Indian Reservation and he attended Sherman Institute, where he was an outstanding football player in the 1930s. (Courtesy of Pauline Ormego Murillo.)

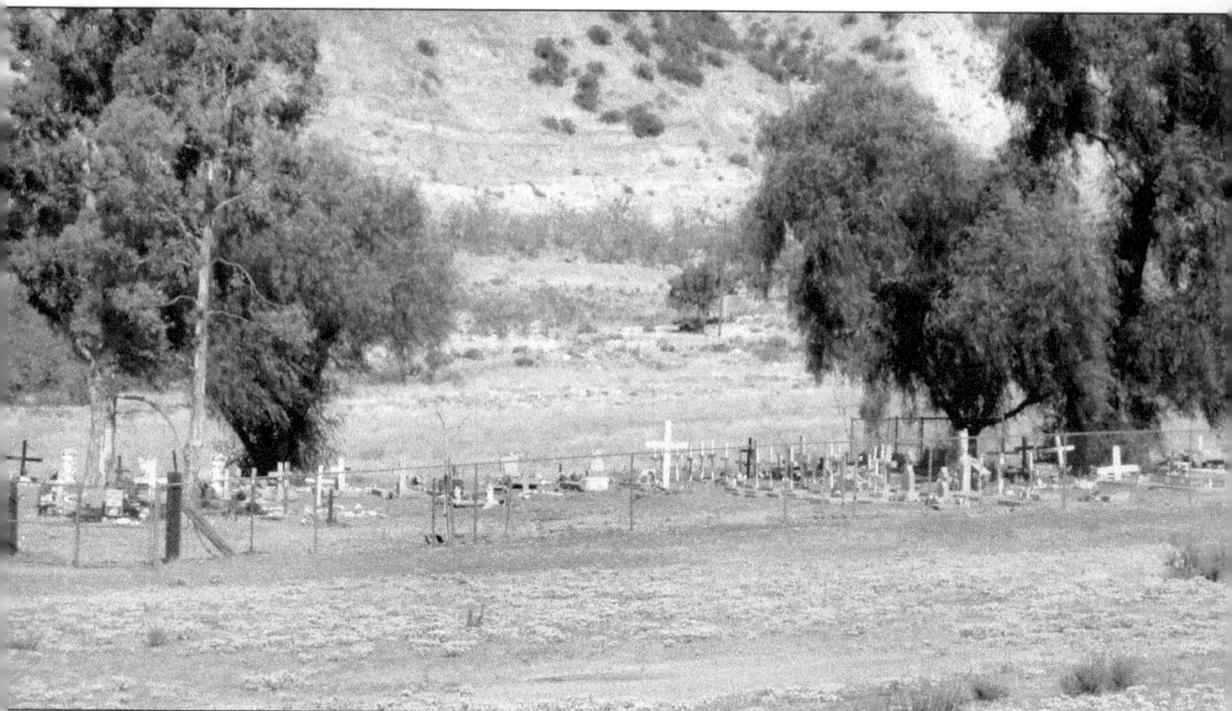

The Morongo Indian Reservation graveyard was the final resting place of many people, including students who had attended government boarding schools. (Courtesy of authors.)

Five

TRIBAL SOVEREIGNTY

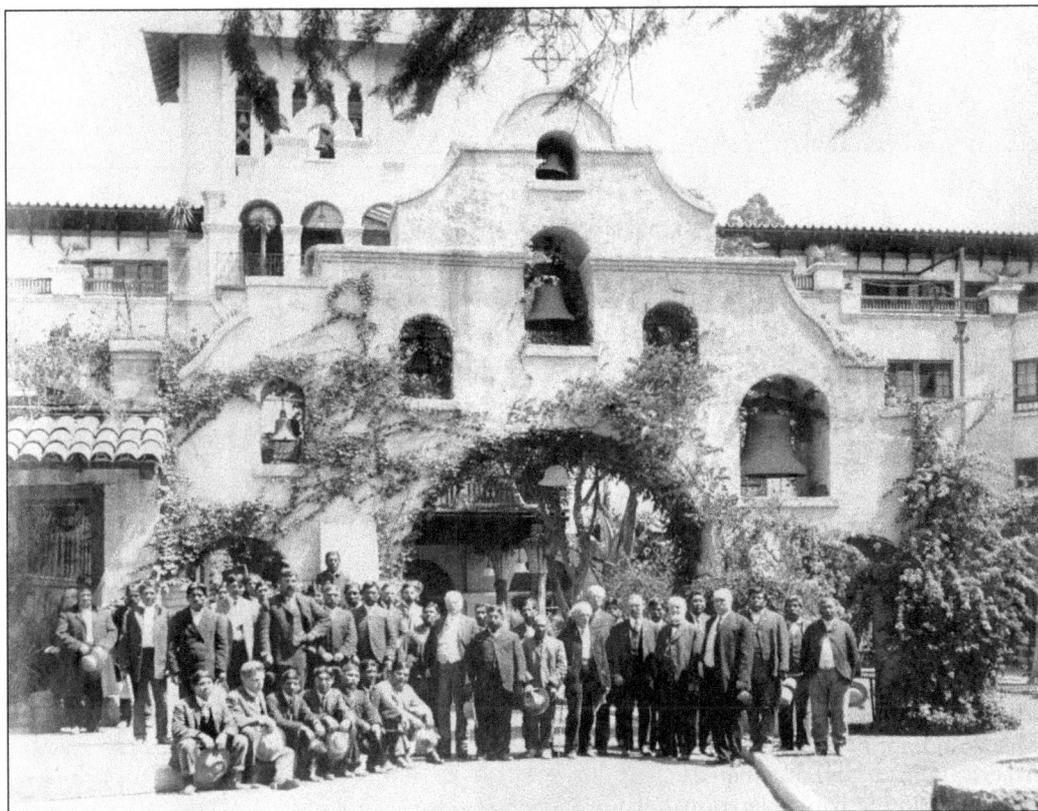

Southern California Native Americans hosted a large conference in Riverside, California, of Native American leaders and non-native reformers, including Charles Lummis, Clara True, Frank Miller, and A. K. Smiley. Sometimes dubbed the "Lake Mohawk Conference of the West," the participants discussed the best ways to protect Indian rights. Both Indians and non-natives posed for this photograph. (Courtesy of Riverside Metropolitan Museum.)

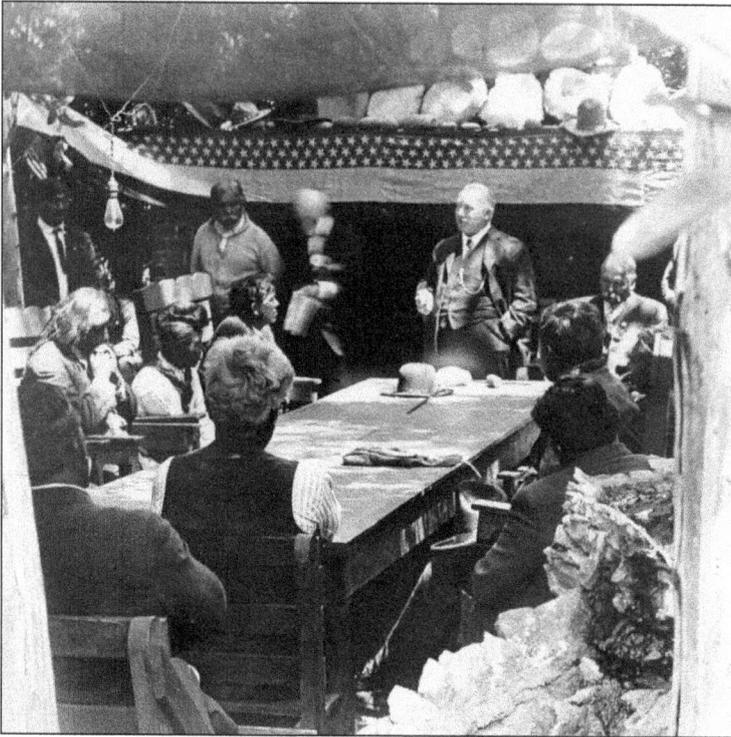

A Mission Indian Federation conference was held at the home of Jonathan Tibbet. (Courtesy of Riverside Metropolitan Museum.)

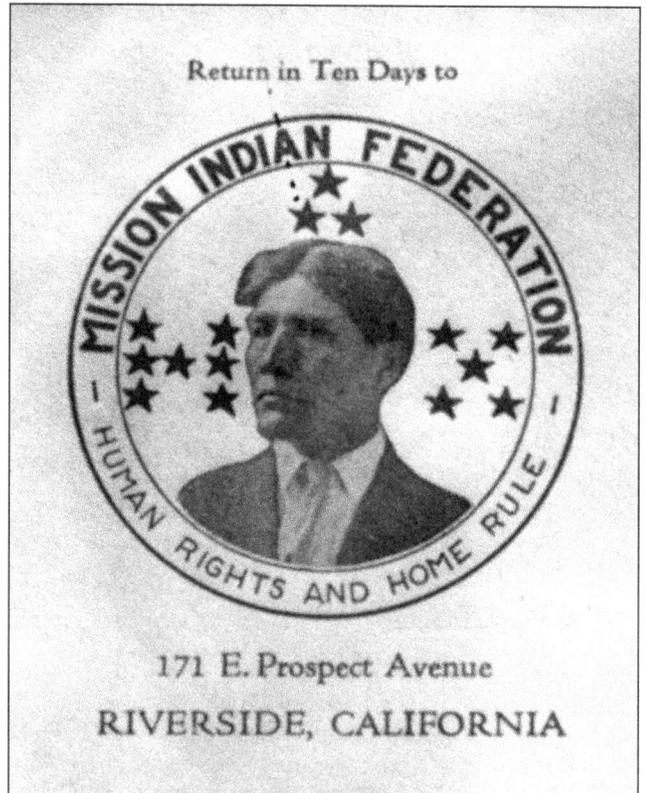

Return in Ten Days to

MISSION INDIAN FEDERATION

— HUMAN RIGHTS AND HOME RULE —

171 E. Prospect Avenue

RIVERSIDE, CALIFORNIA

The Mission Indian Federation had its headquarters in Riverside, California. The organization created its own newsletter, stationary, posters, and programs. This is an imprint of a Native American, made and distributed by the Mission Indian Federation. The organization selected the image of John Ortega of the Pala Reservation to grace their publicity. (Courtesy of Riverside Metropolitan Museum.)

The Indian, the magazine of the
Mission Indian Federation, was
first published in 1922 in Riverside,
California. Note the drawing in the
center on the cover of a Plains Indian
tipi and blankets, not that of Southern
California Native Americans. This may
have been an attempt to be inclusive
of all Indians. (Courtesy of Riverside
Metropolitan Museum.)

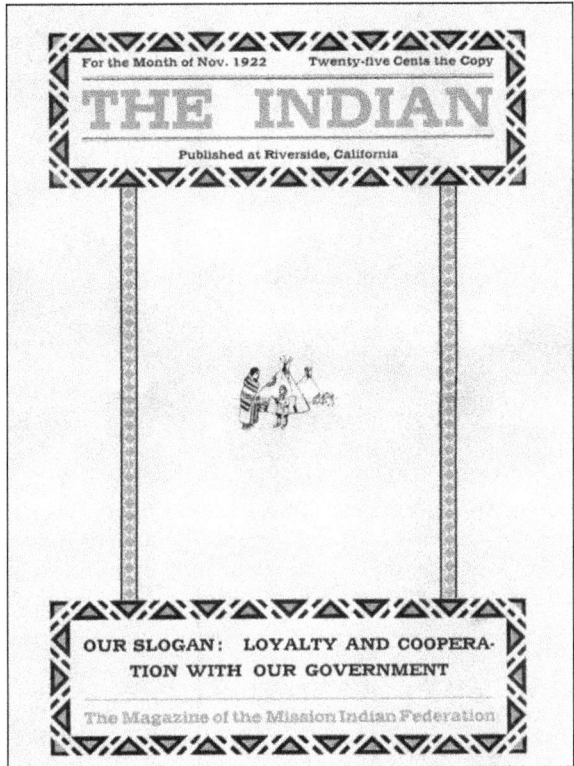

For the Month of Nov. 1922 Twenty-five Cents the Copy

THE INDIAN

Published at Riverside, California

OUR SLOGAN: LOYALTY AND COOPERA-
TION WITH OUR GOVERNMENT

The Magazine of the Mission Indian Federation

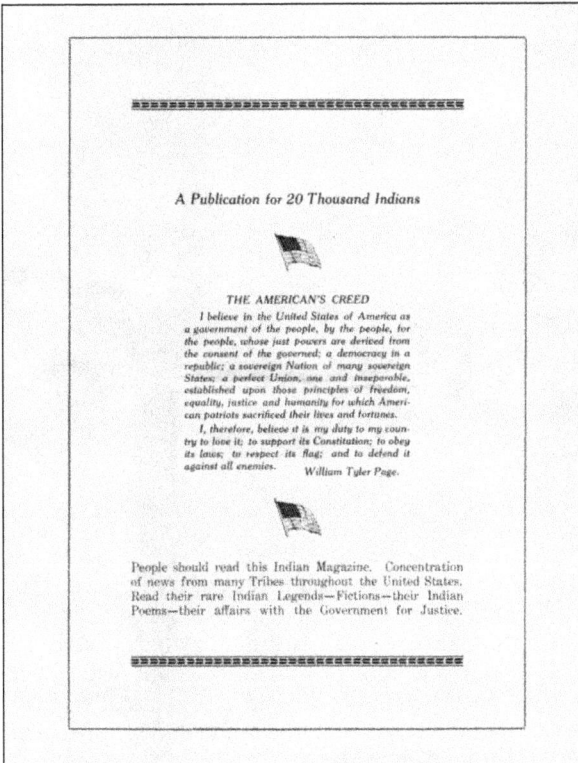

A Publication for 20 Thousand Indians

THE AMERICAN'S CREED

I believe in the United States of America as
a government of the people, by the people, for
the people, whose just powers are derived from
the consent of the governed; a democracy in a
republic; a sovereign Nation of many sovereign
States; a perfect Union, one and inseparable,
established upon those principles of freedom,
equality, justice and humanity for which Ameri-
can patriots sacrificed their lives and fortunes.
I, therefore, believe it is my duty to my coun-
try to love it; to support its Constitution; to obey
its laws; to respect its flag; and to defend it
against all enemies. William Tyler Page.

People should read this Indian Magazine. Concentration
of news from many Tribes throughout the United States.
Read their rare Indian Legends—Fictions—their Indian
Poems—their affairs with the Government for Justice.

The Indian, while published in
Riverside, covered issues important
to indigenous peoples across the
United States. The two images of
the American flag and William Tyler
Page's America's Creed explicitly
displays a profound sense of American
patriotism felt by many Native
Americans. Note that Indians were
not citizens of the United States until
1924, and America's Creed often was
part of the naturalization ceremony
for new Americans. (Courtesy of
Riverside Metropolitan Museum.)

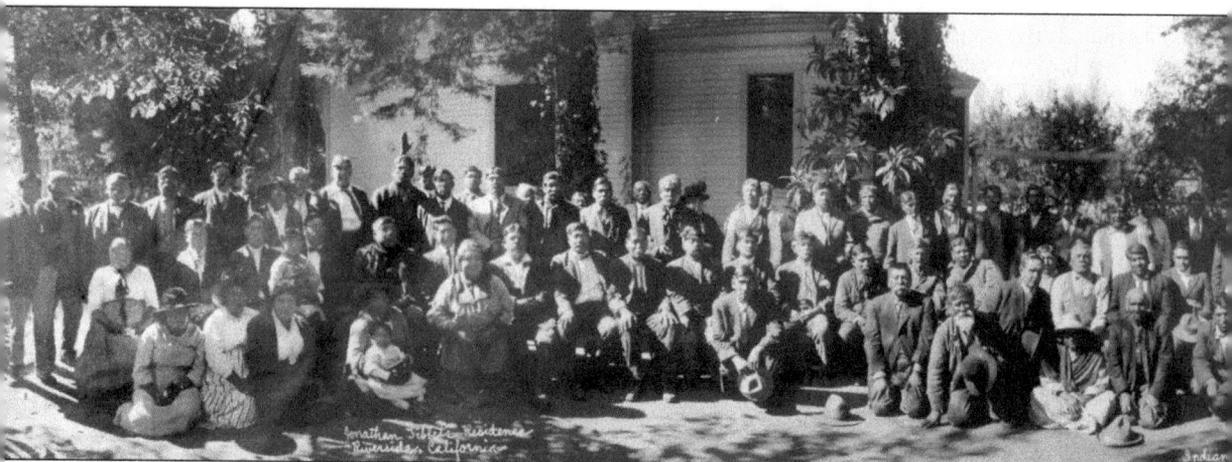

In 1920, several Native American leaders met to form the Mission Indian Federation, an intertribal organization formed to protect Indian rights and push for self-rule. One of the primary goals of the federation was to seek financial compensation for the land and resources that were taken from them through executive orders. In addition, most members of the federation wanted to eliminate or substantially diminish the power the Bureau of Indian Affairs held over native

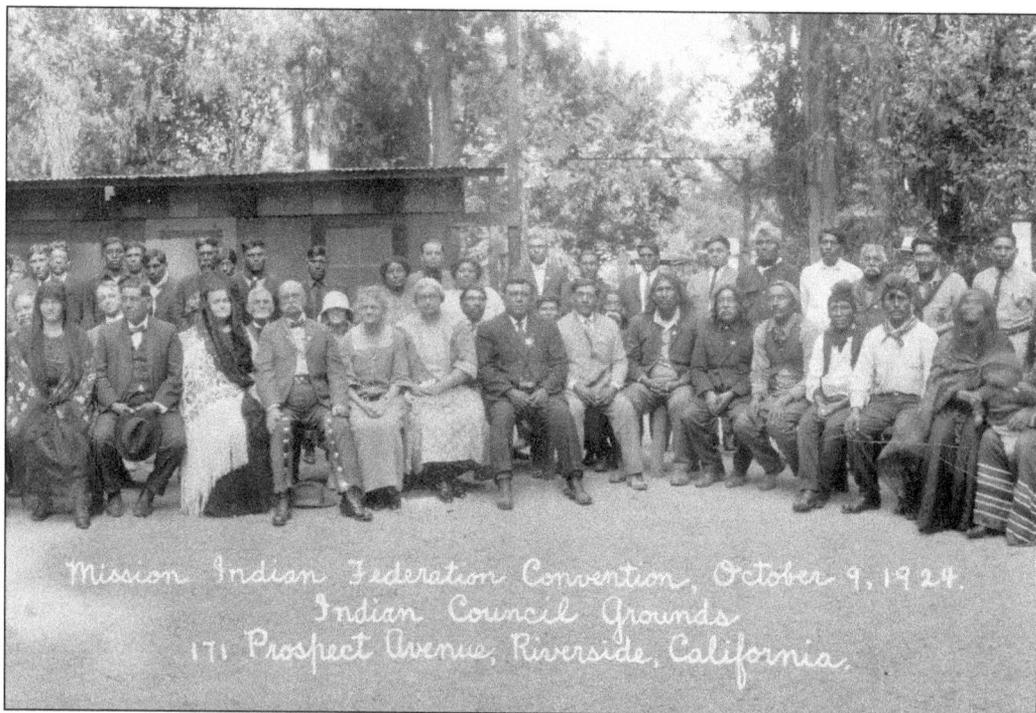

Mission Indian Federation Convention, October 9, 1924. Indian Council Grounds 171 Prospect Avenue, Riverside, California.

The Mission Indian Federation often allied with national figures to further their objectives. The federation opposed government allotment of native lands and the encroachment of white settlers onto reservation lands. Federation members opposed the Bureau of Indian Affairs, fought for Native American water rights, and severed as a body of volunteer law enforcement deputies on reservations. Jonathan Tibbet, a non-native leader, sits in the front dressed in a charo, or vaquero, outfit. Seated at the far right are a few Quechan Indian leaders from the Yuma Crossing between Arizona and California. (Courtesy of the A. K. Smiley Public Library.)

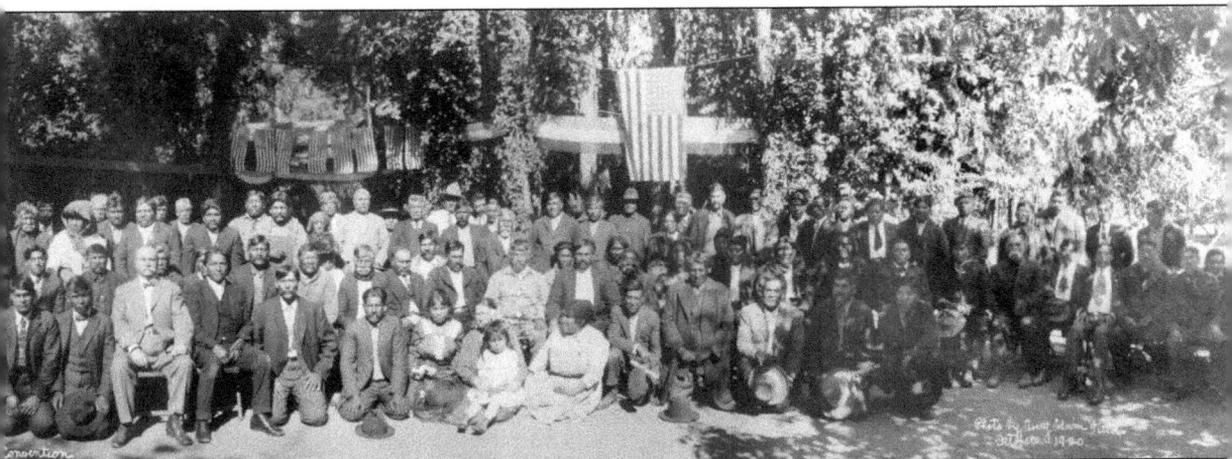

government and goods. However, not all Indians in Riverside County supported the federation, which invariably caused friction between native peoples. This photograph depicts the Indian Federation Convention at Jonathan Tibbet's residence in Riverside, California, in October 1920. (Courtesy of Riverside Metropolitan Museum.)

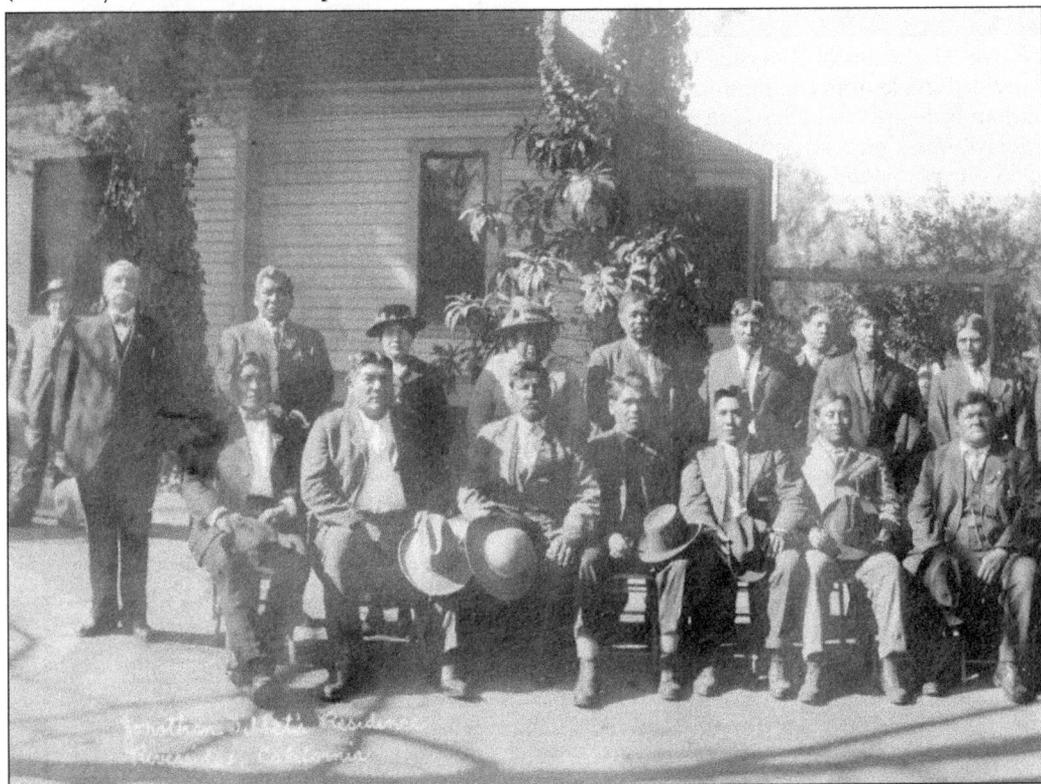

At the conference of 1920, members of the Mission Indian Federation voted for Adam Castillo of the Soboba Indian Reservation to lead the federation. This photograph depicts some of the key leaders of the federation. Sitting second from the right is Adam Castillo and standing at the far right is John Ortega. Jonathan Tibbet stands on the far left. This photograph was taken in Tibbet's backyard; his home is visible in the background. (Courtesy of the A. K. Smiley Public Library.)

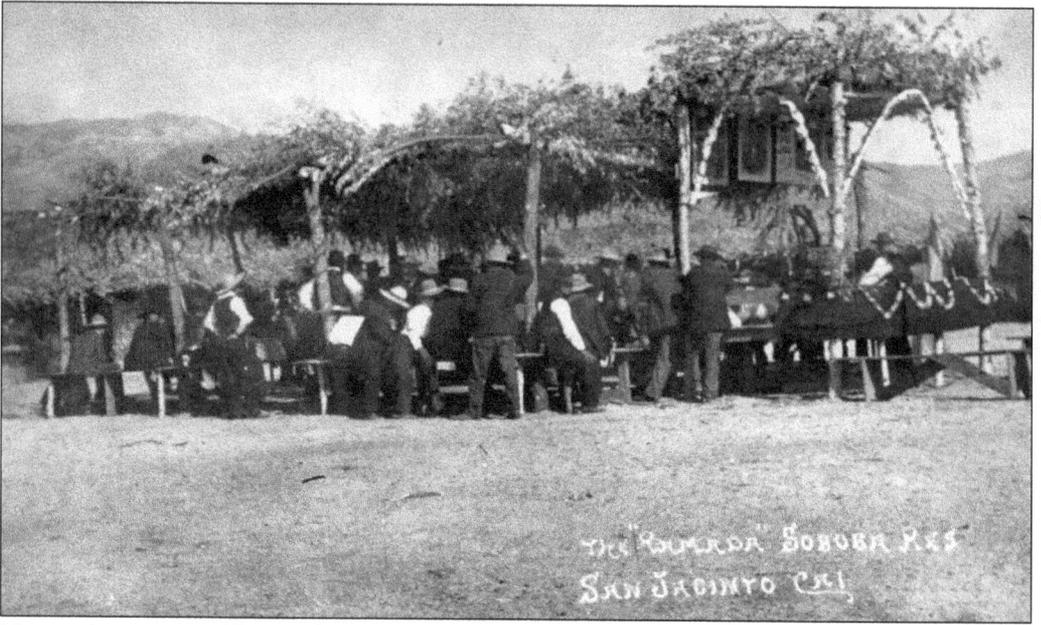

The "Ramada" Soboba Res
San Jacinto Cal.

Native Americans of Riverside County often built brush-covered lodges called ramadas, which provided shade from the intense summer sun. Natives used ramadas for meetings of the Mission Indian Federation and fiestas or social gatherings. During the 1920s and 1930s, reservation tribes in Riverside County often built ramadas to serve as reception areas for Bureau of Indian Affairs field nurses to conduct free health and baby clinics. (Courtesy of A. K. Smiley Public Library.)

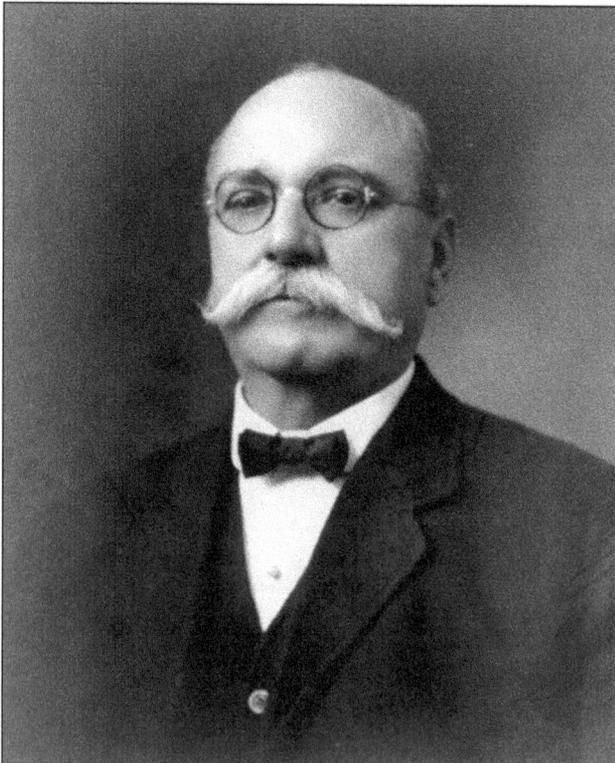

This is a portrait of Jonathan Tibbet, who helped start the Mission Indian Federation and whose residence was used by the federation to hold their famous conventions in 1920s. (Courtesy of Riverside Metropolitan Museum.)

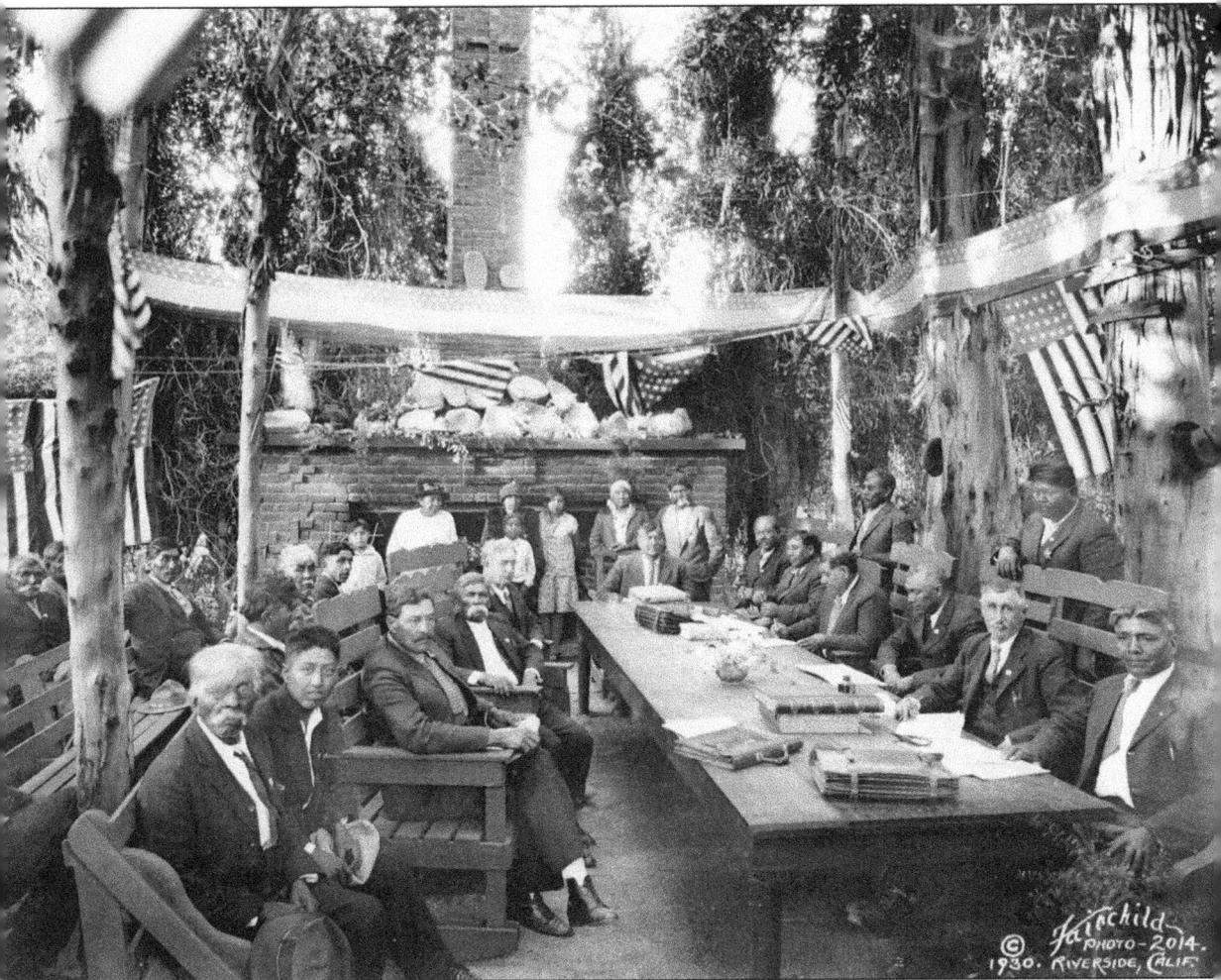

In 1930, the Mission Indian Federation met in Riverside, California, in the backyard of Jonathan Tibbet. The federation made a concerted effort to display their loyalty to the United States while criticizing the Bureau of Indian Affairs. Here the federation displays at least a half dozen American flags. (Courtesy of Riverside Metropolitan Museum.)

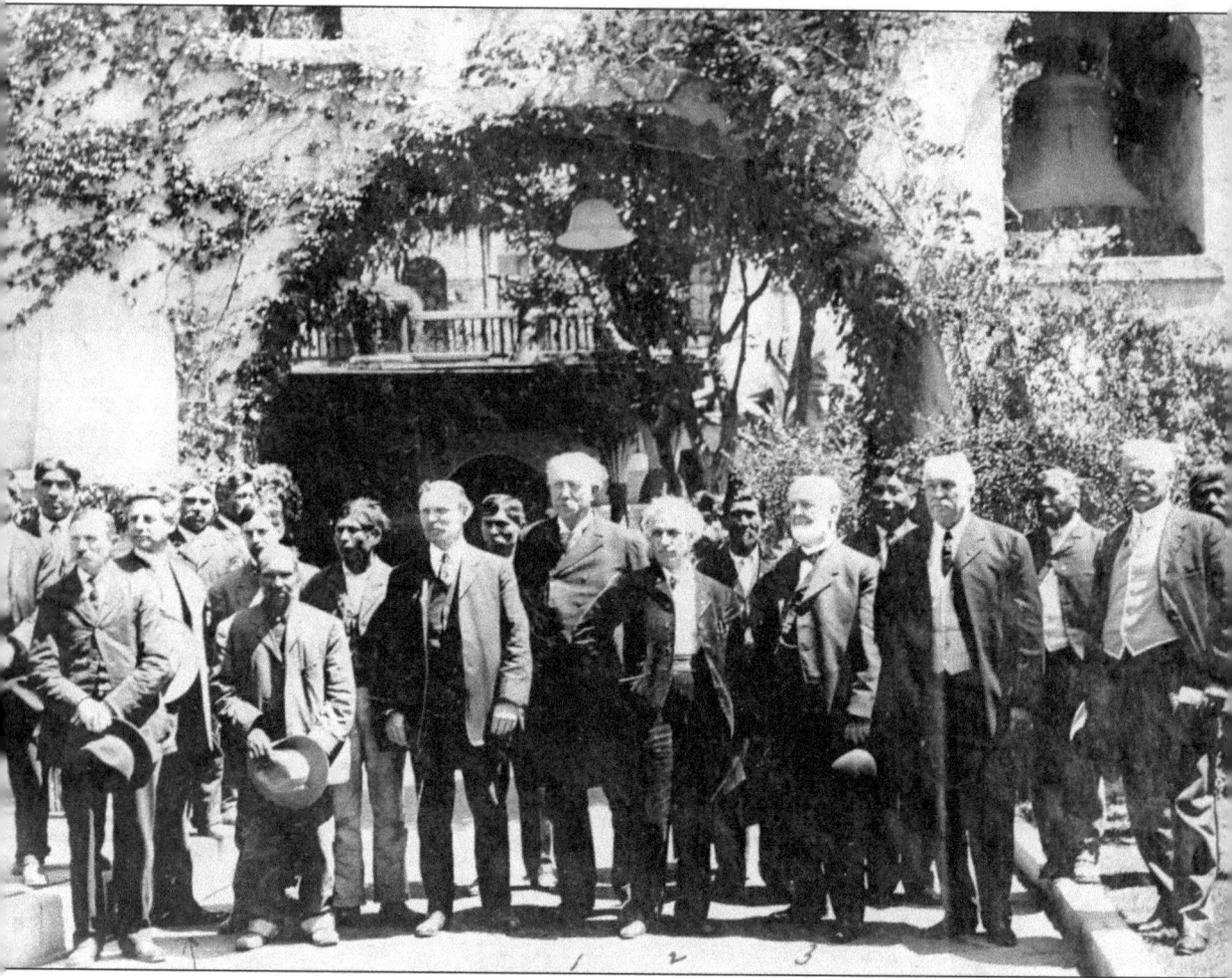

During the Indian Conference of 1908, participants met at the Mission Inn located in Riverside, California. Indian and non-native leaders pose for this photograph in front of the entrance to the Mission Inn, which still hosts the conferences and meetings. Some of the most notable leaders of Riverside County attended the conference to discuss Indian rights. (Courtesy of Riverside Metropolitan Museum.)

In 1997, a group of Native Americans and non-native people from Riverside County met to form the Native American Land Conservancy (NALC). The organization bought the Old Woman Mountains and created a habitat sanctuary there; Cahuillas, Chemehuevis, and Southern Paiutes are among the participants. The NALC is an extension of tribal sovereignty to intertribal issues like the native environment. (Courtesy of Kurt Russo.)

Riverside County contains many landforms local Native Americans consider sacred. Non-Indians know about some of these, but native people do not openly discuss most of these out of fear that people will harm or desecrate them. Native Americans of Riverside County protect their sacred sites as an element of their sovereignty. (Courtesy of Kurt Russo.)

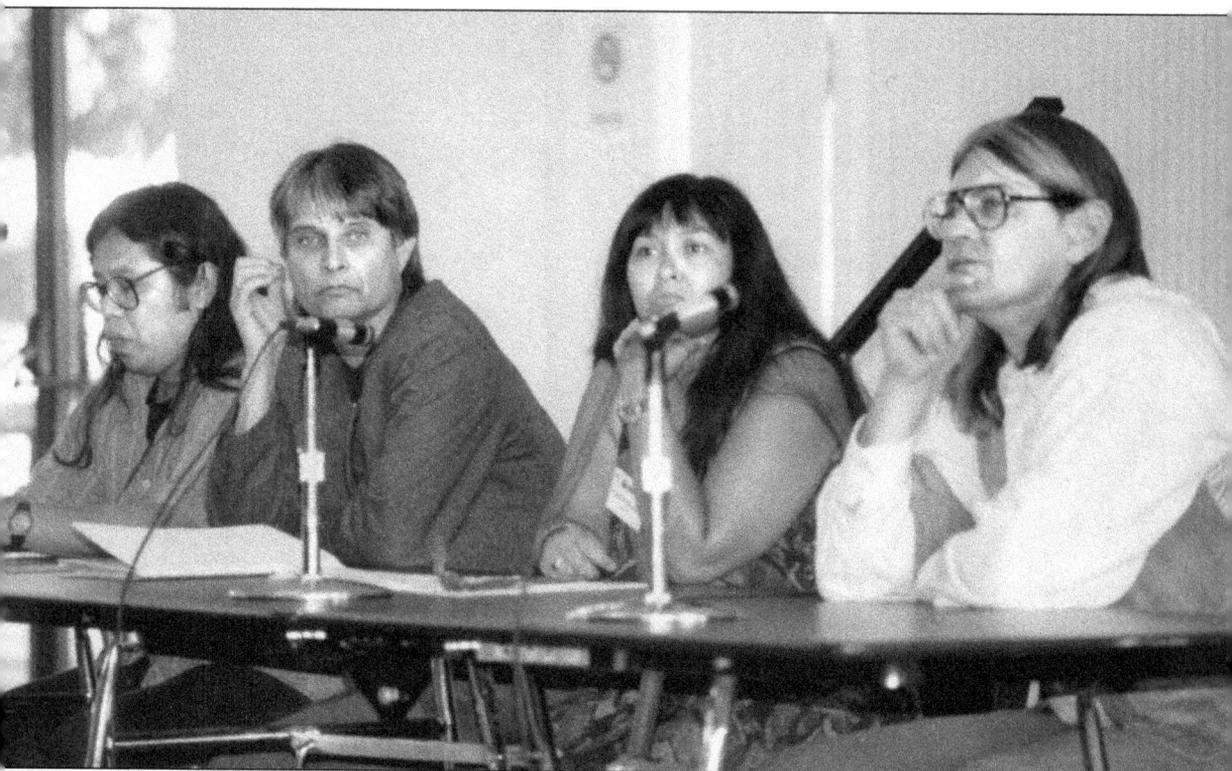

A panel of American Indian scholars discusses the importance of traditional Native American medicine at the annual Medicine Ways Conference at the University of California, Riverside. Included in the photograph are Donald Grinde (second from the left) and Ward Churchill (far right). (Courtesy of authors.)

Six

CONTEMPORARY LIFE

In the 1990s, the Twenty-Nine Palms Band began its casino in Coachella, California. This tribe of Chemehuevi has used some of its funds from gaming to support land conservation, educational scholarships, language preservation, historical studies, and a host of philanthropic causes. (Courtesy of authors.)

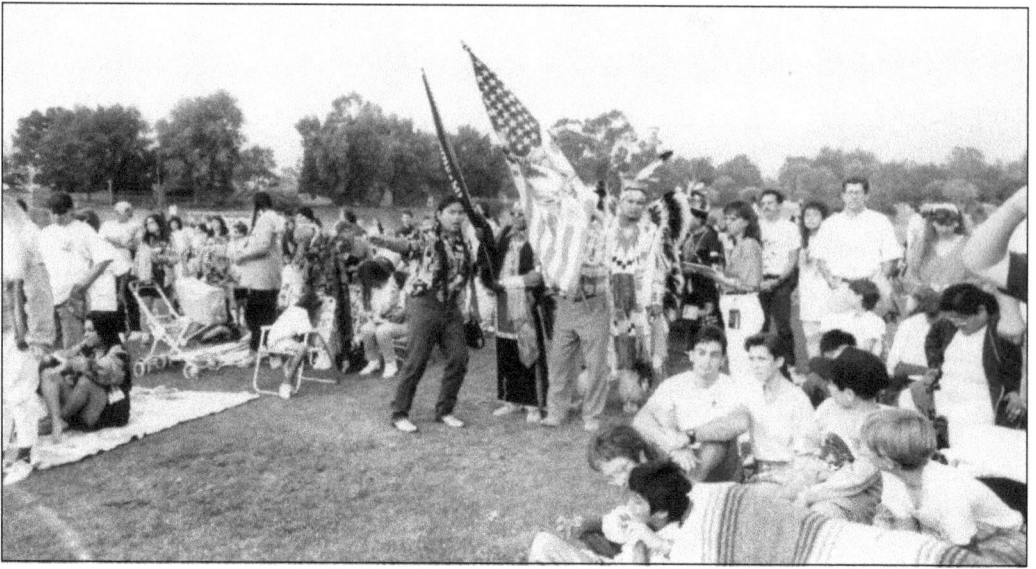

During the grand entry of a powwow, veterans and elders often carry the American flag and the Canadian flag. Native Americans are generally very patriotic because they wish to protect their people and land. The first peoples of the United States are Native Americans, and they exhibit their loyalty to their country at the powwow. (Courtesy of authors.)

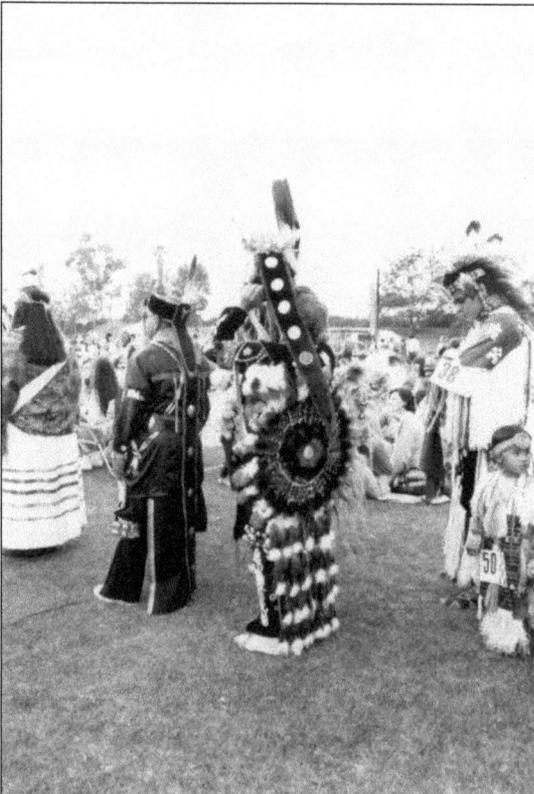

Native American people from all over the Americas have made Riverside County their home. They have brought their traditions to the region, including the powwow that originated on the Great Plains and Great Lakes. Here traditional dancers prepare for the grand entry. (Courtesy of authors.)

Traditional male dancers perform at a powwow at the University of California, Riverside. The dancer to the left wears the number 38 so that judges may evaluate his performance and determine if he should win a cash prize. Men, women, and children compete for prize money in dancing and drumming. (Courtesy of authors.)

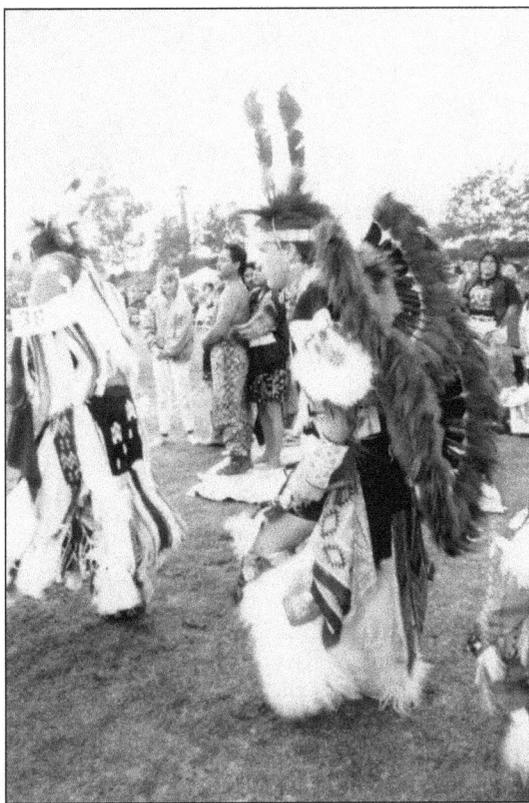

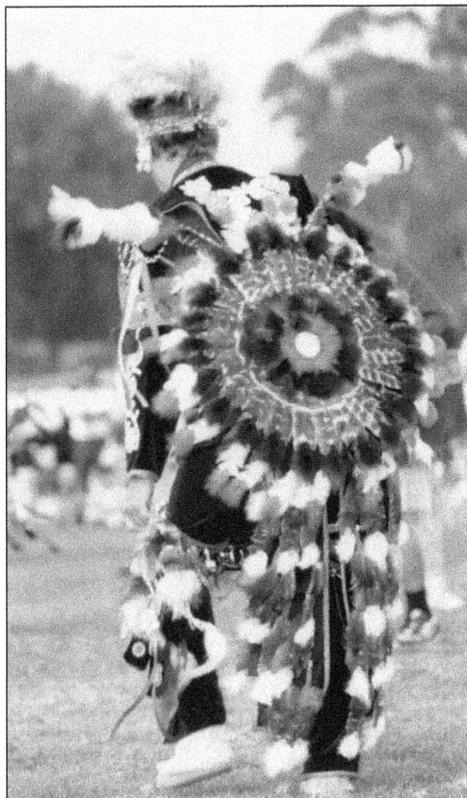

A Native Alaskan dances at a powwow showing his dance bustle, part of the dance outfit made of leather and feathers of multiple colors. This urban Indian in Riverside County combines the traditions of his people with those of the Great Plains, creating a new tradition at the powwow. (Courtesy of authors.)

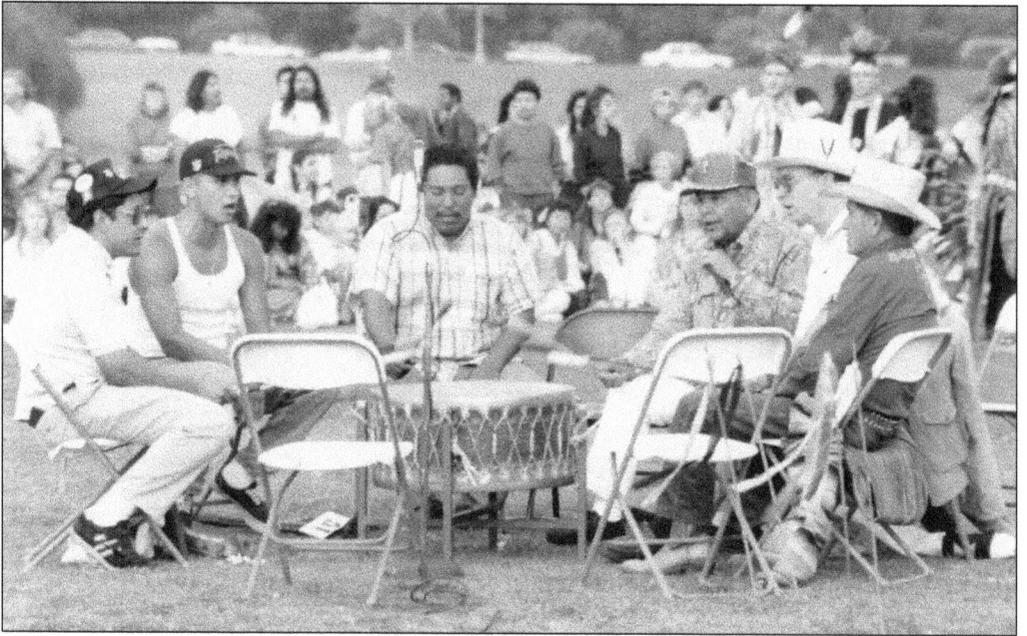

The first people of Riverside County knew about drums, but they did not use them in their ceremonies. Instead, they used rattles as their chosen musical instrument, and newcomers to Riverside County brought the drum. Here a Northern Plains drum group from the inland empire performs at a powwow. (Courtesy of authors.)

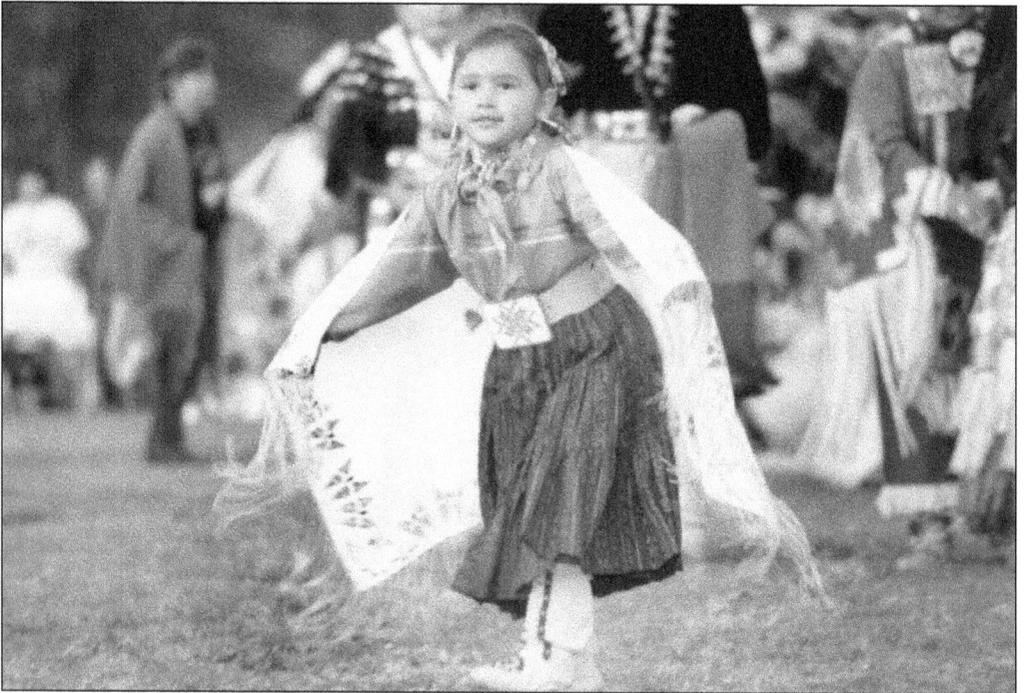

This Tiny Tot Dancer is strutting her stuff at the powwow, where she is competing in a dance contest. Note her "ribbon shirt" and her beautiful white shawl decorated with butterflies that help her whirl about in a graceful fashion. (Courtesy of authors.)

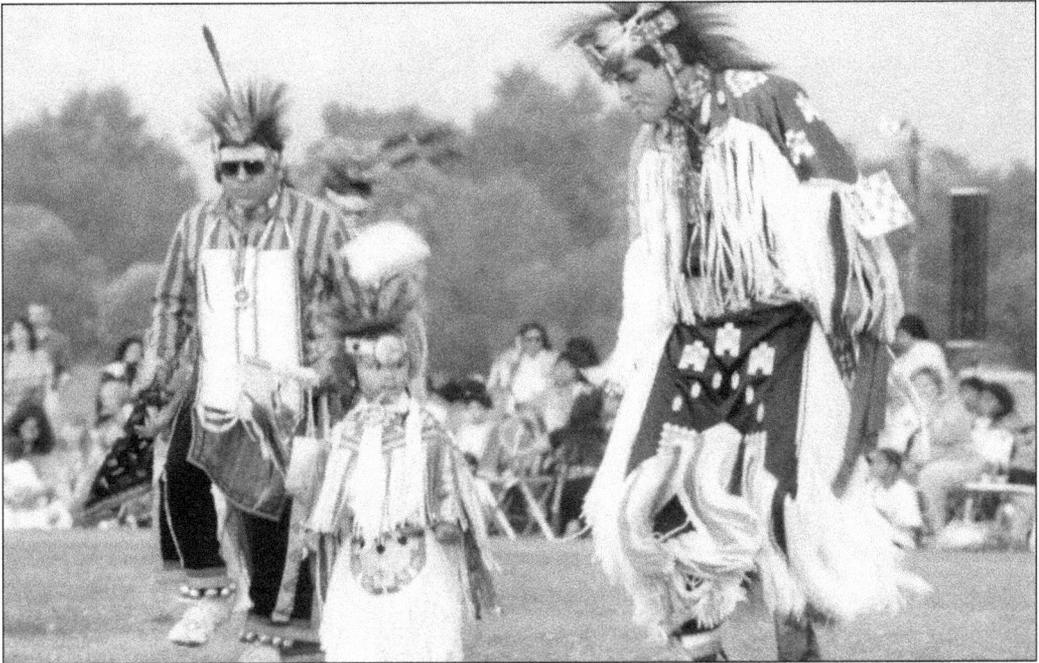

A father and son dance at the powwow where the father passes along the dance through the oral tradition—the ancient native way of sharing knowledge. The Indians of Riverside County have always taught their children native traditions through oral communication until recently, when the government and churches established schools and taught Native Americans to write English. (Courtesy of authors.)

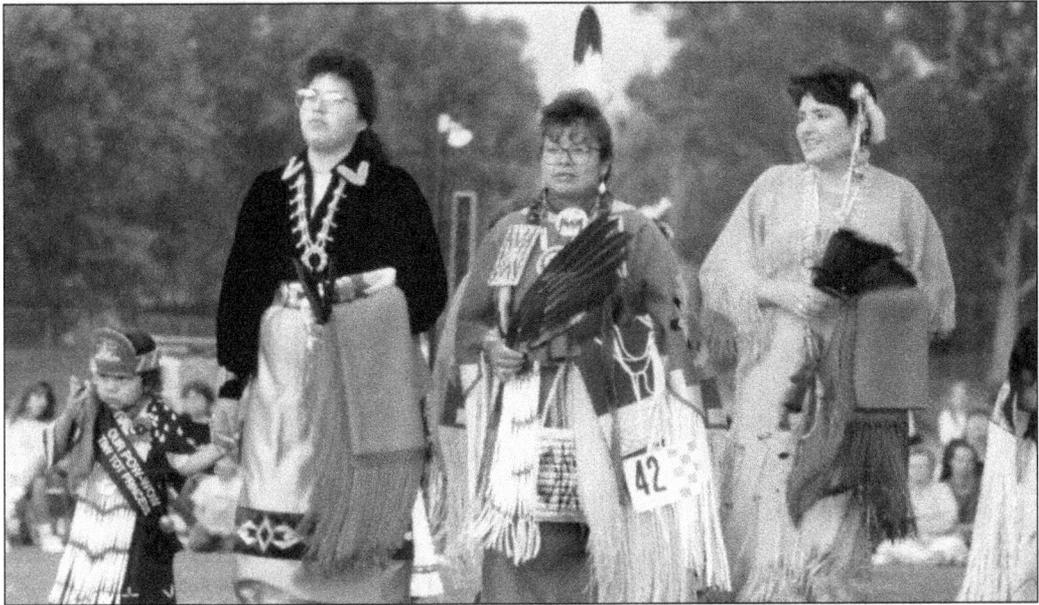

Three women dancers prepare to dance at the powwow. The little girl on the left is a Tiny Tot Princess, winner of a competition at a powwow where people of all ages compete through dancing. Note the spectators in the background sitting on lawn chairs and enjoying the afternoon dances and drumming. (Courtesy of authors.)

Iris and Matthew Leivas are cultural leaders who live along the Colorado River. Matt is a Salt Singer and spiritual man who attended Sherman Indian High School. (Courtesy of Leleua Loupe.)

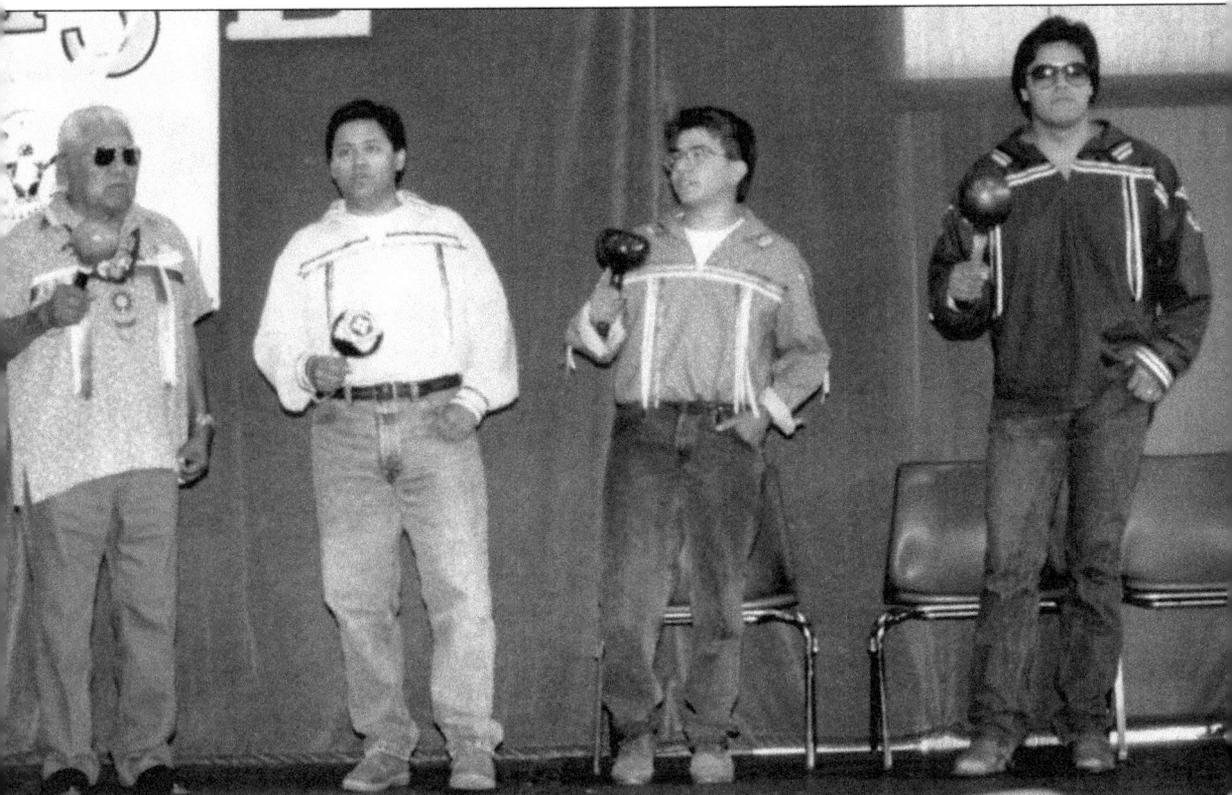

Cahuilla Indian elder Robert Levi leads a singing of the Bird Songs with, from left to right, Mark Macarro, John Macarro, and Luke Madrigal—all of whom he taught to sing these songs. Today all of the younger Bird Singers are leaders among their people. Mark Macarro is tribal chair of the Pechanga Band of Luiseño Indians, and his brother John is an attorney for the tribe. Luke Madrigal, director of Indian Family and Child Services, and all the men in his family are Bird Singers. (Courtesy of authors.)

Karlene Vernaci is Luiseño from the La Joja Reservation. In the 1990s, Karlene served in Student Services at the University of California, Riverside, where she tutored and mentored Native American students living in Riverside County. Here Karlene, with her friend Heather, sells T-shirts at the annual Medicine Ways Conference. (Courtesy of authors.)

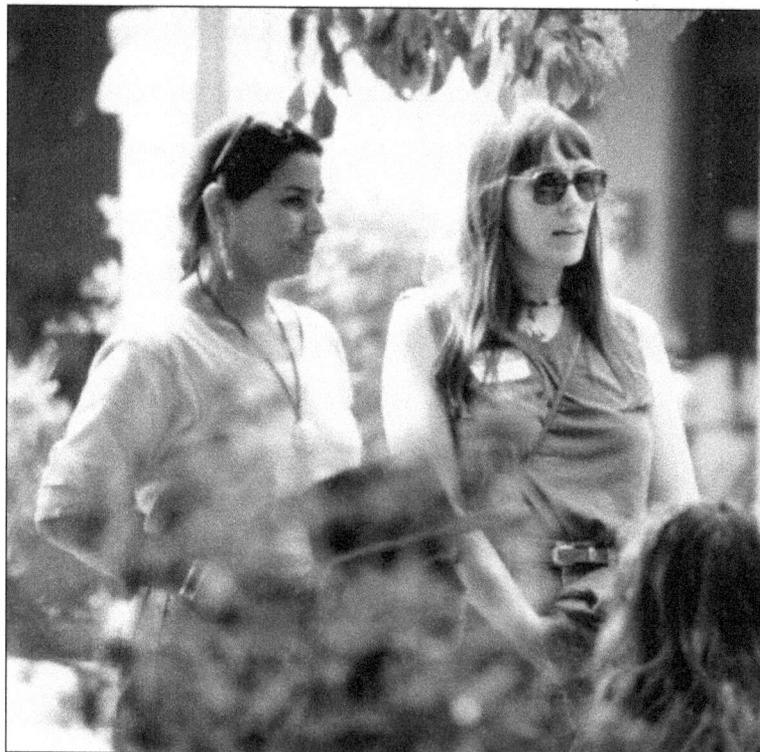

Two Native American teachers converse at the University of California, Riverside. Cindi Alvitre, Tongva-Gabriellleno with ties to Riverside County, is completing her Ph.D. at the University of California, Los Angeles. Rebecca Kugel is Ojibway and a master professor of American Indian history at the University of California, Riverside. (Courtesy of authors.)

The Malki Museum, founded by
Katherine Siva Sauvel and Jane Penn
on the Morongo Indian Reservation,
serves as an Native American
cultural center in Riverside County.
The museum publishes a scholarly
journal, books, and a newsletter and
sponsors many cultural programs.
(Courtesy of authors.)

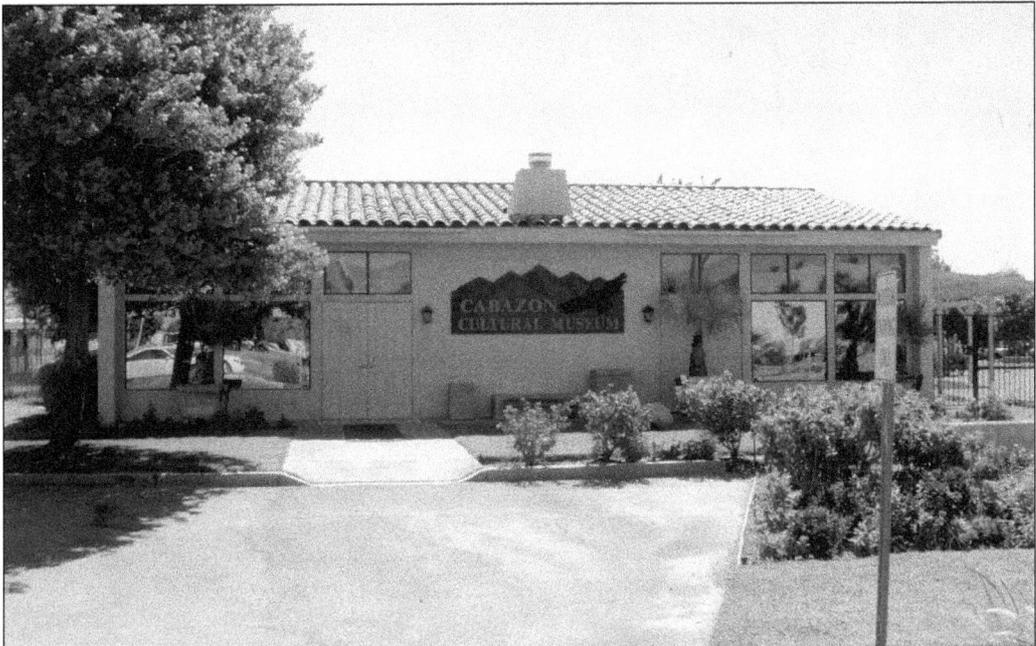

The Cabazon Band of Mission Indians in Indio, California, has long supported cultural and
historical programs through the Cabazon Cultural Museum. Preservation and education is a
priority for the tribe. (Courtesy of authors.)

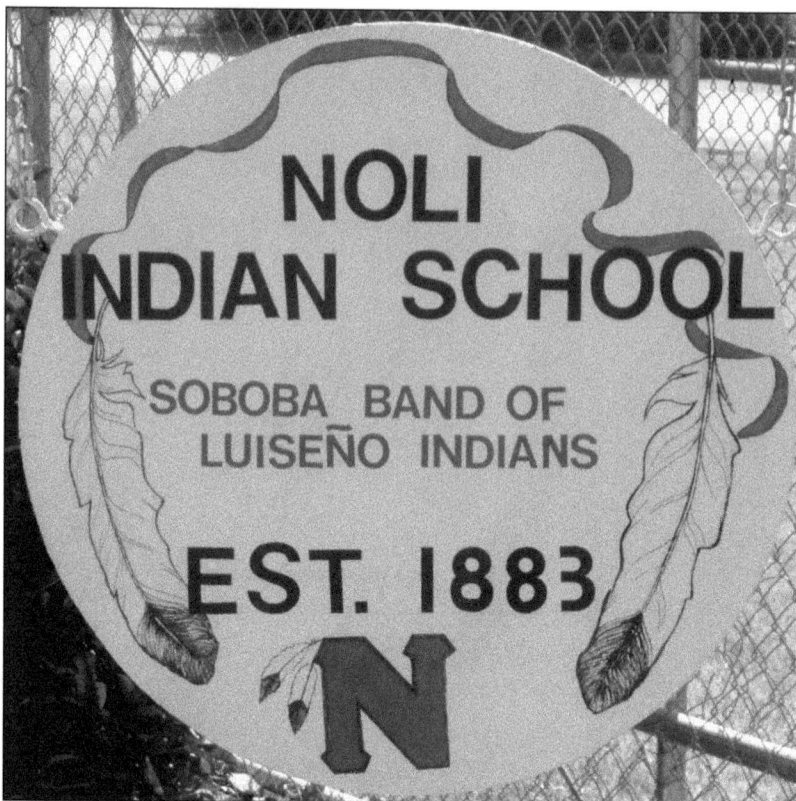

Education is significant to the tribes of Riverside County. This is the sign for the Noli Indian School on the Soboba Indian Reservation, which is funded privately by the monies made by the tribe from gaming. (Courtesy of authors.)

This is one view of the Noli Indian School on the Soboba Indian Reservation. Students learn a good deal about Native American culture, history, and language as well as taking on Western curriculum. (Courtesy of authors.)

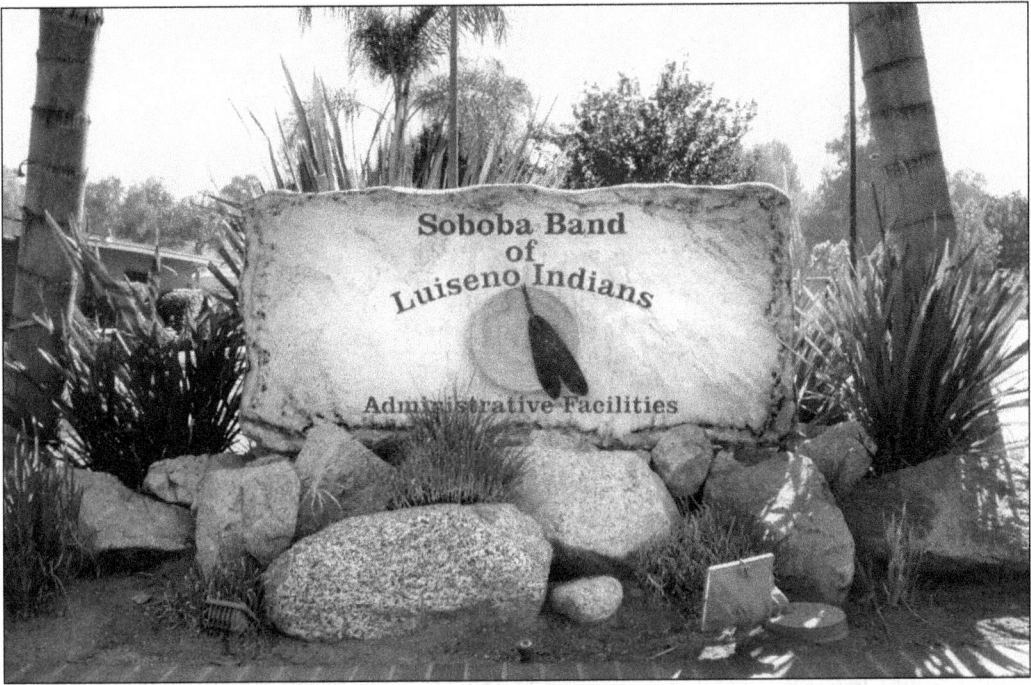

This is the sign at the entrance to the administrative offices of the Soboba Band of Luiseno Indians. (Courtesy of authors.)

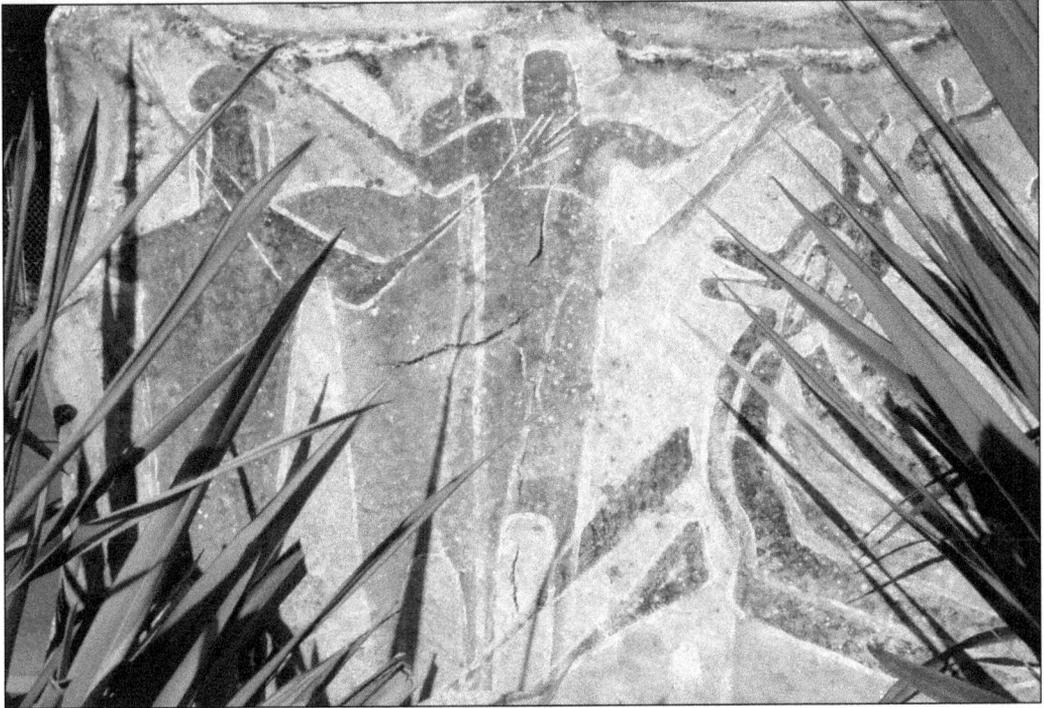

These are modern pictographs found on the reverse side of the sign leading into the offices of the Soboba Band of Luiseno Indians. Native Americans throughout the county draw on their heritage for inspiration found in contemporary art. (Courtesy of authors.)

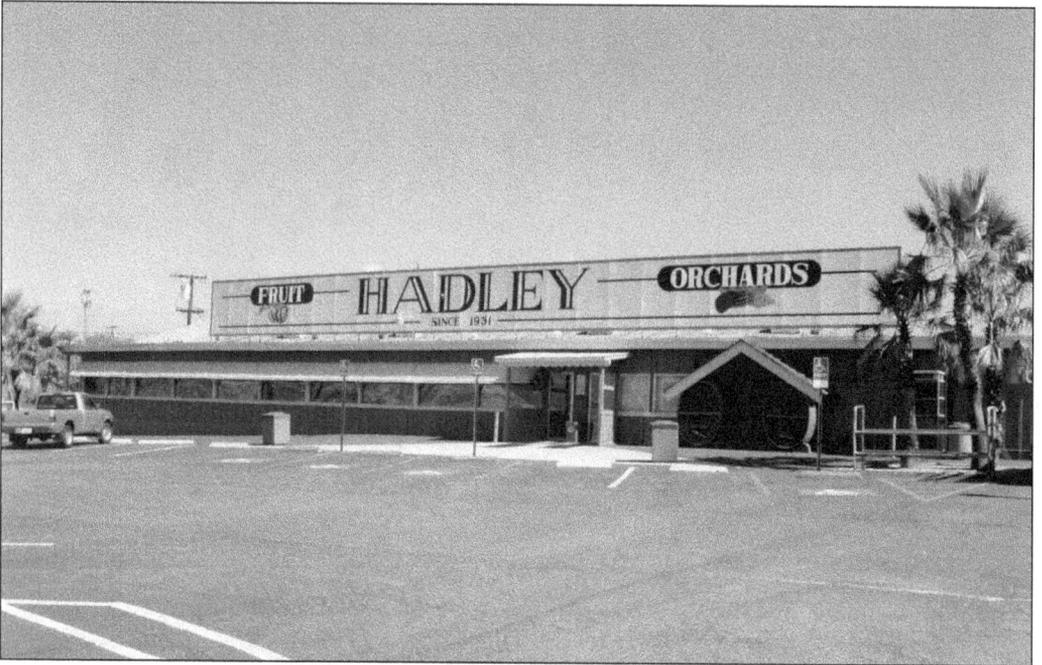

Hadley Fruit Orchards, owned and operated by the Morongo Band of Mission Indians, is yet another example of economic diversification. (Courtesy of authors.)

A&W and Coco's are two other businesses owned and operated by the Morongo Band of Mission Indians. Many tribes in Riverside County have diversified economically to plan for their future. (Courtesy of authors.)

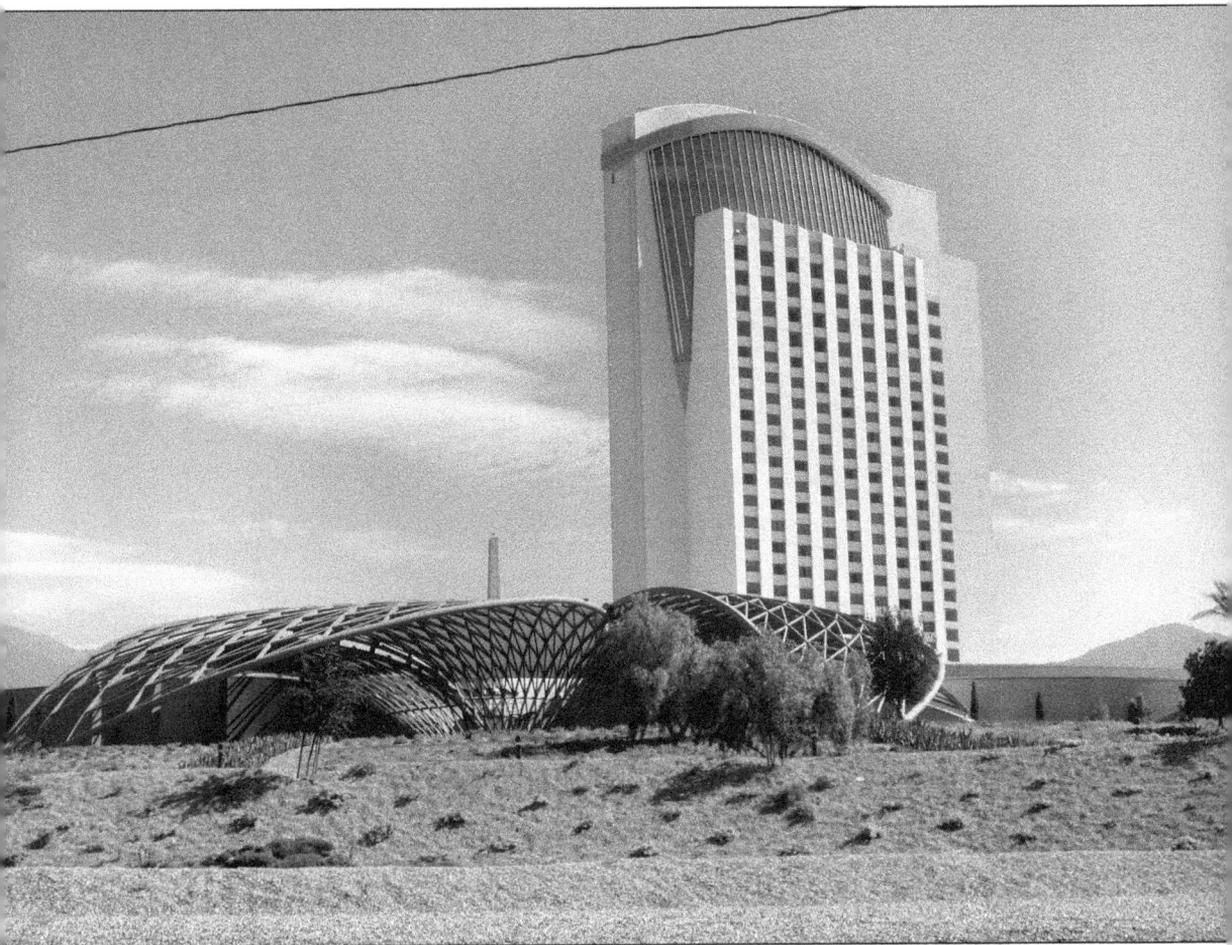

Casino Morongo on the Morongo Indian Reservation is pictured here. The hotel/casino was such a large structure that it required the rewriting of the Riverside County building code. (Courtesy of authors.)

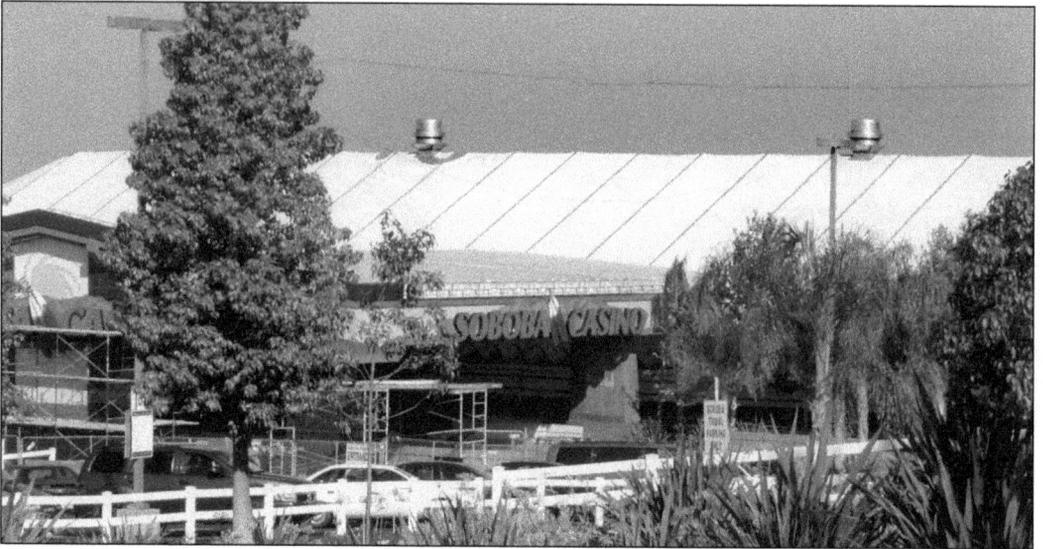

Here the Soboba Indian Casino, one of many Indian businesses found in Riverside County, is undergoing a renovation of its entrance. (Courtesy of authors.)

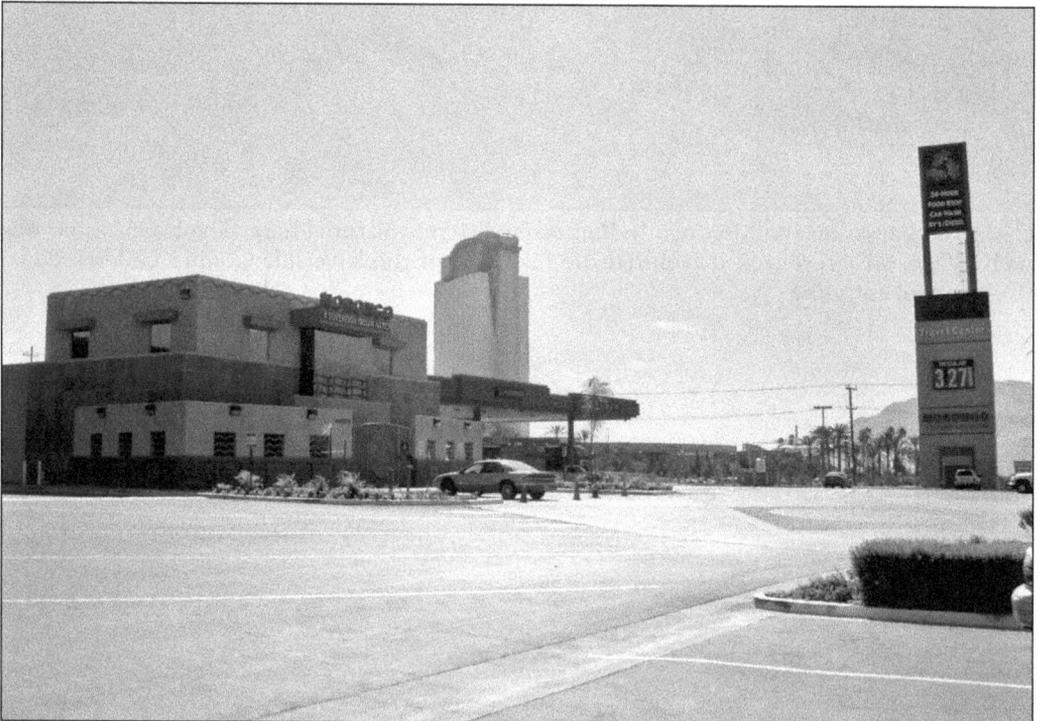

This is the Morongo 24-hour travel center, which is one of numerous businesses owned and operated by the Morongo Band of Mission Indians. Note the casino and hotel in the background, an imposing structure seen for miles when driving west on Interstate 10. (Courtesy of authors.)

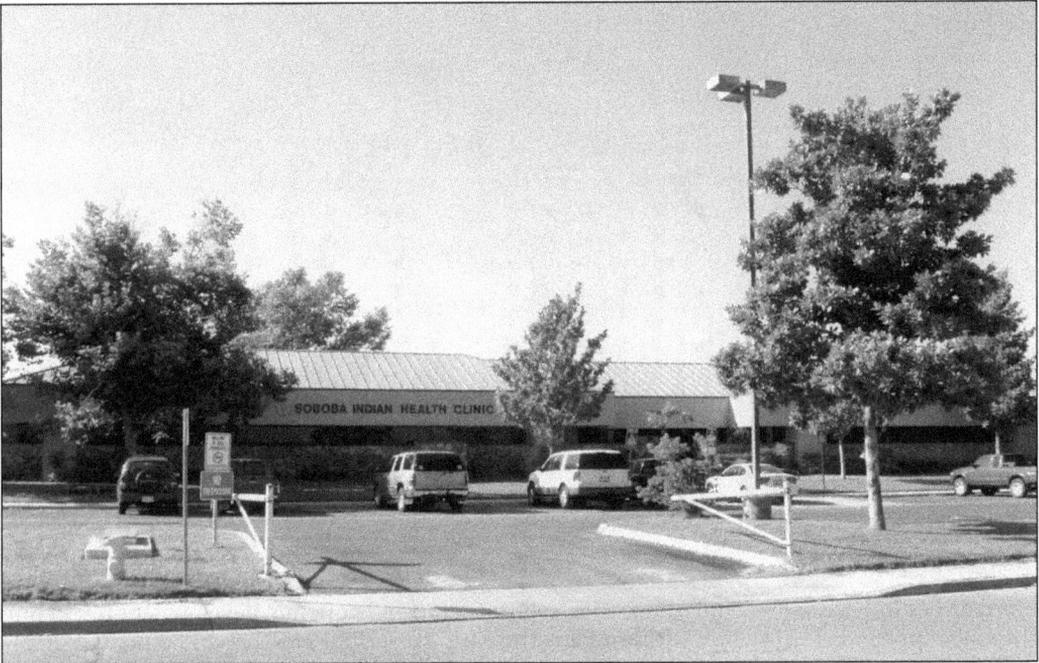

Health has always been important to Native Americans of Riverside County. The Indian Health Service serves the indigenous peoples of Riverside County at the Soboba Indian Health Clinic. (Courtesy of authors.)

The Twenty-Nine Palms Band has been a leading sponsor of the Environmental Protection Agency of the United States by supporting its own tribal EPA and a sophisticated laboratory directed by Dr. Marshall Cheung and Anne Cheung. (Courtesy of authors.)

121

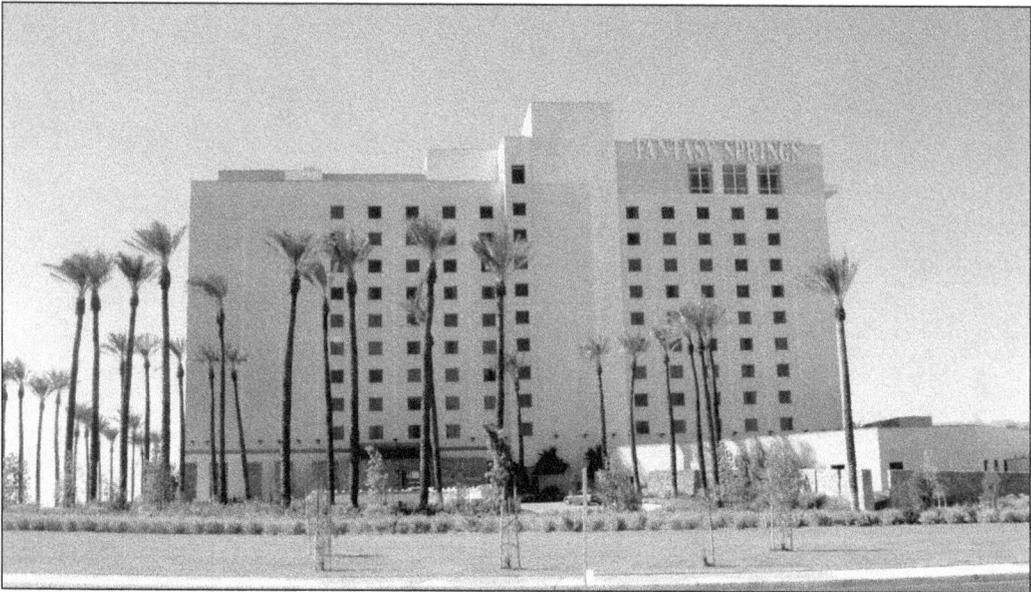

Many tribes in Riverside County have invested in their own economic development, including the Cabazon band. Their major investment is the Fantasy Springs Hotel and Casino. (Courtesy of authors.)

The Agua Caliente Band in Palm Springs, California, has two successful casinos and have used some of their funds generated by gaming to support a state-of-the-art museum. The tribe also supports programs focused on education, health, language, and environmental preservation. (Courtesy of authors.)

Many Native American people in Riverside County are Christians. Although the Spanish never created an Indian mission on lands that became Riverside County, Catholic churches grace several reservations, including the Soboba Indian Reservation. (Courtesy of authors.)

Christianity has become an important religion on every reservation in Riverside County. This is a Christian Church on the Morongo Indian Reservation. (Courtesy of authors.)

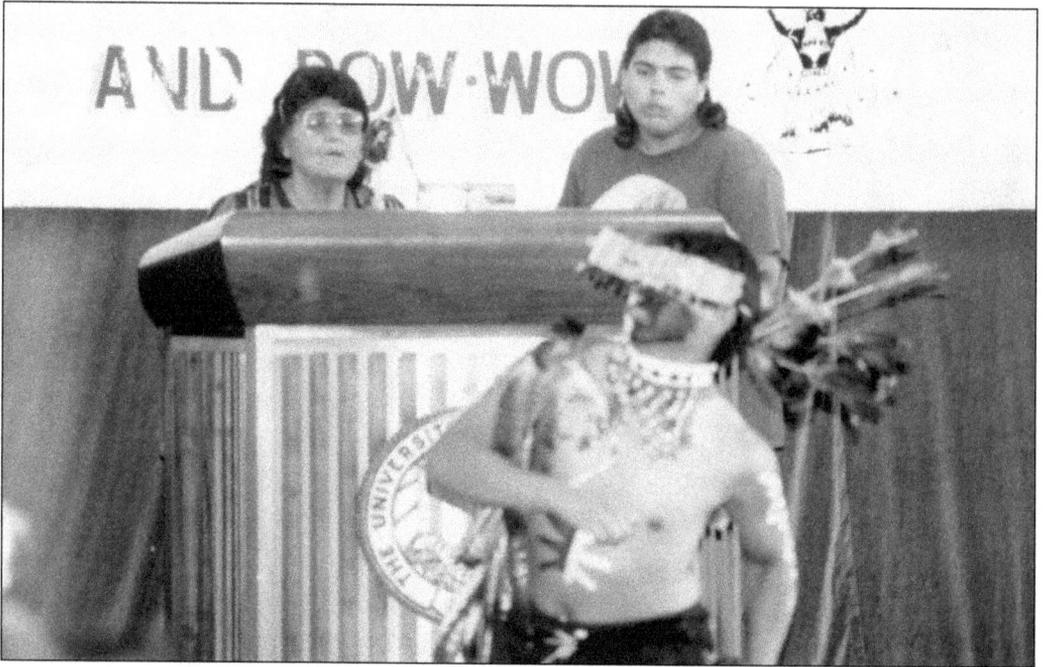

During the centuries before 1900, people from many parts of the Native American country came to Riverside County to dance and sing. In this photograph, two Indian singers provide the accompaniment for the California Indian dancer at a Medicine Ways Conference at the University of California, Riverside. The conference emphasizes Indian culture, preservation, and continuance of a strong Native America. (Courtesy of authors.)

Paul Apodaca is a Navajo man who often serves as a community leader among reservation and urban Indians. He received a Ph.D. in anthropology at the University of California, Los Angeles. He has researched the history of Bird Songs and is a Bird Singer himself. Apodaca has worked tirelessly to protect and preserve California Indian culture. (Courtesy of authors.)

Robert Levi is from the Torres Martinez Reservation of the Coachella Valley. He is one of the most famous Native American singers in Riverside County, training many young people how to sing Bird Songs. Levi attended Sherman Institute, and after graduation, remained at the school in Riverside, California, to work. He retired from Sherman Institute and is a leading elder who trains young people to preserve the culture and history of all Native Americans in Riverside County. (Courtesy of authors.)

ACKNOWLEDGMENTS

Many people, tribes, and institutions have contributed to this book. The Cabazon Cultural Museum, the Cabazon Band of Mission Indians, and director Judy Stapp supported the work from the outset. We will contribute all proceeds from this book to the museum, and we thank chairman John James and the tribal council for their sponsorship. We thank the A. K. Smiley Public Library, Twenty-Nine Palms Band of Mission Indians, Riverside Metropolitan Museum, and Sherman Indian School Museum for sharing their photographs. Pauline Murillo and Leleua Loupe allowed us use of their personal photographs. The following individuals helped us with this project: Michelle Raheja, Anthony Madrigal, Dean Mike, Ernest Siva, Theresa Mike, Joe Bentitez, Charlene Ryan, Katherine Saubel, James Ramos, Anthony Madrigal, Lori Sisquoc, Jean Keller, Nathan Gonzales, Larry Burgess, Lynn Voorheis, Richard Hanks, Brenda Focht, Dean Ayer, Teresa Woodard, Ennette Nusbaum, Vince Moses, Kevin Hallaran, Marshall Cheung, Anne Cheung, Kurt Russo, Dick McClung, Fay McClung, Tom Cogeswell, Monte Kugel, Pedro Santoni, Edward Gomez, Matthew Gilbert, and Luke Madrigal. We thank Jerry Roberts of Arcadia Publishing for his interest in the project. Finally, we offer our sincere appreciation to our wives, Lee Ann and Dani, to whom we dedicate this book.

—Clifford E. Trafzer and Jeffrey A. Smith

BIBLIOGRAPHY

Bean, John Lowell. *Mukat's People*. Berkeley, CA: University of California Press, 1972.

Bean, Lowell John, and Katherine Siva Saubel. *Temalpakh: Cahuilla Indian Knowledge and Usage of Plants* Banning, CA: Malki Museum Press, 1972.

Bean, Lowell John, and Lisa Bourgeault. *The Cahuilla*. New York: Chelsea House Publishers, 1989.

Burgess, Larry E., and Nathan D. Gonzales. *Redlands*. Charleston, SC: Arcadia Publishing, 2004.

Carico, Richard. *Strangers in a Stolen Land*. Newcastle, CA: Sierra Oaks, 1987.

Costo, Rupert, and J. H. Costo. *The Missions of California*. San Francisco: American Indian Historian Press, 1987.

Murillo, Pauline Ormego. *Living in Two Worlds*. San Bernardino, CA: Dimples Press, 2002.

Patencio, Francisco. *Stories and Legends of the Palm Springs Indians as told to Margaret Boynton*. Los Angeles: Times—Mirror Press, 1943.

Perez, Robert. *The History of the Cabazon Band of Mission Indians: 1776–1876*. Indio, CA: Cabazon Band of Mission Indians, 1999.

Ramon, Dorothy, and Eric Elliott. *Wayta'yawa: Always Believe*. Banning, CA: Malki Museum Press, 2000.

Russo, Kurt. *In the Land of Three Peaks: The Old Woman Mountains Preserve*. Coachella, CA: Native American Land Conservancy, 2005.

Sauvel, Katherine Siva, and Eric Elliott. *'Isill Héqwas Wáxish: A Dried Coyote's Tail*. Two Volumes. Banning, CA: Malki Museum Press, 2004.

Strong, William Duncan. *Aboriginal Society in Southern California*. Banning, CA: Malki Museum Press, 1987.

Trafzer, Clifford E. *The People of San Manuel*. Patton, CA: San Manuel Band of Mission Indians, 2002.

Trafzer, Clifford E., Luke Madrigal, and Anthony Madrigal. *Chemehuevi People of the Coachella Valley*. Coachella, California: Chemehuevi Press, 1997.

Visit us at
arcadiapublishing.com